1994

A Proud Heritage: Two Centuries of American Art

A Proud Heritage: Two Centuries of American Art was
prepared on the occasion of the inaugural exhibition
of the same name celebrating the opening of the
Terra Museum of American Art on North Michigan Avenue
in Chicago.

ISBN-0-932171-01-X

Library of Congress Catalog Card Number: 87-9948

Edited by Terry A. Neff, T. A. Neff Associates, Chicago
Designed by Michael Glass Design, Inc., Chicago
Typeset by AnzoGraphics, Chicago
Printed by Colorcraft Lithographers, Inc., New York
Photographs by Michael Tropea, Chicago, and courtesy
of the Pennsylvania Academy of the Fine Arts,
Philadelphia

Cover:
George Caleb Bingham, *The Jolly Flatboatmen*, 1848 (pl. T-18)

A Proud Heritage

TWO CENTURIES OF AMERICAN ART

Selections from the Collections of the

Pennsylvania Academy of the Fine Arts, Philadelphia,

and the

Terra Museum of American Art, Chicago

Essays by
D. Scott Atkinson, Linda Bantel, Judith Russi Kirshner,
Elizabeth Milroy, and Michael Sanden

Edited by
Terry A. Neff

Published by
Terra Museum of American Art, Chicago

Contents

Foreword
By Daniel J. Terra
7

Statement
By Frank H. Goodyear
8

Introduction and Acknowledgments
By Michael Sanden
9

Collecting the Image of America:
Charles Willson Peale's *The Artist in His Museum*
and Samuel F. B. Morse's *Gallery of the Louvre*
By Judith Russi Kirshner
10

Painting the Image of America:
Portraiture and Genre in the 19th Century
By Elizabeth Milroy
18

Americans in the Landscape
By D. Scott Atkinson
24

American Impressionism
By Elizabeth Milroy
30

America and the Modernist Spirit
By D. Scott Atkinson
36

Selections from Pennsylvania Academy of the Fine Arts
with an Introduction by Linda Bantel
44

Selections from Terra Museum of American Art
with an Introduction by Michael Sanden
108

Index of Artists
300

Foreword

The art of a nation kindles the spirit of its people. Daniel J. Terra

Statement

The long, distinguished history of the Pennsylvania Academy of the Fine Arts is replete with great moments from the annals of American art. The Pennsylvania Academy has been a kind of "heartline" in this history. The collaboration between this country's newest museum devoted to American art, the Terra Museum of American Art, and the Pennsylvania Academy of the Fine Arts is another extremely proud moment in this evolution.

It is a pleasure for the Pennsylvania Academy to join with the Terra Museum in presenting to the American people a selection of their glorious heritage. In so doing, we salute the Terra Museum for its own spectacular accomplishments, and look ahead to many more cooperative ventures. Our missions are shared: to collect, preserve, and exhibit the finest art of this nation and, in so doing, to reveal its remarkable achievements.

Frank H. Goodyear, Jr.
President, Pennsylvania Academy of the Fine Arts

Introduction and Acknowledgments

This beautiful book on American art first and foremost owes its existence to Ambassador Daniel J. Terra, whose vision, courage, and resourcefulness have been inspiring to all of us fortunate enough to be involved with this project. Daniel J. Terra is unquestionably the United States' most enthusiastic spokesman for American art. To experience first-hand his leadership, awe-inspiring energy, and values has been an unforgettable adventure for all those associated with this publication. It has been a rare and exciting opportunity to work directly with the driving force and founder of a great collection and a museum established for the purpose of presenting and interpreting the art of our nation.

It is equally important here to recognize the tremendous contribution of Philadelphia's Pennsylvania Academy of the Fine Arts, this country's first museum devoted solely to American art. We are sincerely grateful for their participation in *A Proud Heritage: Two Centuries of American Art*, the book that accompanies the inaugural exhibition at the Terra Museum of American Art on Chicago's North Michigan Avenue. In that regard we wish to express our appreciation to the Pennsylvania Academy's board of trustees and president, Frank Goodyear. Linda Bantel, director of the Pennsylvania Academy of the Fine Arts, has throughout this period provided expert support and encouragement; she and her staff have helped make this collaboration a success.

For the very fine essays on aspects of American art that are included in this book, we would like to thank the three curators of the Terra Museum: D. Scott Atkinson, Judith Russi Kirshner, and Elizabeth Milroy. Their contributions serve to clarify some of the issues of the period and the emergence of a truly American art. In addition, we would like to thank the staff of the Terra Museum, without whose efforts this publication could not have been accomplished. In particular, we wish to mention Barbara D. Hall for her assistance in preparing the manuscript, and Janna Eggebeen for her research on the artists' biographies. Likewise, the editorial, design, and production team has performed extremely well. Terry A. Neff, of T. A. Neff Associates, Chicago, has been absolutely invaluable in her role as coordinator of this publication. The designer, Michael Glass, has sensitively collaborated with Ambassador Terra and the museum to provide a book of classical elegance and beauty. Colorcraft Lithographers, Inc. has taken care to assure that this publication has reproductions of the highest possible quality and accuracy.

The Terra Museum of American Art sincerely wishes to thank all those associated with this book and, furthermore, to express appreciation to the museum's constituencies and many friends both locally and nationally. It is this expanding circle of friends and supporters that serves to encourage our role of seeking to provide the community with an opportunity to view and learn about our American artistic heritage.

Michael Sanden
Director, Terra Museum of American Art

Collecting the Image of America: Charles Willson Peale's *The Artist in His Museum* and Samuel F. B. Morse's *Gallery of the Louvre*

By Judith Russi Kirshner

It has been more than 150 years since Samuel F. B. Morse returned from Paris with his grand ambition to exhibit his painting *Gallery of the Louvre* (1831-33) throughout the United States. His idealism—and this ambition—were dashed by a lack of response from audiences in 19th-century America. It seems, therefore, extremely appropriate and even symbolic that this impressive image of a magnificent European museum has found a permanent home at the Terra Museum, an institution devoted exclusively to American art. The inaugural exhibition of the Terra Museum brings together two fascinating collections: the oldest, the Pennsylvania Academy of the Fine Arts, founded in 1805 in Philadelphia, and the youngest, founded in 1980 in Evanston, Illinois, thereby presenting more than two hundred paintings from over two centuries of American art.

If we look at the stunning portrait of Charles Willson Peale, *The Artist in His Museum* (1822), and compare it to the endlessly intriguing six-by-nine-foot canvas of Samuel F. B. Morse's *Gallery of the Louvre*, which also contains a portrait of the artist and was painted a decade later, we can explore the motivations of two extraordinary individuals and two very different artistic sensibilities. Such a unique juxtaposition also sheds considerable light on the means by which 19th-century

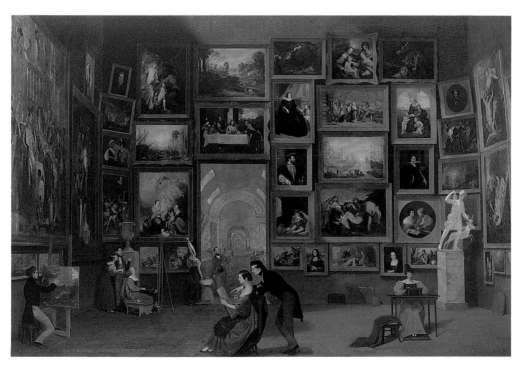

Samuel F. B. Morse, *Gallery of the Louvre* (pl. T-12)

1. Veronese
The Marriage at Cana

2. Murillo
The Immaculate Conception

3. Jouvenet
The Descent from the Cross

4. Tintoretto
Self-Portrait

5. Poussin
The Deluge

6. Caravaggio
The Fortune Teller

7. Titian
The Crowning with Thorns

8. Van Dyck
Venus Entreating Vulcan

9. Claude Lorrain
The Landing of Cleopatra

10. Murillo
The Holy Family

11. Teniers, the Younger
The Knife Grinder

12. Rembrandt
Tobias and the Angel

13. Poussin
*Diogenes Casting Away
His Cup*

14. Titian
The Supper at Emmaus

15. Huysmans
Landscape

16. Van Dyck
*Portrait of a Lady and
Her Daughter*

17. Titian
Francis I, King of France

18. Murillo
A Beggar Boy

19. Veronese
*Christ Fallen Under
the Cross*

20. Leonardo da Vinci
The Mona Lisa

21. Correggio
*Mystic Marriage of
St. Catherine*

22. Rubens
*The Flight of Lot and
His Family from Sodom*

23. Claude Lorrain
Sunset–View of a Seaport

24. Titian
The Entombment

25. Le Sueur
Christ Bearing the Cross

26. Salvator Rosa
*Landscape with
Soldiers and Hunters*

27. Raphael
La Belle Jardinière

28. Van Dyck
Man Dressed in Black

29. Guido Reni
*The Union of
Design and Color*

30. Rubens
Suzanne Fourment

31. Simone Cantarini
Rest on the Flight to Egypt

32. Rembrandt
Head of an Old Man

33. Van Dyck
*The Woman Taken in
Adultery*

34. Vernet
A Marine View by Moonlight

35. Guido Reni
*Dejanira and the
Centaur Nessus*

36. Rubens
*Thomysris, Queen of the
Massagetae*

37. Mignard
Madonna and Child

38. Watteau
Embarkation from Cythera

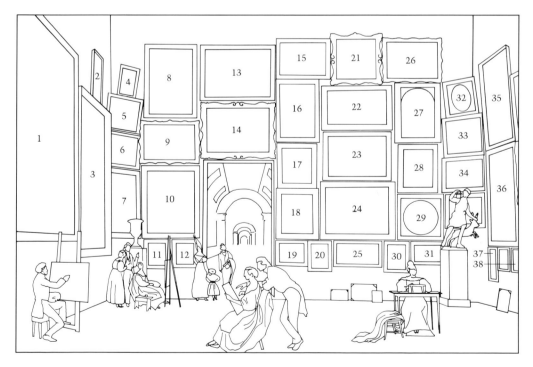

Key to Samuel F. B. Morse's *Gallery of the Louvre*

American artists represented themselves in relationship to museums, on attitudes of collecting, and on larger notions of patronage and patriotism.

The remarkable coincidence of both paintings appearing together illuminates the education of artists and the educative role of art and artists in the 19th century. Issues of presentation, education, and accessibility, which are at the heart of all discussions of museum policy, first occurred immediately after the French Revolution when Napoleon, in March 1802, opened the doors of the Salon Carré in the Louvre, formerly a royal palace, and made available to the public the greatest exhibition of art ever assembled in Europe. Such issues consumed Charles Willson Peale, a respected portraitist and recognized naturalist, who founded the brief-lived Columbianum, a cooperative institution for instruction. Peale was also one of the principle organizers of the Pennsylvania Academy as well as director of his own museum. Well known for his invention of the electromagnetic telegraph, Samuel Morse in 1826 was a founder and later president of the National Academy of Design in New York.

Samuel F. B. Morse, a 20-year-old Yale graduate, first visited London in 1811 and, like his predecessors and illustrious fellow countrymen Benjamin West and Washington Allston, began to reap the fruits of the rich inheritance that museums and collections in Rome, London, and Paris provided for American artists and collectors. Morse's first visit lasted a mere two months, but his curiosity was whetted and he made other, more extensive, trips. Morse's intelligence, cultivation, and great artistic ambition inspired him to confront what was a central dilemma of a new country dedicated to material and economic growth but desirous of a rich cultural life. The conflict between American pragmatism and European tradition, between practical inventions of science based on a synthesis of previous experimentation, and imaginative inventions of art inspired by past examples, was epitomized in Samuel Morse's career. In 1814 he wrote, "Taste is only acquired by a close study of the Old Masters," for without, "large supplies of really good specimens of European art, ancient or modern," Americans would be hard pressed to produce truly fine art.[1]

With one hand raising a crimson curtain in a gesture that partakes of the grand manner – the pose recalling that of George Washington in the Pennsylvania Academy's *"The Lansdowne Portrait"* by Gilbert Stuart (pl. P-8) – and the other open in an inviting gesture, the imposing figure of Charles Willson Peale ceremoniously unveils his treasury of man-made and natural specimens. Peale's museum flourished from humble beginnings as an exhibition space in his home to an internationally recognized institution which, when it was dispersed in 1848 and 1854, boasted collections of 800 Indian costumes and artifacts, 269 portraits, 650 fishes, 135 reptiles, and 250 quadrupeds – a total of 100,000 objects displayed in the State House and rented galleries of the American Philosophical Society. What is striking about Peale's museum is its delightful and, by our standards, astonishing, eclecticism and the astute recognition that fine art could draw a larger audience if it was also presented with showmanship, the lure of rarity, and the promise of edification – Peale's formula for "rational amusement."[2] In the long room, a spacious gallery facing Chestnut Street, ornithological specimens in glass cases were displayed under tiers of portraits of prominent Americans matted and framed in gold. Juxtaposing natural species – in 1805, 700 birds were displayed against painted habitats in 160 cases – with rock and insect collections, Peale's miniature world anticipated modern techniques of display that recognize the importance of contextual arrangements.

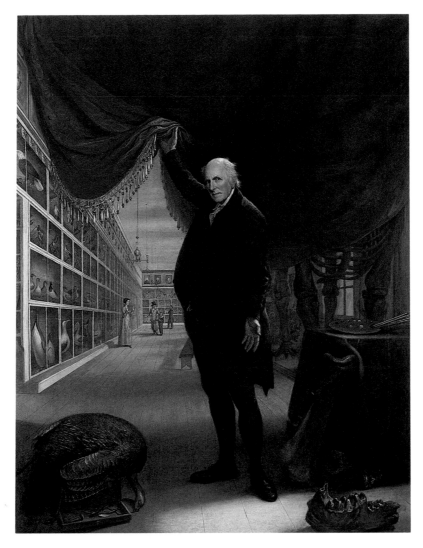

Charles Willson Peale, *The Artist in His Museum* (pl. P-5)

The resourceful patriarch of a famous artistic family – several of his 17 children were either museum professionals or portraitists – Peale believed that natural history and religious truths should exist side by side. Drawing his classification system from the 18th-century Swedish botanist Carolus Linnaeus, Peale arranged his specimens according to developmental taxonomies explained in didactic panels mounted near the cases. Similarly, the painstakingly faithful likenesses of illustrious individuals (human specimens like George Washington, Benjamin Franklin, and General Lafayette) suggested models of human behavior and pinnacles of developmental evolution. These popular displays demonstrated the unification of art and nature. Dedicated to preserving scientific order and natural forms in harmony, Peale was also a moralist who attached signs over his entrances that read "School of Wisdom" and "School of Nature." According to his biographer he believed that the fundamental law of nature was also fundamentally divine law. Enlightened, he published an eight-page guide which could be purchased for twenty-five cents, and formed a distinguished committee whose duty it was to collect information on natural and archaeological American antiquities. A practical man, he always

charged admission. Like most entrepreneurs, Peale understood the value of publicity and, in addition to exhibits donated by Thomas Jefferson from the Lewis and Clark expeditions, one could find a five-legged, six-footed, two-tailed cow in one of the galleries.

To be sure, Peale's museum was never limited to freakish displays; its most spectacular holding was the giant bones, teeth, and tusks of a mammoth excavated by Peale from glacial deposits in upstate New York (visible in the foreground of the painting). This scientific marvel, unearthed in 1801, held a prehistoric place at one end of a chronological spectrum that also displayed live animals in outdoor cages. On several occasions these creatures escaped into the galleries where they were dispatched; more routinely, they were preserved in arsenic and classified in Latin. An inscription on a placard installed above one of the museum entrances exemplified Peale's dual commitment to education and pleasure:

> The book of Nature is open –
> – Explore the wondrous work.
> A solemn Institute of laws eternal
> Whose unaltered page no time can change,
> No copier can corrupt.

Ten years after Peale painted his dramatic portrait of the artist, a depiction that still carries an air of magical revelation, Samuel F. B. Morse represented an entirely different version of the artist as copyist in one of the greatest collections in Europe. Notwithstanding that both artists were dedicated to fidelity to nature and to scientific investigation, the aesthetic differences between them, as well as their training and sensibility, are obvious and noteworthy. A colorful character, Charles Willson Peale belonged to an earlier generation, to the founding fathers of the late 18th century, while Morse, whose biographer called him the "American Leonardo," in his success and in his failures, helped to transplant the grand manner of Europe to American soil.

In both pictures the artist revealed the tools of the trade, thereby underscoring the centrality of his role in the creation and representation of culture. Peale's palette is displayed on a table to the right. Morse's self-identification is more subtle, and indeed he did not include the identities of the ten figures in the foreground of his own great masterpiece when he published his guide to the painting, "Descriptive Catalogue of the Pictures, Thirty-seven in Number, From the Most celebrated Masters copied into the *Gallery of the Louvre*" (see p. 11). At the center of the canvas, Morse depicted himself leaning over the shoulder of an unidentified young woman, offering guidance to his student copyist. Calling attention to his role as an educator, Morse observed several conventions in this learned display, which is probably the first American version of a well-known genre, the gallery picture. Both Morse and Peale have extended the convention of the artist in the studio to elaborate settings filled with objects that reinforce their prominence in their profession. Peale's emphasis on a theatrical presentation and celebration of natural history precludes its being a direct model for Morse, who was certainly familiar with *The Artist in His Museum*.

When he first visited the Louvre in January 1830, Morse spent two weeks there. In Paris he became involved with heady Republican politics of postrevolutionary France and the Committee for Polish Independence led by General Lafayette. He

then traveled to Italy where he joined his close friend, the writer James Fennimore Cooper, and spent more than a year copying Italian masterpieces as commissions for American clients. A common mode of supporting European travel became a financial necessity for Morse, whose success as president of the National Academy of Design had not brought him the material rewards he required. Borrowing from the grand manner was an acceptable pedagogical technique furnishing the classical framework from which American artists launched their own expression. One example is Gilbert Stuart's state portrait of George Washington, *"The Lansdowne Portrait"* (1796), based on an engraving of Hyacinthe Rigaud's portrait of Bishop Bossuet. Many other American artists, such as Washington Allston, John Singleton Copley, John Trumbull, John Vanderlyn, and the expatriate Benjamin West, all found prototypes in classical sculpture and Old Master painting. However, when William Sidney Mount painted *The Painter's Triumph* in 1838 (pl. P-22), the only vestige of the grand manner, besides the flamboyance of the artist's pose, was a drawing of an antique bust pinned to the wall of the studio.

Morse's continental experience reinforced a preference for historical subject matter which he deemed more exalted and substantial than the standard portrait fare that provided his bread and butter. But there were contradictions between his private sentiments and public nationalistic pronouncements. As president of the National Academy of Design, Morse had always encouraged the development and support of a uniquely American aesthetic and championed its quality in the face of European models. His goals for a national cultural identity were interdependent: to raise artistic standards and to improve the taste of the American audience. Attracted by its monumental beauty yet ambivalent about the theatrical, even decadent, quality of the life and customs of Europe, Morse (like his French contemporaries) recognized that copying in the Louvre constituted an education in itself. In the mid-19th century, artists, particularly those who painted the human figure rather than landscapes, worked in museums as a complement to their academic training. Contemporary accounts of the Louvre describe forests of easels springing up in the galleries.

Scholars have speculated that the idea of depicting the *Gallery of the Louvre* emerged from discussions between James Fennimore Cooper, who might also have been the intended purchaser of the work, and Morse. Whatever the private motivations, what is certain is that the enormous project was destined to fulfill a public function – to educate through appreciation of the masters. The *Gallery of the Louvre* must also be discussed as an American version of a tradition known as "gallery pictures" or paintings of *cabinets d'amateurs* that originated in the lively art market of 17th-century Flanders. Other models for Morse's unique variation on this theme include two fantastic gallery pictures by Giovanni Paolo Pannini (1691-1765) which Morse saw at the Boston Athenaeum in 1834. Even more specific precedents of public galleries, rather than private collections favored by Flemish painters such as David Teniers the Younger, would be Johann Zoffany's *Tribuna of the Uffizi* (1772-77) which Morse might have seen in London in 1814.[3] Other contemporary depictions of the Salon Carré by N.-S. Maillot and the English painter John Scarlett Davis provide comparisions with Morse's invention.

Characteristics of the gallery picture genre include numerous miniature copies, figures in the foreground who have a particular relationship to the works on display, and, finally, the intention to communicate the exquisite taste and remark-

able perspicacity of the collector and/or artist who is associated with the real or imagined gallery. In order to accomplish this last effect, the author of a gallery picture rearranges the placement and adjusts the size of the works on exhibit.

Begun in the fall of 1831, Morse's painting presents a democratic departure from the convention of aristocratic patronage. Its art historical scope as well as its scale have been magnified to fulfill its primarily didactic purpose. Even before his French trip, Morse studied copies and engravings in London under the tutelage of his friend and mentor Washington Allston, who greatly admired the Venetian School. The older painter's influence on Morse is reflected in the strong representation given to these painters in the *Gallery of the Louvre.* Actually, only French paintings were exhibited in the Salon Carré in 1831, but Morse collected his forty-one examples from almost every school and every major period over three centuries. He included landscapes, seascapes, portraits, religious and mythological scenes. Organizing his composition according to the subtle iconographic lessons and subjective insights he wished to convey, Morse positioned himself in a manner that echoes the figure of the pilgrim in Titian's *Supper at Emmaus,* installed above the entrance to the Grand Galerie of the Louvre. His pose is animated and informal. Indeed the atmosphere of this painting evokes a relaxed but respectful attitude of appreciation and instruction which Morse rather charmingly orchestrated against the lofty architecture of Le Vau. Nevertheless, the educator-painter's heroic and back-breaking project had to be put aside in October 1832 when Morse sailed for the United States. The project, which was not resumed until February 1833, was completed in August of that year. Back in the States and after attending to the magnetic telegraph, Morse added frames to the miniatures and put figures in the foreground.

The scale of this painting is much larger than the usual gallery invention and the contemporary viewer can almost imagine walking into this space. The pictures have been consciously rearranged to relate to the characters portrayed in the gallery, associates of Morse who were probably added after the painting was first exhibited. In the left-hand corner of the room stands James Fennimore Cooper with his wife and 18-year-old daughter, Susan, also copying. Indeed rumors at the time insinuated that the relationship between the 40-year-old widowed Morse and the young woman was more than platonic. Morse underscored Cooper's identity and testified to their friendship and shared experiences by flanking the author with two favorite images, Rembrandt's *The Angel Leaving Tobias* and Teniers's *The Knife Grinder.* In Morse's capable hands, American art and literature meet amidst a rich and ancient cultural patrimony.

In his lectures on the "Affinity of Painting wih the Other Fine Arts," Morse established himself as a theorist in the tradition of Sir Joshua Reynolds and became the first practicing artist to deliver a series of lectures on art in the United States. Demonstrating his own erudition, the lectures, like the *Gallery of the Louvre,* emphasized the imaginative and intellectual qualities of art and acknowledged the authority of the European grand manner. Morse received high praise from the press, who admired his magnificent design and personal sacrifice when he first exhibited the painting at his home in New York in September 1833. Still, Morse could never generate the dialogue that was always so crucial to him, and could not find an audience who shared his enthusiasm or, more exactly, his familiarity with this subject matter. By the time Morse returned from France, American artists were originating their own distinct school, a national identity, and a suitable imagery in

landscape painting. Nature and instinct replaced culture and programmatic copying as American collectors turned their attention to innovation and native genius. When Morse was composing his Athenaeum lectures, Thomas Cole was already winning praise for his appealing romantic expression. By 1840 Morse believed that painting had abandoned him and, after failing to find an audience for the *Louvre* and a commission for a mural in the Capitol in Washington, the artist abandoned painting for scientific invention. He was enormously frustrated at not being able to share democratically his encyclopedic vision of European images – what Morse scholar Paul Staiti has called "a didactic cultural machine" and a "surrogate museum" – with the American public.[4] He sold the *Gallery of the Louvre* for a disappointing sum of 1,200 dollars and, dejected, wrote, "My life of poetry and romance is gone. I must descend from the clouds and look more at the earth."[5]

In 1987 art audiences can easily appreciate the curiosities in both Peale's and Morse's museums. They can also enjoy the challenge of identifying the protagonists in Morse's theater of masterpieces: Correggio, Guido, Leonardo, Raphael, Rembrandt, Rosa, Rubens, Van Dyck, Titian, and Watteau. In the late 20th century, these visions of artistic excellence and eclecticism can be admired for their beauty and skill, their dedication to educational ideals, and as eloquent evidence of America's rich history. Both artists, Peale and Morse, represented themselves as central to the production and distribution of culture, mediators who in their assemblage of ideal collections bridged past and present, art and life. When Daniel J. Terra purchased the *Gallery of the Louvre* in 1982, the invitation to join the artist in the museum was extended. The painting has traveled to 18 cities across the United States where it has found thousands of new students of American art and dramatically fulfilled Morse's intentions. At the Terra Museum of American Art, the painting of an imagined European installation continues to be an informative and popular work of art. Furthermore, it becomes emblematic of the role of collectors in the triad of artist/museum/collector articulated so brilliantly in both the Peale and Morse paintings. American artists need no longer look to Europe for cultural legitimacy as art museums promote dynamic exchanges between Europe and America, between tradition and innovation. Absolute criteria for either artists or collectors have become more flexible as multiple approaches and exciting new forms become available to individual and institutional patronage. With the opening of the Terra Museum of American Art in Chicago, another instance of the transformation of private patronage into public patrimony assumes its place in the history of American museums that began privately with Charles Willson Peale's Museum and publicly with the Pennsylvania Academy in Philadelphia in 1805.

Notes

1. Lillian B. Miller, *Patrons and Patriotism: The Encouragement of the Fine Arts in the United States 1790-1860* (Chicago: University of Chicago Press, 1966), p. 141.

2. For a discussion of Peale's Museum, see Charles Coleman Sellers, *Charles Willson Peale* (New York: Charles Scribners Sons, 1969), and E. Richardson, B. Hindle, and L. Miller, *Charles Willson Peale and His World* (New York: Barra Foundation, 1983).

3. David Tatham, "Samuel F. B. Morse's *Gallery of the Louvre* : The Figures in the Foreground," *The American Art Journal* 13, 4 (Autumn 1981), pp. 38-48.

4. Paul Joseph Staiti, "Samuel F. B. Morse and the Search for the Grand Style" (Ph.D. diss., University of Pennsylvania, 1979.)

5. Paul Joseph Staiti and Gary A. Reynolds, *Samuel F. B. Morse* (New York: Grey Art Gallery, 1982).

Painting the Image of America: Portraiture and Genre in the 19th Century

By Elizabeth Milroy

When the United States of America came into being, the leaders and citizens of the young republic faced a formidable identity crisis. What exactly was the "United States" and who were these people who called themselves "Americans?" How should the young culture and its citizens be described or portrayed? European thinkers had developed the democratic philosophy on which this country's political system was based. European countries had supplied the North American continent with colonists whose aspirations reflected that philosophy. The declaration of political independence was one thing. But how would the new nation and its people demonstrate their *cultural* independence?

Well aware of their "newness" within world history, Americans were extremely self-conscious and self-analytical. In a country founded upon the rights of the individual, defining the exact look and character of that individual in his collective form was very important. Creative minds were confronted with the challenge of recording, indeed creating, an accurate "American" image. How should the character and exploits of "Yankee Doodle Dandy," already celebrated in song and fable, be portrayed in pictures?

This challenge was complicated by the fact that in the young United States, the fine arts of painting and sculpture were regarded with some suspicion and not a little skepticism. To a people engaged daily in the struggle to tame a seemingly endless wilderness, with its attendant physical and psychological hazards, the arts of painting and sculpture were superfluous luxuries. Moreover, many Americans equated the fine arts with memories of the aristocratic European societies they had left and ultimately rebelled against. Yet the United States was not without artists of noteworthy talent. Despite an unsympathetic climate, these artists persisted in their efforts to produce faithful images of the burgeoning young society. Even before the War of Independence, several American painters gained celebrity in England and on the continent. They included Benjamin West, a native of Pennsylvania and the master chronicler of America's early history (see pl. P-2), who rose to the very highest rank of England's artists as history painter to King George III and as president of the Royal Academy, and John Singleton Copley, who painted the prosperous merchants (see pl. P-1) and fashionable dames (see pl. T-2) of Boston before also leaving the colonies to seek his fortune in England.

Throughout American history artists have labored to portray the accomplishments of their fellows in pictorial form. Well into the 19th century, itinerant portraitists toured throughout the territories, pushing as far west as there were settlements and carefully recording the plain features of hard-working men and women. Although none ever made a fortune from this enterprise, these artists were not lacking for subjects, whether a shy ingenue (see pl. T-22) or the healthy young son of a proud and indulgent father (see pl. T-20). Other artists working in East Coast cities for an urban clientele produced slicker, more idealized, images but could not completely disguise the awkward posing of the young citizenry, as witness the

Philadelphia painter John Neagle's portrait of an overdressed young matron fussing with her velvets and frills (see pl. P-21).

Not surprisingly, perhaps, the most popular subject for artistic treatment during the first half-century of American independence was George Washington. Washington was the epitome of the American patriot, a gentleman-farmer who had left the security of his home to defend that home and his political ideals in a seven-year conflict and then again agreed to leave his home and family to lead the country through its early struggle for political and economic survival.

Washington was a legendary hero in the United States even before his death, and the artists who painted or sculpted his features were desirous of evoking the mythic qualities of the man as much as recording his physiognomy. Gilbert Stuart painted Washington in 1796 as a dignified counselor, garbed in black, presented in the traditional rhetorical pose of the Roman orator surrounded by the symbols and paraphernalia of a statesman (pl. P-8). In fact, Stuart's image was an adaptation of the

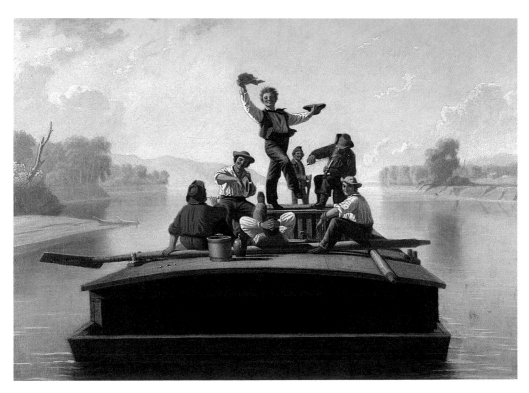

George Caleb Bingham, *The Jolly Flatboatmen* (pl. T-18)

ancient Roman imperial portrait, a reflection perhaps of the wishes of some Americans that Washington declare himself king and install a traditional monarchy. Such ambitions were in vain, but Stuart's imperial image still conveys a vital sense of Washington's personal charisma and political authority.

Some 50 years later, Washington was still a popular subject. Indeed, the Philadelphia artist and entrepreneur Rembrandt Peale, who had painted the aging Washington from life in 1795, maintained a thriving industry in Washington portraits – producing some 79 replicas of a standard "Washington," which he sold or gave away to suitable clients, including the U.S. Senate and various private and institutional collections (see pl. T-4). Peale's efforts should not be discredited, for he was honestly concerned with providing a mass audience with images of importance and popular interest. So popular a subject was Washington, in fact, that allegories of his leadership were engraved for countless copies by master printmakers, memorial designs stitched into innumerable embroideries by nimble-fingered women, and variations of his portrait chromolithographed unendingly for sale to every 19th-century American household.

As the 19th century progressed and the United States moved steadily toward economic prosperity and a political identity respected by the countries of Europe, lingering antipathy to the arts gradually decreased. Settlers on the very frontier of the young country were edified by the traveling art shows of artist-entrepreneurs, often in the form of dioramas depicting spectacular natural wonders or famous historic events, or single paintings of an allegorical or educational import. In the larger cities on the East Coast, newly established museums and commercial galleries showcased paintings in annual exhibitions to encourage the acquisitive instinct and desire for cultural sophistication of the country's more prosperous citizens. Ironically, the new class of American collectors pursued "masterpieces" (real and imagined) produced for the rulers of Europe against whom their forefathers had rebelled – all but ignoring the work of America's own artists.

Lack of interest among American collectors did not deter the efforts of the nation's artists, for the young country and the activities of its enterprising citizens offered a wealth of image and anecdote for pictorial treatment. Before the turn of the 19th century, Philadelphia was the second-largest English-speaking city in the world. John Lewis Krimmel, America's first important genre painter, recorded the diversity of Philadelphia's citizenry and their proud civic monuments in his 1812 souvenir of the Fourth of July at Centre Square (pl. P-18). And as the frontier was pushed westward, artists accompanied their compatriots along the burgeoning trade routes of the country's great rivers and harbors. Missouri-born George Caleb Bingham specialized in group portraits of the hardy barge sailors who plied the Mississippi and Missouri rivers, the men who were spearheading the steady movement westward of railroads and settlements that would transform the once-quiet plains of the inner continent (see pl. T-18).

The eager hopes of the young republic were most eloquently expressed in the frank and innocent faces of its children, and throughout the 19th century, artists returned again and again to this subject. Early in the century Krimmel painted a rollicking game of blind man's buff, glimpsed perhaps in his own Philadelphia home (pl. T-9). William Sidney Mount, whose views of life in rural Long Island during the 1840s and 1850s are invaluable records of our social history, painted two young hunters treading carefully through new-fallen snow to examine their trap (pl. T-16).

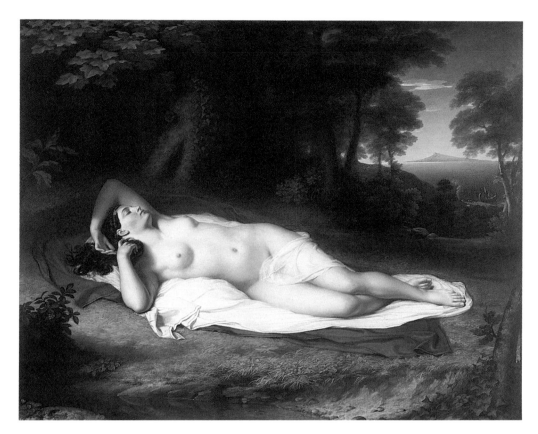

John Vauderlyn, *Ariadne Asleep on the Island of Naxos* (pl. P-10)

The English immigrant artist John George Brown, renowned for his paintings of children, lined up country youngsters along a split-rail fence; their cheeks are almost bursting with hastily munched apples as they pose near the cider mill (pl. T-31). Samuel S. Carr chose a more sedate view: suburban children gathering for a picnic in Brooklyn's Prospect Park (pl. T-55) or sailing ships at the seashore (pl. T-54). And at the century's end, the Impressionist painter Edward Potthast set his youthful subjects awhirl upon a sandy beach (pl. T-93).

For many Americans the Civil War shattered the naïve optimism celebrated in early 19th-century images. Although artists affected by the war did not abandon popular subjects, they allowed a sense of quiet melancholy to invade their imagery. The frank, direct stares of earlier generations were replaced with averted glances and distracted airs. "Aroused and angry, I thought to beat the alarum and urge relentless war. . . ," wrote Walt Whitman in an epigraph to his poems on the Civil War. "But soon my fingers fail'd me, my face drooped and I resign'd myself. To sit by the wounded and soothe them, or silently watch the dead."[1] So Whitman's face seems to droop in sad reminiscence in his portrait by Thomas Eakins (pl. P-33). The haunting realism of Eakins's portraits unnerved a generation desperate to forget its darker

side, a generation that wanted America's growing economic prosperity to bring only "progress" and pleasant security.

Winslow Homer saw first-hand the effects of battle as an artist-correspondent for the news magazine *Harper's Weekly*. And perhaps it was the memory of war that provoked the quiet melancholy pervading his mature pictures. In a small painting of the late 1860s called *The Croquet Match* (pl. T-48), Homer set the figures of attractive young women, ostensibly enjoying a sunny summer day, into curiously immobile poses, their gazes, like their bodies, frozen, almost defensively self-contained. Twenty years later Homer again set the subject of a painting into desperate immobility, in his disturbing image of a fox brought to bay by a flock of crows across a relentless winter landscape (pl. P-29), a tour de force of design and color which some writers have called an autobiographical statement of the artist's isolation within a hostile world.

Ironically, some of America's most important painters of the late 19th century chose to pursue their careers in Europe. Following the Civil War, dozens of Americans left for the art academies of Paris, Munich, and other cities. Most returned to their native land after completing their studies, but many elected to remain, noting that the climate for the arts was still warmer and more sympathetic in the older cultures of the continent than in the still brashly materialistic and driving young republic. Thomas Eakins, William Merritt Chase, Frank Duveneck, John H. Twachtman, Theodore Robinson, and countless other artists spent extended periods in Europe studying and working. Daniel Ridgway Knight, for example, though born and raised in Philadelphia, lived for most of his career in France and painted specifically French, not American, subjects. Best known for his paintings of Norman and Breton peasants, Knight was for many years a regular, and very successful, exhibitor at the Paris Salon (see pl. P-32).

Indeed, two of America's most accomplished and internationally influential artists pursued their careers almost wholly outside of the United States. James Abbott McNeill Whistler left America in 1855, at the age of 21, traveling first to France, where he worked with such masters as Gustave Courbet and Edouard Manet, before settling permanently in England. He would never return to the United States. Dapper, brilliant, difficult, Whistler crafted his art as carefully as he crafted his public image. Throughout his career he held steadfastly to the principle that art should function in and of itself, not in the service of literary or didactic purposes. Art, like the butterfly with which Whistler signed his pictures, was the exquisite combination of forms and color harmonies; that combination was evidence enough of the creator's purpose and, not coincidentally, his virtuosity (see pl. T-35). Whistler's coolly elegant portraits and figure studies, sparklingly atmospheric landscape paintings and prints, and his innovations in interior design and decoration inspired younger artists on both sides of the Atlantic. Despite his permanent residence abroad, Whistler's influence would be felt throughout American art at the end of the 19th century.

John Singer Sargent, like Whistler, was an American citizen, but never a true resident of the United States. Born abroad, he maintained his residence in England, although he made frequent trips to the States for portrait commissions and was always a generous and welcoming mentor to younger American artists, such as Dennis Miller Bunker (see pl. T-89). Less eccentric than Whistler, Sargent was a true "citizen of the world" who moved with equal ease and grace among English aristo-

crats and American parvenus, portraying both communities with the perceptive flattery of the artist-diplomat. Many of Sargent's spectacular portraits are images of sophisticated cosmopolites who, like the artist, knew no specific country. They were the 19th century's "jet set" – attractive, capricious beings whose lives were enacted far from the practicalities of a homestead or factory town (see pl. T-91).

As America progressed into her second century, the fact of cultural identity and independence was confirmed. No longer content to document the simple reality of an American "image," artists tested and manipulated that image. The itinerant portraitists of the early 19th century had created icons to pragmatism in their frank and unflattering portrayals of America's citizenry. Their successors at century's end, comfortable and secure in a prosperous industrial nation-state, were free to create art for pure delectation. Charles Courtney Curran's prim ingenues (see pl. T-135) and Thomas Wilmer Dewing's frail sophisticates (see pl. T-75) give no thought to the harsh realities of the frontier.

But one concern did continue from the 18th century to the eve of the 20th century. The idiom of examination and description may have changed but Americans remained intensely self-conscious. Our eyes are forever turned to a mirror, as we draw ourselves up into a formal pose to study what is "American" (see pl. T-134).

Notes

1. Walt Whitman, "The Wound Dresser" from "Drum Taps," in *Leaves of Grass* (New York, 1892; repr. New York: Bantam Books, 1983), p. 249.

Americans in the Landscape

By D. Scott Atkinson

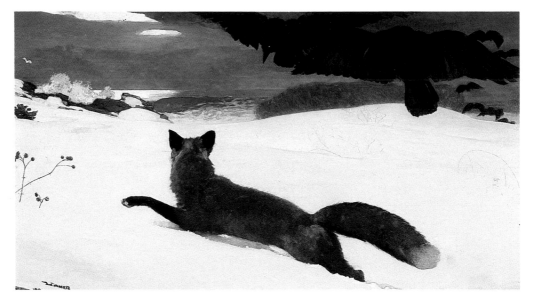

Winslow Homer, *Fox Hunt* (pl. P-29)

The War of Independence that severed the American colonists from their ties with the British Crown also established the need to create an artistic style that could express the independence and democratic ideals of the new republic. This situation was not without a trace of irony, for the model most readily accessible to the young artists was England's Royal Academy. The teachings of the Academy stressed history painting as the highest form of artistic expression – a category that included representations of great historical events, ancient mythology, and literature. Some American artists adopted the approved methods of the Academy and produced pictures such as John Vanderlyn's *Ariadne Asleep on the Island of Naxos* (pl. P-10). Others chose to portray great scenes in America's brief history, for example, *Penn's Treaty with the Indians* (pl. P-2) by Benjamin West. But few found this emphasis on history painting relevant to their experience as Americans. The history of the new world was measured in decades rather than centuries and there was no prevailing tradition to form the basis of a strong national identity. Without a common cultural heritage on which to build a national imagery, artists turned to the most unique aspect around them: the American landscape.

The geography of America had no parallel in Britain or the continent, and its seemingly limitless expanses of virgin wilderness were like no others painted before. The spectacular quality of this land presented new pictorial challenges, for there were no existing models for representing the wilderness. The first to attempt

it were English painters who immigrated to America throughout the 18th century, bringing with them the topographical landscape tradition. This was the most literal interpretation of the landscape and emphasized the general appearance and details that characterized the terrain.

Following this pattern the first American landscapes represented the new environment which needed no embellishment beyond an accurate portrayal of its own unique frontier. The work of these early artists was technically unsure, but their paintings provide a record of colonial America. One of these painters was William Groombridge, who was born in England and came to the United States in the early 1790s. His *View of a Manor House on the Harlem River* (pl. T-3) represents Groombridge's adaptation of the English topographical painting to the American landscape. He depicted the manor house and vast estate as it first appeared to the viewer over the rugged hill that occupies the lower right portion of the foreground. By maintaining this vantage of the estate, seen from the hill covered in wild vegetation, Groombridge forcefully reminded the viewer that America was at this time an agrarian nation emerging from the untamed wilderness.

During the 19th century the American wilderness came to personify the natural heritage from which the new nation had risen, as well as embodying all the potential for its future. Artists made visual their national chauvinism by portraying the broad expanses and rich resources so closely associated with the new world. *Conestoga Creek and Lancaster* (pl. P-12) by Jacob Eichholtz is an early landscape that portrays nature in this fashion. The trees on either side of the foreground are *repoussoirs*, framing Conestoga Creek as it leads the eye far into the distance. Spreading out before the viewer is a vast, picturesque panorama with the artist's place of birth, Lancaster, Pennsylvania, visible on the horizon line. Eichholtz has captured the spirit of nationalism and prosperity associated with the presidency of Andrew Jackson; the vastness of the panorama implies a nation full of promise and optimism.

Many artists were to combine the picturesque view with elements of Romanticism, the single most important artistic influence of the early 19th century. One painter to do so was Thomas Doughty, who is acknowledged as the first American-born artist to devote himself exclusively to the painting of landscapes. In his *Morning Among the Hills* (pl. P-19), the mood has changed from one of peace and tranquility to a sense of foreboding and drama. The graceful swan in the foreground is in contrast to the jagged, shear cliffs and impending storm brewing in the tumultuous sky. Doughty has dispensed with the accurate topographic account and, instead, was more interested in capturing the mood and appearance of the tempest. As one of the first painters to explore the Hudson River Valley, Doughty established early the interest in the majestic wilderness that was to become a principle aspect of the Hudson River School.

John F. Kensett was among the most successful of the Hudson River painters of the mid-19th century but, as is evident in his *Almy Pond, Newport* (pl. T-21), he was not averse to painting other regions of the country. In this scene, which emphasizes the horizontality of the land, all traces of Romanticism have vanished. It is reminiscent of the bucolic landscapes of the 17th-century French painter Claude Lorrain which Kensett had admired on his European sojourn during the 1840s. Like Claude, Kensett has infused this scene with a softer, more delicate light and concentrated on the atmospheric affects while eliminating the hardness of detail found in the earlier topographic landscapes. The emphasis on light and atmosphere was to remain of primary importance throughout the 19th century.

This fascination with light and its effect was exploited further in the 1860s by a group of artists who have become known as Luminists; among the most important were Sanford Robinson Gifford, Martin Johnson Heade, and Fitz Hugh Lane. The style is marked by a heightened sense of realism bathed in intense light. Gifford traveled extensively in both the United States and Europe, rendering the landscape of all locales in a radiant golden glow. This light brings to Gifford's landscapes an expression of spirituality that is evident in his paintings of two disparate locations, *Hunter Mountain, Twilight* (pl. T-26) in New York State and *St. Peter's from Pincian Hill* (pl. P-25) in Rome. The glowing light seems to emanate from Hunter's mountain in the same manner as it does from the spiritual center of Catholicism, St. Peter's Cathedral.

Heade's light is much cooler and clearer than Gifford's, and he delineated his forms in very crisp silhouettes. Heade also traveled extensively to find sites as subject matter for his works; these were as diverse as *Newburyport Marshes: Approaching Storm* (pl. T-24) and *Sunset Harbor at Rio* (pl. P-24). In both these paintings, changing atmospheric conditions are the focus of the artist's attention, with the setting sun forming a bright band of light across the harbor of Rio de Janeiro or bursting through the threatening storm clouds hovering over the New England marsh.

Brace's Rock, Brace's Cove (pl. T-13) by Fitz Hugh Lane is imbued with a mood of isolation and silence. Lane's light, clear and cool, is similar to Heade's, creating hard-edged silhouettes; but absent is the sense of atmospheric movement and change. Lane was able to convey through Luminism a sense of time perserved in a vacuum. The only hint of human activity in this uninhabited scene is the ruined boat in the foreground which only adds to the prevailing feeling of haunting loneliness.

Although not Luminists, Frederic Edwin Church and James Hamilton used light and atmosphere with very dramatic results. In *Our Banner in the Sky* (pl. T-28), Church united the crimson glow of sunset, strategically placed white clouds, and a patch of blue sky to create an extraordinary vision of the American flag hovering above an unspoiled wilderness. Undoubtedly inspired by the outbreak of the Civil War, this scene makes clear that by the 1860s the landscape had become as closely identified with the United States as the nation's flag. Another scene associated with the Civil War was Hamilton's *Old Ironsides* (pl. P-23). In this marinescape the famous battleship is depicted in the midst of a violent storm. The raging sea threatens to engulf the foundering vessel while a bolt of lightning strikes from the massive thunderhead above. The feelings of awe and terror that this scene induces in the viewer are the dramatic counterpart to the tranquility of the picturesque and have been referred to as the Sublime since the 18th century.

After the middle of the century, French influences began to appear in American landscape painting. American painters visiting Europe were attracted to the circle of French artists who had left their studios and begun to paint out-of-doors in the Barbizon Forest. Of the American followers of this style, George Inness was the principal exponent of the American Barbizon School. Instead of emphasizing either topographic detail or majestic grandeur, the Barbizon painters explored the contemplative aspect of a landscape, treating the scene as visual poetry. In both Inness's *Summer, Montclair* (pl. T-27) and *Apple Blossom Time* (pl. P-27), the colors are few

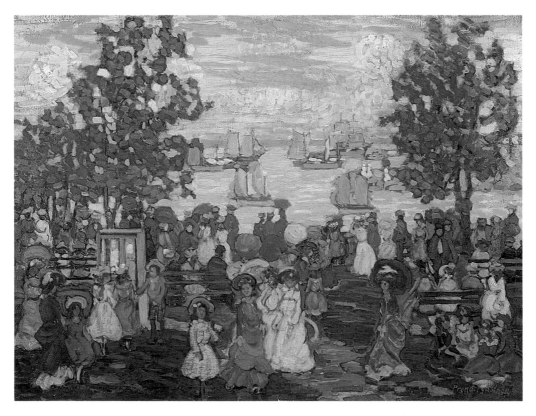

Maurice Brazil Prendergast, *Salem Willows* (pl. T-117)

and rendered in soft, muted tones. Each scene seems to be enveloped in a mist that blurs detail and enhances the poetic mood. Figures are present but play insignificant roles in the compositions beyond that of deepening the sense of introspection.

Another group of French artists who exerted particularly strong influence on late 19th-century American landscape painting were the Impressionists. Like the Luminists, the Impressionists preferred to depict their landscapes under the effects of bright sunlight, but they replaced the smooth surface treatment of the earlier group with a loosely constructed pattern of short, abbreviated brush strokes. Through their painterly approach they sought to represent light and atmosphere in a constant state of flux. The many textures and surfaces that make up an Impressionist landscape, particularly foliage and the surface of water, move with a shim-

mering vibrancy. Unlike its French antecedent, Impressionism in the United States met with success and public acceptance from its introduction in the 1880s. The bright palette and comfortable surroundings often represented in these scenes appealed to the tastes of the growing middle class in Victorian America. As a style Impressionism was to survive well into the 20th century, as is evidenced by the paintings of Daniel Garber and Edward Willis Redfield.

Perhaps America's greatest Impressionist was William Merritt Chase, who was to produce some of his best landscapes at Shinnecock Hills, Long Island, where he established the nation's first summer art school. In his *Morning At Breakwater, Shinnecock* (pl. T-71), Chase presented the viewer with a sun-drenched beach contained within a rocky breakwater and populated by women in bright attire watching their children at play. It is quite possible that Chase included part of his own family in this beachscape. As in most Chase landscapes, the horizon line is very low so that the sky, which is filled with billowing cumulus clouds, dominates the picture plane. This network of painterly brush strokes infused with light and color enlivens the surface of this relaxed summer scene.

Impressionism was able to capture the effects of a cold winter day as well as the warmth of the sun. This is apparent in Theodore Robinson's *Winter Landscape* (pl. T-76). Rendered in a predominantly cool palette of blues and grays, this scene depicts the French town of Giverny, home of the elderly Impressionist master Claude Monet and a mecca for Americans interested in practicing this style. The gray mist that envelops this frigid scene appears almost tactile, demonstrating both the artist's concern and the capacity of the style to simulate the atmosphere surrounding a landscape.

One of the first Americans to visit Giverny and a friend of Robinson's was Willard Leroy Metcalf. His *Havana Harbor* (pl. T-96) is a study for a large mural project he was commissioned to paint for the Havana Tobacco Company in Manhattan's Saint James Building. In high contrast to Robinson's winter scene, Metcalf depicted Havana in full sunlight and the bright tropical colors of the Caribbean. Another Impressionist cityscape, *Commonwealth Avenue, Boston* (pl. T-127), by Childe Hassam, depicts a very different environment. This is Victorian Boston with the bell tower of Brattle Square Church dominating the skyline. The broad avenue, well-dressed pedestrians, and hansom cab convey the flavor of the New England city just as the exotic vegetation, red-tiled roofs, and blue water of the harbor describe Havana. Both paintings demonstrate how sensitively Impressionism could portray the life and ambience of two disparate locales.

After the turn of the century, some American painters began to search for a style that could provide a stronger emotional impact and a grittier form of realism than that represented in Impressionist paintings. These results were achieved through the use of intense color in broadly applied brush strokes that deemphasize detail. This approach concerns itself less with the effects of light and atmosphere than with the expressive power of the paint itself. Applying paint in thick impasto, this heavy brushwork went beyond the depiction of movement and energy to a more subjective representation of the artist's own moods and observations. Ernest Lawson's *Peggy's Cove, Nova Scotia* (pl. P-56) provides a transitional example of this progression. Here the Impressionist brush strokes are much longer and wider than before, and the colors are more intense and less pastel in hue. The overall surface

remains vibrant but with greater expressive impact. Even bolder and more vivid handling appears in two pictures by George Bellows of the New Jersey Palisades titled *North River* (pl. P-59) and *The Palisades* (pl. T-168). In these winter scenes the Hudson River appears before the Palisades. A white plume of smoke or steam rises from the industrial activity visible on the near shore. The bright and broadly depicted areas of blue water and white snow are in high contrast to the dark, rich tones of the exposed earth. Detail has given way completely to generalized forms and their impact is so dramatic that the subject has become obscured and not immediately recognizable. The picture plane continued to diffuse as the century progessed, and almost completely dissolved in the visionary landscapes of Charles Burchfield (see pls. T-179, T-180).

More than a century separates the Groombridge topographical study of the *View of a Manor House on the Harlem River* from Bellows's views of the Palisades. The evolution of American landscape from a simple representation of the land to an entirely subjective vision is beautifully illustrated in this exhibition. These pictures are a reflection of the national identity of a given period: they portray the manner in which Americans have viewed their land and themselves. The landscapes, executed over the 115 years spanned in this exhibition, not only reflect the continuing evolution of artistic styles, but chronicle the evolving American psyche as well.

American Impressionism

By Elizabeth Milroy

During the last quarter of the 19th century, landscape painters throughout Europe and the United States let the brilliance of full sunlight flood across their canvases. The deep shadows of black and brown that had dominated landscape painting for decades were replaced by high-keyed pastel blues, greens, pinks, and violets, set in prismatic patterns of brushwork. The verdant expanse of a farmer's field and the sooty fog of an industrial city were rendered as symphonies of color, each hue left intact to energize the setting.

This new vision of light and color in painting was called "Impressionism." In its strictest sense, the term "Impressionism" was a label given derisively by conservative critics to the paintings exhibited by a group of young French artists in Paris in 1874. The inspiration for that label was a painting by Claude Monet called *Impression, Sunrise*, a view of the port of Le Havre befogged in a mist of soft blues and pinkish-grays. But Monet's painting and the "Impressionist" style represented a radical new approach to the rendering of light on form. Inspired by recent discoveries in the science of optics, the young painters contended that traditional painting techniques did not provide a true rendition of the actual process of seeing.

The Impressionists aimed at combining verisimilitude of subject with truth to the mechanics of sight. In this, they were taking a step beyond the art of the "realist" artists of the 1850s and 1860s, such as Gustave Courbet and Edouard Manet, who had championed the representation of nature and the human environment as they truly exist rather than through the filter of narrative or mythic convention. The Impressionists' art was an expression of nature and human life in communion. Their subject matter was almost exclusively landscape. As one critic wrote, "It was no longer form alone that had to be considered; but form in relation to and as affected by the surrounding, that it has in nature, of lighted atmosphere . . . [Impressionism] is realism extended by study of what the French call the *milieu* – surrounding conditions, through which the subject is viewed."[1]

Impressionism was not an organized "movement," nor did its practitioners issue an aesthetic manifesto. The young artists were a disparate group, seeking only the opportunity to exhibit their paintings free of the conventions and prejudices of the French academic establishment. The leading members of this group were five in number. Claude Monet, considered by many to be the father of pure Impressionism, painted landscapes with an unerring eye for color mixtures. Edgar Degas, scion of the *haute bourgeoisie* and a master draftsman, invented novel compositional designs and color arrangements in powerful images of the human figure; he seldom essayed landscape. Pierre-Auguste Renoir painted both landscape and figure pieces, using a delicate, feathery touch that reflected his own gentle nature. Camille Pissarro was the oldest of the group, a talented landscape painter who was also the quiet diplomatist who had brought the group together. The fifth leading member was Alfred Sisley who, like Monet and Pissarro, was a devoted student of the French landscape.

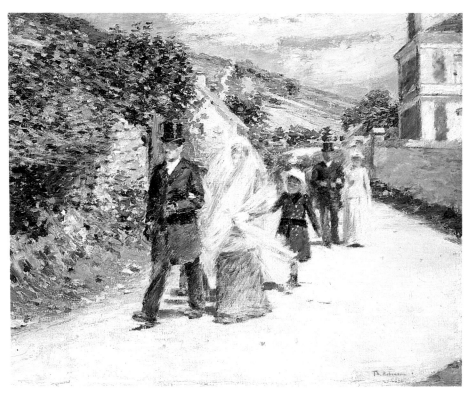

Theodore Robinson, *The Wedding March* (pl. T-79)

In all there would be some eight "Impressionist" exhibitions in Paris between 1874 and 1886. Only Camille Pissarro participated in all eight. Many artists who sent work to the subsequent exhibitions were not "Impressionist" painters at all, but supportive friends or hangers-on. Of the core group, those artists now most famous as having been the "makers" of the new painting – Monet, Degas, Renoir, Sisley – had gone their separate ways as early as 1880.

But within that short span of 12 years, Impressionism had gained a firm foothold in French art circles, notwithstanding the unrelenting skepticism of conservative artists and critics. Moreover, the Impressionist style of painting had begun to take on an international aspect and importance. Artists in countries as distant as Canada, Australia, and the Scandinavian nations, having seen Impressionist pictures while studying in France, returned to their homelands and adapted the new style to their own "milieu."

In few countries outside of France did Impressionism make as dramatic an impact as in the United States. Until the mid-1880s, few French Impressionist pictures were seen in this country. However, in 1883 over a dozen Impressionist pictures, including Renoir's now-famous *Boatman's Lunch at Bougival*, were in-

cluded in the "Foreign Exhibition" in Boston. Three years later the Paris dealer Paul Durand-Ruel – long one of the Impressionists' few supporters – sent some three hundred pictures by contemporary French artists for exhibition at the American Art Association in New York. Included in this exhibition were twenty-three works by Edgar Degas, forty-eight by Claude Monet, forty-two landscapes by Camille Pissarro, and thirty-eight works by Auguste Renoir, as well as three pictures by the up-and-coming young painter Georges Seurat. Public response was encouraging and because the facilities of the American Art Association were available for only a limited time, the exhibition was moved to the National Academy of Design to extend the showing.

America's curiosity had been piqued. During the next several years, exhibitions of French Impressionist pictures became more frequent as the interest of American collectors increased. In 1888 Durand-Ruel opened a New York branch of his gallery in order to meet the demand. Such men and women as Alexander J. Cassatt of Philadelphia, Erwin Davis of New York, Mr. and Mrs. H.O. Havemeyer of New York, and Mr. and Mrs. Potter Palmer of Chicago began to collect in earnest. In 1893, at the Chicago World's Columbian Exposition, the work of the French Impressionists – still ignored by the conservative art establishment of their country and sorely underrepresented in the French Fine Arts section – was triumphantly showcased in a "Loan Collection of Foreign Masters," gathered from several American collections by the irrepressible Mrs. Potter Palmer. Thanks to the efforts and generosity of these and other American collectors, museums in the United States now easily rival those of France as repositories of Impressionist masterpieces.

But as American collectors were setting their sights on acquiring Impressionist pictures, so too were American artists testing the new style in their painting. Indeed, many collectors were indebted to America's painters for having encouraged them to give Impressionism more than a cursory glance. John Singer Sargent, William Merritt Chase, and Julian Alden Weir all acted as advisors to American collectors; Chase and Weir were also instrumental in bringing Impressionist pictures to the United States for exhibition.

But the most influential artist-advisor was the one American who had actually exhibited *with* the Impressionists – Mary Cassatt. Raised in Philadelphia and first trained at the Pennsylvania Academy of the Fine Arts, Cassatt moved permanently to Europe in the late 1860s. The close friend and confidante of Edgar Degas, and an exhibitor at four of the "Impressionist" exhibitions in Paris during the 1880s, Cassatt adapted Degas's design innovations and the Impressionist palette to genteel portraits of friends and family members, set within the comfortable domesticity of America's prosperous upper middle class (see pl. T-64). Cassatt also played an important role as advisor to several American collectors of Impressionist art, including her brother and Louisine Havemeyer who, with Cassatt's encouragement, amassed one of the most extensive collections of Impressionist painting in America.

The growing popularity and legitimacy of Impressionism among American artists was signaled in 1894 at the 64th Annual Exhibition of the Pennsylvania Academy of the Fine Arts. That year the prestigious Temple Gold Medal was awarded to one of America's leading Impressionist painters, John H. Twachtman, who had sent five landscapes to the exhibition. Among the first American painters to have experimented with Impressionism during the mid-1880s, Twachtman was credited by several contemporaries with having persuaded them to attempt the new style as well. Although he gained little public recognition during his lifetime,

Twachtman's lyrical visions of winter landcapes near his home at Cos Cob, Connecticut (see pl. T-83), were widely admired and respected by fellow artists.

That same year the Gold Medal of Honor, granted to the American artist who, in the opinion of his peers, had achieved distinction in his art or in service to the arts in general, was given to William Merritt Chase. Chase was best known for his virtuoso portraits (see pl. P-37) and still lifes in the dark painterly style of the Munich Academy where he, like Twachtman, had received his early training during the late 1870s. But at the 64th Pennsylvania Academy Annual, Chase announced his growing interest in the Impressionist idiom with a group of colorful, light-filled paintings and one pastel, done at the summer home he recently had bought in Shinnecock, Long Island. Delighted by the cloudless sunlight of the seaside setting,

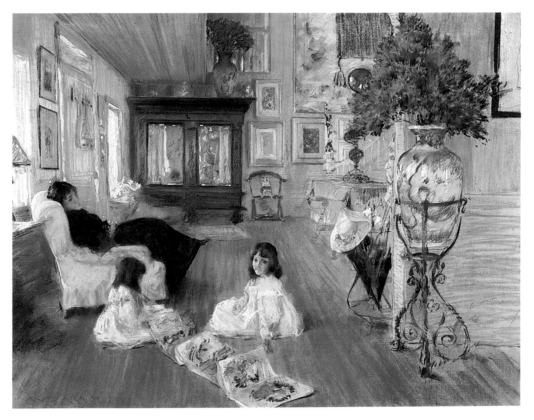

William Merritt Chase, *Shinnecock Hall* (pl. T-70)

Chase produced some of his most successful adaptations of the Impressionist style while summering at Shinnecock during the 1890s (see pl. T-71). Chase was also a master of the pastel medium; he exploited pastel's intrinsic color intensity and delicacy of touch in renderings of his beloved family and artfully decorative domestic milieu (see pl. T-70).

Perhaps no one was surprised that two painters practicing the "Impressionist" style should have been honored at the 1894 Annual. For among the members of the exhibition jury were several other artists then coming into prominence as "Impressionists": Frank Weston Benson, Joseph Rodefer De Camp, Theodore Robinson, Robert W. Vonnoh, and Julian Alden Weir.

Most of these men had known of the French Impressionists and their work since the early 1880s. As young men all had traveled to France to study and had spent long years laboring at the traditional art curriculum with independent tutors or at such free ateliers as the Académie Julian. And by the mid-1880s, while their compatriots in New York were viewing Durand-Ruel's wares, America's painters were turning their attention to the art of Claude Monet and the new aesthetic of light.

Many young Americans actually sought out Monet at his home in the village of Giverny north of Paris. John Leslie Breck, Willard Leroy Metcalf, Lilla Cabot Perry, John H. Twachtman, Theodore Wendel – an unending line of would-be Impressionists flocked to the village to enjoy the same "milieu" within which Monet was creating his masterpieces. By the turn of the century, a "second generation" of Americans had arrived in Giverny – artists such as Frederick Frieseke (see pl. T-156) and Richard Emil Miller (see pl. T-159) – who would work hard to keep the flame of Impressionism burning.

But Claude Monet was not an easy man to befriend. He had moved to Giverny in 1883 to retire and build a garden. He was not altogether ready to accept advances from foreign strangers. Nonetheless, some of the young artists succeeded.

Wisconsin-born Theodore Robinson arrived at the village of Giverny in the summer of 1887. Introductions were made and friendship developed. And, in 1892, Robinson recorded the wedding of Monet's step-daughter Suzanne Hoschedé to yet another American painter, Theodore Butler, in a composition glittering with sunlight and evidencing Robinson's admiration for the French master (pl. T-79). That same year Robinson published an essay on Monet in the prestigious *Century* magazine, one of the first sympathetic studies of the French painter to appear in English.

Theodore Robinson's promising career was cut short by his death in 1896. However, the secure position of Impressionism in the United States was signaled by the appearance of an organized exhibiting group of artists who came to be identified with the style. In 1898 ten artists – including four who had served on the Pennsylvania Academy's 64th Annual jury – exhibited together at Durand-Ruel's New York gallery. "The Ten" (as they were called by the press) were: Frank Weston Benson, Joseph Rodefer De Camp, Thomas Wilmer Dewing, Childe Hassam, Willard Leroy Metcalf, Robert Reid, Edward Simmons, Edmund C. Tarbell, John H. Twachtman, and Julian Alden Weir. All had seceded the year previous from the Society of American Artists, in protests against the size and declining standards of that organization's increasingly unwieldy annual exhibitions.

The Ten's 1898 exhibition, although called a "secession" by some reviewers, was simply a statement of the artists' collective preference for smaller shows of higher quality. Not all of The Ten were Impressionists, nor did the group include every Impressionist painter then at work in the United States. But landscape paintings executed in an Impressionist style – even by artists such as Simmons and Reid who were better known as muralists – did dominate the group's many exhibitions. In 1904 William Merritt Chase was elected to membership to replace the recently deceased Twachtman. The Ten would hold annual shows for two decades, with the last one at the Corcoran Gallery in Washington in 1918-19.

One of the most popular American Impressionist painters and, by his own account, the founder of The Ten, was Childe Hassam. (In fact, Twachtman and Weir had called the group together.) Hassam started his career as an illustrator; he had

established a firm professional reputation before adopting the Impressionist palette in the early 1890s. His delightful view of Boston's Commonwealth Avenue (pl. T-127) demonstrates how quickly Hassam mastered the style and so expertly applied the feathery touch of the brush and daring eye for color mixtures that became the trademarks of his many Impressionist pictures. Indeed, at the time of his death in 1935, Hassam was "the grand old man" of Impressionism in America. Although Hassam's later work showed some weakening of his skills, he remained unswervingly faithful to the Impressionist style he had adopted almost 50 years earlier.

Ironically, just as America's artists were embracing Impressionism in the 1890s, the style had been supplanted in its native France. The Neo-Impressionism of Georges Seurat, the Post-Impressionism of Paul Gauguin and Vincent van Gogh which in turn inspired the daringly garish compositions of Henri Matisse, André Derain, and Raoul Dufy, soon made the art of Monet and his fellows seem sedate and old-fashioned.

One American who experimented with the "Post-Impressionist" style was Maurice Prendergast, an artist whose inquisitive talents and personal acquaintance with several members of the Paris avant-garde encouraged his quest for a very personal painting style. By 1904 Prendergast was painting views of Boston's environs in a manner very different from Hassam's view of Commonwealth Avenue. Prendergast's compositions and palette reflected his study of Impressionism, but he conceived his pictures not as records of the process of seeing common to all people, but as renderings from his eye alone.

In his painting of a park near Boston, called *Salem Willows* (pl. T-117; dated 1904 at the time of its sale), Prendergast meticulously brushed in the promenading figures and seaside landscape as a mosaic of bold strikes of color. The unrelenting flatness of his image and the graphic reduction to total anonymity of his figures were new elements not seen in the work of Hassam, Robinson, or other "Impressionists." By 1910 Prendergast had moved even further from Impressionism, adding strident pink, orange, robin's egg blue, and turquoise to his palette to create a unique color calligraphy (see pl. T-116). Called by some writers and fellow artists the "first American modernist," Prendergast was a contemporary of many American Impressionists, but his art was grounded in the concepts and interests of the generation that followed.

Impressionism was once a daring innovation in painting. It attracted young American painters eager to explore new artistic territory and many of these painters became respectable interpreters of the style and aesthetic formulated by Monet, Pissarro, Degas, and their fellows. And although even the most radical innovation becomes conventional in time, Impressionism remains in currency. The "Impressionist" style is still practiced by many landscape painters and Impressionism in its many forms, as adapted by countless artists since its invention, is immensely popular. Little did that group of young Frenchmen realize, when they introduced their "new painting" to Paris in 1874, that it would speak to the common man in so many languages.[2]

Notes

1. Charles H. Caffin, *The Story of American Painting* (New York: Garden City Publishing Co., 1907), pp. 268-69.

2. The primary source for this essay has been the volume by William H. Gerdts, *American Impressionism* (New York: Abbeville Press, 1984).

America and the Modernist Spirit

By D. Scott Atkinson

By the early 20th century, the United States was in the midst of a massive social and economic restructuring out of which would emerge a modern industrialized nation. The technological advances, occurring at a frenetic pace, were accompanied by a demographic shift from rural farming communities to factory jobs suddenly available in the growing urban centers. The dramatic improvements in communications and transportation greatly accelerated the pace of life while industry and urbanization transformed the old world into a modern environment.

But artists in the late 19th century were discouraged from addressing the explosion of change that was occurring around them; instead they expressed themselves within the limited repertory of accepted artistic conventions. These conventions were governed by the art academies that had originated in France and England in the 18th century and continued to direct the course of artistic development well into the 19th century. The academies imposed a rigorous curriculum – drawing from plaster casts of antique sculpture – and a strictly prescribed hierarchy of subject matter dominated by history painting and followed by landscapes, portraits, still lifes, and genre. The paintings, approved by the academies and adored by most patrons, were saccharine moral allegories that appealed to Victorian tastes but made no concessions to the modern world. Annual salon exhibitions allowed the academies to reinforce their teachings, and painters seeking approval and success were obliged to follow the prescribed dictates. Artists wanting to digress from the academic standard and investigate avant-garde styles expressive of the modern spirit sought inspiration in the radical new painting emerging in France. The progressive artistic forces appearing there during the first decade of the 20th century were to become known collectively as Modernism.

Many American painters first discovered the Modernist trends while pursuing their academic training in Europe. Others were introduced to these styles by the United States' first champion of Modernism, Alfred Stieglitz, who exhibited both French and American Modernists in New York at his "Little Galleries of the Photo-Secession" in 1908. But the one event long credited as the introduction of Modernism to the United States was the famous Armory show held in New York in February 1913. This landmark exhibition brought together a large cross-selection of European and American painting and sculpture and provoked a great deal of attention and much controversy. Regardless of how Americans discovered Modernism, what they found were revolutionary new concepts concerning the form, color, and structure of painting. These concepts were engendered during the late 19th century in the work of the Post-Impressionist painters, Vincent van Gogh, Paul Gauguin, and Paul Cézanne. Van Gogh brought life and expression to his paintings by means of vibrant, unrestrained color applied in broad, active brush strokes. Gauguin not only exploited color for all of its expressive potential, but used it to create spiritually symbolic imagery. Cézanne was concerned with how color defined form and structure, and he sought a fundamental geometry in his landscapes, still lifes, and portraits.

Marsden Hartley, *Painting No. 50* (pl. T-162)

During the first decade of the 20th century, two other painters emerged with new styles that solidified the accomplishments of their predecessors and established the course of modern art. They were Pablo Picasso and Henri Matisse, both shown at Stieglitz's "Little Galleries" between 1910 and 1911. Picasso, in his revolutionary development called Analytical Cubism, continued to advance Cézanne's exploration of structure by reordering form and space. The Cubists dissected their angular compositions into faceted planes that conveyed an impression of movement. Another style related to Cubism and developed concurrently in Italy was called Futurism. In their manifestos the Futurists praised the new technology and industrialization that were altering the world. Their adaptation of the fragmented, Cubist structure, combined with their own "lines of force," allowed them to depict the speed and constant motion that they felt were the essence of modern life.

Fauvism, on the other hand, concerned itself with color rather than form. Developed by Henri Matisse, this style was inspired by the brilliant palette of van Gogh, but the Fauves generated an even greater intensity through the use of seemingly arbitrary and unnatural juxtapositions of color. Like the Cubists and Futurists, the Fauves, too, dislocated and distorted forms in order to enhance their expressive power. These styles established the foundations of Modernism and they – in either a pure form or, more often, a synthesis – became the principal influences on American artists living at home or abroad in the early part of the 20th century. A discussion of the Modernist paintings in the collection of the Terra Museum provides an opportunity to examine the impact of these styles on American art.

American by birth, Lyonel Feininger lived in Germany from 1887 to 1933 with an interlude in Paris from 1906 to 1908. In his painting *Denstedt* (pl. T-150), Feininger, who was particularly impressed with the exciting innovations of Cubism, fractured the composition into angular prisms. Planes provide a skeleton for the painting while suggesting the dynamic sense of movement associated with Italian Futurism, particularly apparent in the jagged, yellow figure in the foreground. Feininger was a friend and admirer of Robert Delaunay and shared the French painter's fascination with the expressive potential of intense Fauve color and Cubist structure. The brilliant yellows suggest artifical illumination, and the German city appears to vibrate under its radiant glow. Feininger's long residency abroad afforded him great familiarity with European Modernism and *Denstedt* is an adroit demonstration of his synthesis of various styles.

However, most American advocates of Modernism were unable to spend decades in Europe in order to glean Modernism at its source. More usual was the one-to-two year visit centering around Paris, with compulsory excursions to Italy and other artistic centers of Europe. From 1908 to 1909 Arthur Dove lived in Paris, where he quickly absorbed the developing new styles. On his return to the United States, he executed a remarkable group of pastels known collectively as the "Ten Commandments" (1911-12) – a series of works in which Dove utilized the entire stylistic vocabulary of European Modernism. In one pastel from this series, *Nature Symbolized #3: Steeple and Trees* (pl. T-164), Dove used Analytical Cubism to present a fairy-tale mountain backdrop rendered in a series of repetitive, conical shapes. Jagged like irregular saw-teeth, these forms are complemented by radiating polygons whose riblike structures, suggestive of open umbrellas, represent surrounding foliage. Muted reds and greens are offset by black and yellow and the overall effect is that of an imaginary theater set where two-dimensional stage flats are stacked in front of one another.

Another American who produced an early work deeply inspired by nature was Charles Sheeler. From 1910 to 1919 he explored all of the Modernist innovations, from vivid Fauvist still lifes to Cubist landscapes. *Flower Forms* (pl. T-171), atypical of Sheeler's later career, is the culmination of his Modernist experimentation and stands as his most abstract work. In this painting nature has been reduced to a group of organic shapes resembling internal organs. Organic, natural forms also mark Arthur Dove's work from the mid-teens forward when he developed his own unique style less indebted to European Modernism. In his pastel titled *A Walk - Poplars* (pl. T-165) Dove replaced the geometric structure of *Nature Symbolized #3* with sinuous forms that convey the undulating rhythms of nature instead of its angular construction.

Stuart Davis, *Super Table* (pl. T-176)

The American painters Marsden Hartley and Patrick Henry Bruce utilized Modernist forms and colors to develop styles distinct from their European counterparts. In the two groups of paintings he executed in Berlin between March 1914 and December 1915, Hartley combined Cubism with Symbolism to produce some of the most powerful compositions found in American Modernist painting. One group of pictures was inspired by the trappings of the growing German military presence which Hartley saw all around him in the years just prior to, and at the beginning of, the First World War. The second group is even more astonishing, for Hartley chose to explore decidedly American imagery while in Berlin; the result was the "Amerika Series." *Painting No. 50* (pl. T-162) is a part of this series based on images derived from American Indian motifs. Hartley placed against brightly colored grounds overlapping diagonal bands of red, yellow, and white which culminate at the center in a tepee. Filling the foreground of the painting and piercing the open front of the tepee is a drawn bow with an arrow. American Indian ornamentation forming the lively

surface patterns includes circles, triangles, zigzagging and curving lines. Through this complex layering of design and symbolism, Hartley produced a potent icon that captures the mysticism of native American culture.

The expatriate Patrick Henry Bruce made a significant and lasting contribution to Modernism in a unique series of works derived from Orphism, the name given to the style that combined Cubist form with Fauve color. For this series Bruce limited his experiments to still-life compositions he arranged from the various objects he had in his Paris apartment. In this extraordinary group of paintings, Bruce explored the inherent geometry and interaction of these forms just as Cézanne did before him. Begun in 1917, the first extant work from this revolutionary group of paintings was *Peinture* (pl. T-163). Bruce reduced the elements of the composition to their most fundamental, geometric forms of triangles, cylinders, and rectangles, with each segment rendered in bright primary and secondary colors. From this, Bruce developed a type of abstraction based on edges of color that meet but do not intermingle, so that each form remains separate and discrete. Very different from the convoluted and fragmented compositions of Analytical Cubism, this painting not only depends on basic geometric structure, but also on the order and logic found in mathematical equations. Each element stands firmly planted in its own space with the monumentality of classical architecture. There is nothing organic or amorphous about these shapes, and they make no reference to the natural world. During the 1920s and 1930s, hard-edged abstraction became a usual aspect in both European and American Modernism, and can be seen in paintings such as Charles Green Shaw's painting *Plastic Polygon* (pl. T-177).

During the 1920s American Modernist painters began to assert their own aesthetic independence and a style called Precisionism, sometimes referred to as Cubist-Realism, emerged as the indigenously American response to Analytical Cubism. Practitioners of this style distilled objects to their simplest geometric forms but retained the recognizable image. One of the two most important American Precisionists is Charles Demuth. His tempera painting *Rue du Singe Qui Pêche* (pl. T-170), executed during his last trip to Europe in 1921, ranks among the earliest examples of his developed style. Painted on the site (which translates to "Street of the Monkey Who Fishes"), the narrow, vertical rectangles that delineate the facades lining the Paris street are distorted but remain recognizable, rendered in the cool, restrained colors of Cubism. For the first time Demuth incorporated a lively pattern of signs and lettering over the surface of the painting, often without a logical connection with the buildings. This innovation was adopted by many other prominent painters, and Demuth was to include lettering and numbers in some of his most famous works. All of these aspects combine to create a busy, compressed, and fragmented scene that seems barely containable within the confines of the picture plane.

Precisionist painters were attracted to the symbols of 20th-century technology – skyscrapers, bridges, factory buildings, and industrial machinery – due to their inherent geometric structure and the premise that these were positive images of American progress that should be elevated from the mundane and utilitarian to the heroic. Following his decade of Modernist experimentation, Charles Sheeler was to become the most important of the Precisionist painters. His drawing *Counterpoint* (pl. T-173), which depicts the flannel mill in Ballardville, Massachusetts, consists of a diaphanous veil of shifting Cubist planes overlapping one another to produce a

kaleidoscopic view resembling Futurist "lines of force." This effect, similar to that in Demuth's tempera painting, recalls the sense of simultaneous vision achieved through the double exposure in photography, a medium in which Sheeler was most interested and proficient. This photographic aspect is further enhanced by the fact that the whole image is rendered in monochromatic gradations of conté crayon. In *Counterpoint*, Sheeler combined his great ability as a draftsman and his thorough understanding of Cubism with the Precisionist interest in the mechanical apparatus of the camera.

After spending nearly six years in Europe between 1905 and 1911, John Marin returned to the United States and devoted the remainder of his life to the medium of watercolor. In his numerous representations of the Maine coast and New York City, Marin dexterously blended the dynamics of Cubism with Fauvism and Futurism. In his view of New York titled *Brooklyn Bridge, on the Bridge* (pl. T-149), Marin portrayed the city not as actual structures, but as abstract, geometric blocks, one overlapping the other. The large areas of paper left untinted provide a feeling of spaciousness that allows the bold lines of force to create a vibration over the composition. Marin thought of the city as a living organism and his scenes of Manhattan explode with life and energy. Although they owe much to the European Modernists, Marin's forceful watercolors are uniquely American visions.

Stuart Davis, whose artistic career spanned the entire development of American Modernism, was to appropriate Cubist concepts but, like Marin, he turned them into his own personal statement. Davis was entranced by the design and graphics of commercial advertising and many of his finest works celebrate the enthusiasm of American consumerism well before the appearance of Pop Art in the early 1960s. Davis's painting *Super Table* (pl. T-176) represents the culmination of his experimentation with Cubist forms during the early 1920s. In this work he replaced details with generalized colored planes set against an even gray ground with no shading or modeling to provide dimension. The table, constructed of planes that meet obliquely and seem to lean forward, is rendered in exquisite color fields of pink, white, lavender, and deep purple that provide neither a sense of perspective nor volume. Heavy black lines circumscribe the forms, creating a rhythmic linear network over the surface while continuing to emphasize the lack of perspective. Floating weightlessly on top of the table is a cocktail glass and an enigmatic form bearing a stamp or emblem inscribed with the number 47. An elegant, dark purple drapery with crisp folds highlighted in white rises from behind. *Super Table* was created on the eve of Davis's well known "Eggbeater" series and the flat, unmodulated planes of color and network of schematized surface design all anticipate the artist's future direction.

It is evident that numerous cross-currents inspired American Modernism, and that American painters were not satisfied merely to imitate the European trends, but, instead, freely synthesized them without compunction. They transformed the new styles into a positive vision of the growing industrial society in which they lived, and in so doing, they created a uniquely American type of Modernist image that embodied the energy and dynamism of the new century.

Editor's Note

The plates that follow are divided into two sections: highlights from the collection of the Pennsylvania Academy of the Fine Arts, Philadelphia, and selections from the Terra Museum of American Art, Chicago. The former series is distinguished by the letter "P" (indicating Pennsylvania); the latter series is identified by the letter "T" (indicating Terra). Within each section the plates are arranged chronologically according to the birthdate of the artist. Within each artist's oeuvre, the works follow chronologically according to date of execution, with undated works placed alphabetically at the end.

A Special Perspective: Pennsylvania Academy of the Fine Arts Collecting the Art of Its Time

The Pennsylvania Academy of the Fine Arts opened its doors in 1806, predating as a public institution the National Gallery in London, the Prado in Madrid, and the Pinakothek in Munich. The Metropolitan Museum of Art in New York would not be founded for nearly three-quarters of a century, in 1870; and The Art Institute of Chicago would not be established until 1879. The Pennsylvania Academy began as both a museum and a school at a time when Philadelphia, the largest city in the United States, was the major cultural, scientific, and publishing center in the country. Among the Academy's founders were leading businessmen and the most influential artists of the day, including the extraordinary Renaissance man Charles Willson Peale, his son Rembrandt, and America's premier sculptor, William Rush. The preeminent Pennsylvania artist Benjamin West, who was then head of the Royal Academy in London, was made the Pennsylvania Academy's first honorary member.

The prestige of the Academy's school, particularly in the 19th century, has sometimes overshadowed the museum's rich and diverse collection of American art: over 1,700 paintings, 300 sculptures, and 10,000 graphics, all housed in a carefully restored masterpiece of High-Victorian eclecticism, designed by George H. Hewitt and Frank Furness. The distinctive character of the collection has resulted from two factors: the works have always been purchased soon after they were created, and they have been often selected in collaboration with the artists who supported the institution and/or taught in its school. The Academy was founded at a time when the nation was coming of age and had a growing sense of its place in world history. The demand to record the faces of our heroes made portraiture the primary artistic expression of the early Federal period. For that reason, the Academy's paintings collection is particularly rich in portraits. It boasts over 60 by Charles Willson Peale and his family, 30 by Gilbert Stuart, 45 by Thomas Sully, and many by John Neagle and Jacob Eichholtz. The collection's large historical paintings of the same period are equally distinguished. Washington Allston's *Dead Man Restored to Life* of 1813 was purchased three years after its date of execution. In 1836 the Academy mortgaged its building to purchase Benjamin West's *Death on the Pale Horse* from the artist's son.

The collection has also benefited from several phenomenal gifts, notably the 1878 bequest of Joseph and Sara Harrison. Joseph Harrison was a self-made man who built the first successful freight line for the Reading Railroad and then spent several years in Russia, helping to construct railroads there. A multilingual man of the world, Harrison also lived in London and Paris before building a grand mansion on Rittenhouse Square in Philadelphia and filling it with paintings and sculptures. His bequest to the Academy included Benjamin West's huge canvas *Christ Rejected* (1815) and these American icons: *William Penn Signing the Treaty with the Indians* (1771), John Vanderlyn's *Ariadne Asleep on the Island of Naxos* (1814), and Charles

Willson Peale's self-portrait *The Artist in His Museum* (1822), a work that summarizes the scientific, cultural, and artistic concerns of this phenomenal man.

With the establishment of the Gilpin Fund in 1878 and the Temple Fund in 1880, the Academy began the systematic acquisition of major works by living American artists, selected primarily from its prestigious annual exhibitions. (The exhibitions, which had been held since 1812, were discontinued in 1969.) These purchases have brought the Academy truly remarkable examples of American art of the late 19th and early 20th centuries. They include Alexander Harrison's *The Wave*, Winslow Homer's *Fox Hunt* (for which the artist was awarded the Academy's Gold Medal), Frank Duveneck's *Turkish Page*, William Merritt Chase's *Lady with the White Shawl*, Thomas Eakins's *Cello Player*, and Childe Hassam's *Cat Boats: Newport*. By any measure, this is an extraordinary group of works by the front rank of American artists.

With the creation of the Henry S. McNeil Fund in 1983, the Academy began to address the inevitable historical gaps that were created by concentrating on contemporary works. For example, because the Academy was founded after the American Revolution, colonial painting is less well represented than other periods. Similarly, long before the Academy was established, Charles Willson Peale went, as a fledgling artist, to visit John Singleton Copley in his Boston studio and was awed by his "picture room." Because of this art-historical connection, the Academy has long felt that Copley should be represented in its collection. Thus, in 1984, the first work purchased with McNeil funds was the Copley portrait *William "King" Hopper* (1767), a definitive likeness of a prominent merchant of Marblehead, Massachusetts. The Academy has also been interested in adding to its 19th-century landscape collection. In 1985 it purchased Martin Johnson Heade's *Sunset Harbor at Rio*, a hauntingly mysterious scene painted during the artist's first trip to South America. At the same time, as it has done since 1806, the Academy continues to collect representative examples of art by contemporary Americans. Recent acquisitions include works by Louise Nevelson, Katherine Porter, Frank Stella, Irving Petlin, and Gregory Amenoff.

Two hundred rich, dynamic years of American art are documented in the collection of the Pennsylvania Academy of the Fine Arts. The works are a testimony to the foresight of the founders in deciding to sponsor living American artists, and to the acumen of their successors in carrying out that policy so successfully. The collection reflects the special vitality of an institution that is committed equally to teaching art and to connoisseurship.

Linda Bantel
Director, Pennsylvania Academy of the Fine Arts

JOHN SINGLETON COPLEY (1738-1815)

PLATE P-1

Robert "King" Hooper (1709-1790), 1767
Oil on canvas 50 x 39¾ in.
The Pennsylvania Academy of the Fine Arts, Philadelphia
The Henry S. McNeil Collection. Given in loving memory of her husband by Lois F. McNeil, and in honor of their parents by Barbara and Henry A.
Jordan, Marjorie M. Findlay, and Robert D. McNeil (1984.13)

John Singleton Copley (1738-1815) studied painting with his step-father, the Boston painter and engraver Peter Pelham. A professional artist by the age of 19, Copley achieved some notoriety in London when *Boy with a Squirrel*, a portrait of his step-brother, Henry Pelham, was accepted for exhibition at the Society of Artists in 1765. The celebrated English portraitist and president of the Royal Academy Sir Joshua Reynolds declared Copley's painting to be the best work in the show. Copley became the leading portraitist of fashionable New England during the years preceding the American Revolution. Although indifferent to politics, Copley left America for permanent residence in England in 1775. A tour of the continent at this time enabled him to fulfill his dream of studying the Old Masters. After his move to London, Copley began to produce large historical paintings as well as portraits. He became a friend of Benjamin West's and was elected to the Royal Academy.

BENJAMIN WEST (1738-1820)

PLATE P-2

Penn's Treaty with the Indians, 1771-72
Oil on canvas 75½ x 107¾ in.
The Pennsylvania Academy of the Fine Arts, Philadelphia
Gift of Mrs. Joseph Harrison, Jr. (1878.1.10)

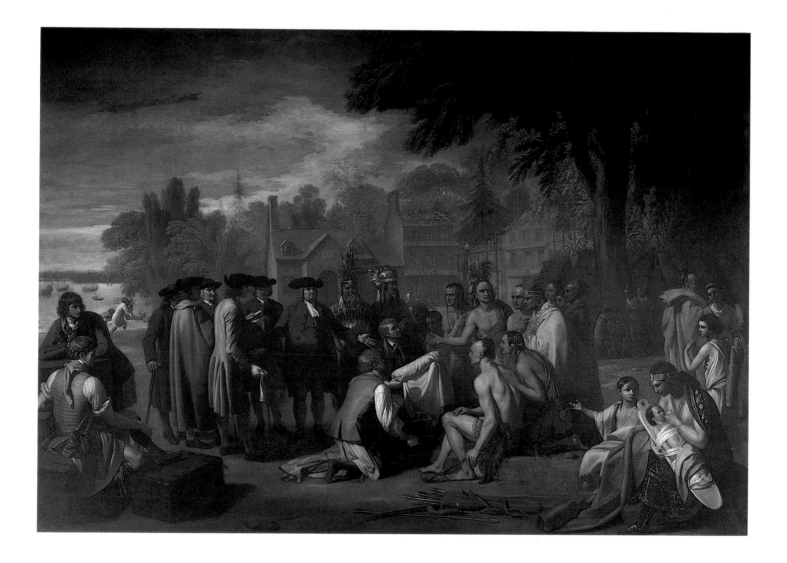

Benjamin West (1738-1820) was born in Springfield, Pennsylvania. He showed remarkable talent as a child and received instruction as early as 1747 from the English artist William Williams in Philadelphia. West worked as a professional artist in Philadelphia until his desire for further training led him in 1759 to visit Rome, where he studied Renaissance and Baroque paintings and classical sculpture. In 1763 he moved to London, where he settled permanently. West's large biblical and historical scenes won him immediate recognition; he became the historical painter to King George III in 1772. In 1792 he became president of the Royal Academy, a position he held until his death in 1820. West was the first American artist to attain international fame. He often served as an informal advisor on the arts to American groups such as the Pennsylvania Academy of the Fine Arts. His popular London studio was frequented by three generations of American painters.

BENJAMIN WEST (1738-1820)

Self-Portrait, 1806
Oil on canvas 36⅛ x 28⅛ in.
The Pennsylvania Academy of the Fine Arts, Philadelphia
Gift of Mr. and Mrs. Henry R. Hallowell (1964.11)

CHARLES WILLSON PEALE (1741-1827)

PLATE P-4

Noah and His Ark, 1819
Oil on canvas 40¼ x 50¼ in.
The Pennsylvania Academy of the Fine Arts, Philadelphia
Collections Fund (1951.22)

Charles Willson Peale (1741-1827) was born in Maryland and earned his livelihood as a saddlemaker and clock repairer, in addition to painting portraits. He received training from John Hesselius around 1762-63, and he may have been instructed briefly by John Singleton Copley. Financial backing by several patrons enabled Peale to travel in 1766 to London, where he studied painting under Benjamin West. He returned to Annapolis, Maryland, in 1769 and later settled in Philadelphia in 1776. Well known as both a portraitist and entrepreneur, Peale established the nation's first important museum of natural history. Peale was the author of a variety of books and was instrumental in the founding of the Pennsylvania Academy of the Fine Arts in 1805. Three of Peale's children, including his sons, Raphaelle, Rembrandt, and Rubens, also became artists of note.

CHARLES WILLSON PEALE (1741-1827)

PLATE P-5

The Artist in His Museum, 1822
Oil on canvas 103¾ x 79⅞ in.
The Pennsylvania Academy of the Fine Arts, Philadelphia
Gift of Mrs. Joseph Harrison, Jr. (1878.1.2)

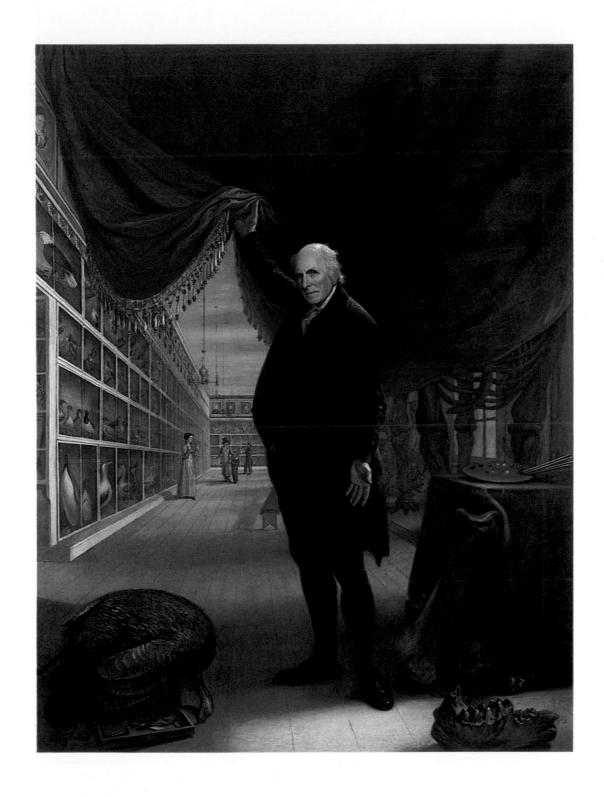

The Artist and His Family, 1795
Oil on canvas 31¼ x 32¾ in.
The Pennsylvania Academy of the Fine Arts, Philadelphia
Gift of John Frederick Lewis (1922.1.1)

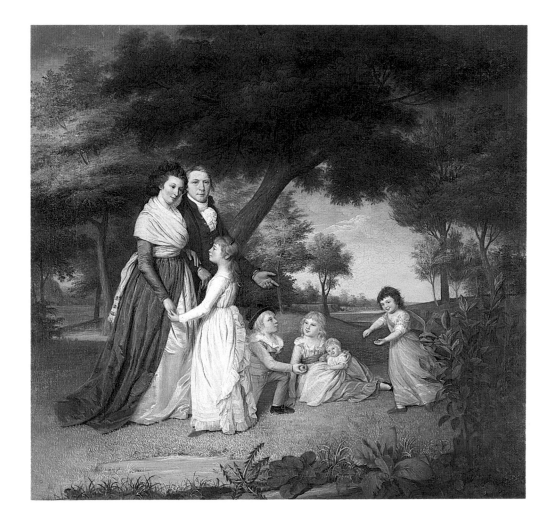

James Peale (1749-1831) was born in Chestertown, Maryland. He began his artistic training in 1771 under his older brother, the famous portraitist Charles Willson Peale. After the Revolutionary War, James lived in Philadelphia with his brother; in 1782 he established his own residence. He made his reputation painting miniatures, but after his eyesight began to fail in 1810, produced mainly still lifes and portraits. He exhibited at the Pennsylvania Academy of the Fine Arts from 1824 to 1830.

GILBERT STUART (1755-1828)

Bishop William White (1748-1836), c. 1795
Oil on canvas 36 x 31 in.
The Pennsylvania Academy of the Fine Arts, Philadelphia
Bequest of William White (1913.11.3)

Gilbert Stuart (1755-1828) was raised in Newport, Rhode Island, and received his first training with the Scottish painter Cosmo Alexander, whom he accompanied to Edinburgh in 1772. After an unsuccessful attempt to set himself up in business in London during the mid-1770s, Stuart was supported for a time by Benjamin West. He first gained official recognition with the exhibition of his portrait called *The Skater* at the Royal Academy in 1782. However, mismanagement of his business affairs forced him to leave London in 1787. Stuart went to Dublin and finally returned in 1792 to the United States. He spent several years in New York, Philadelphia, Germantown, and Washington before settling permanently in Boston in 1805. Stuart was one of the nation's most popular portraitists; he became especially known for his portraits of George Washington.

GILBERT STUART (1755-1828)

George Washington (1732-1799) ("The Lansdowne Portrait"), 1796
Oil on canvas 96 x 60 in.
The Pennsylvania Academy of the Fine Arts, Philadelphia
Bequest of William Bingham (1811.2)

JOSEPH WRIGHT (1756-1793)

Benjamin Franklin (1706-1790), 1782
Oil on canvas 31¾ x 25⁵⁄₁₆ in.
The Pennsylvania Academy of the Fine Arts, Philadelphia
Bequest of Mrs. Joseph Harrison, Jr. (1912.14.6)

Joseph Wright (1756-1793) was born in New Jersey and in 1772 moved to London to join his mother, Patience Wright, who was working there as a sculptress in wax. In 1775 he became the first American-born artist to enroll as a student at the Royal Academy, where he remained until 1781. The following year, bearing letters of introduction from fellow American Benjamin West, Wright traveled to Paris, where he obtained some portrait commissions; before the end of the year, however, he had returned to America. In 1783 Wright obtained a commission from the United States Congress to execute a life portrait bust of George Washington. He made several versions of the portrait, both painted and sculpted, for Washington and various acquaintances before completing the official bust in 1784. Wright was also a skilled medalist and in 1792 was appointed the first die-sinker of the United States Mint. He died in Philadelphia in 1793 during an epidemic of yellow fever.

Ariadne Asleep on the Island of Naxos, 1809-14
Oil on canvas 68½ x 87 in.
The Pennsylvania Academy of the Fine Arts, Philadelphia
Gift of Mrs. Joseph Harrison, Jr. (The Joseph Harrison, Jr. Collection) (1878.1.11)

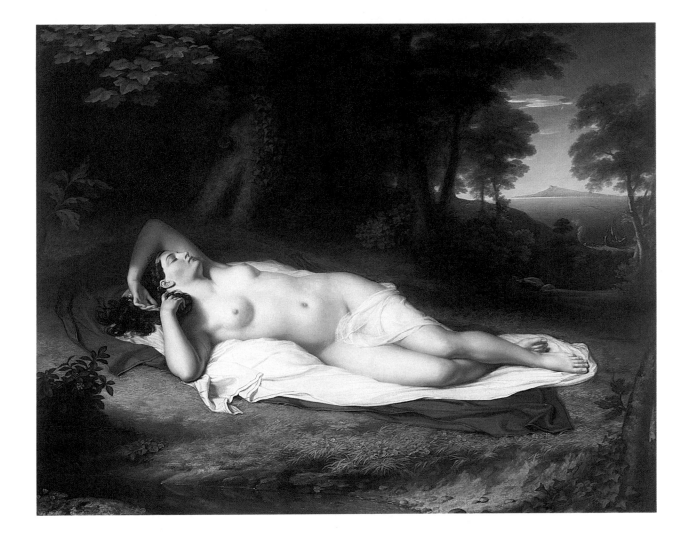

John Vanderlyn (1775-1852) was born in Kingston, New York. At the age of 17, he moved to New York City where he studied with Archibald Robinson and made the acquaintance of Aaron Burr. Burr supported Vanderlyn's art studies, first with Gilbert Stuart, then, in 1796, by sending his protégé to the Ecole des Beaux-Arts in Paris, where Vanderlyn studied with Antoine-Paul Vincent. In 1801 Vanderlyn lived in New York before returning to Europe in 1803. Vanderlyn successfully assimilated the French academic style and he achieved recognition at the Paris Salon of 1808. But success proved fleeting, for when he returned to the United States, Vanderlyn received few private or governmental commissions. He returned to Kingston, New York, and supported himself by painting portraits. Vanderlyn finally received a commission from the United States government in 1832 and another in 1842, which was a panorama for the Capitol Rotunda, Washington, D.C.

JACOB EICHHOLTZ (1776-1842)

PLATE P-11

Mrs. Elizabeth Wurtz Elder and Her Three Children (d. 1852, William Smith Elder, Rebekah Heaton Elder, and Henry Lentz Elder), 1825
Oil on canvas 42½ x 47½ in.
The Pennsylvania Academy of the Fine Arts, Philadelphia
Bequest of Mrs. Blanche Elder Howell (Blanche Elder Larzelere) (1923.12)

Jacob Eichholtz (1776-1842) was born in Lancaster, Pennsylvania. Apart from childhood lessons by a local sign-painter, Eichholtz was entirely self-taught. He received professional encouragement and advice when the noted Philadelphia portraitist Thomas Sully briefly visited Lancaster in 1808. In 1811 Eichholtz also sought the opinion of the famous portraitist Gilbert Stuart in Boston. Eichholtz devoted himself to painting full-time when he was 35 years old; he became an itinerant artist, attracting clients throughout the various localities in Pennsylvania. His reputation grew with his talent, and he exhibited annually at the Society of Artists from 1811 to 1814. In 1822 Eichholtz established a successful studio in Philadelphia and participated in the Philadelphia Academy Annuals until his death in 1842.

JACOB EICHHOLTZ (1776-1842)

Conestoga Creek and Lancaster, 1833
Oil on canvas 20¼ x 30¼ in.
The Pennsylvania Academy of the Fine Arts, Philadelphia
Gift of Mrs. James H. Beal (1961.8.10)

THOMAS SULLY (1783-1872)

Major Thomas Biddle (1790-1831), 1818
Oil on canvas 36½ x 28⅟₁₆ in.
The Pennsylvania Academy of the Fine Arts, Philadelphia
Bequest of Ann E. Biddle (1925.8)

Thomas Sully (1783-1872) was born in England and immigrated to the United States in 1792. His first art training came from family members – his brother and brother-in-law were miniature painters. Sully learned much about the art of portraiture by studying the painting methods of his well-known compatriots Gilbert Stuart and John Trumbull. In 1808 he moved to Philadelphia, where he remained for the rest of his career, becoming an influential member of the art community in that city. In 1838 Sully traveled to England to paint a commissioned portrait of the young Queen Victoria, who had only recently been crowned. In addition to his portraits, Sully painted landscapes and historical subjects.

THOMAS SULLY (1783-1872)

Frances Anne Kemble as Beatrice (1809-1893), 1833
Oil on canvas 30 x 25 in.
The Pennsylvania Academy of the Fine Arts, Philadelphia
Bequest of Henry C. Carey (The Carey Collection) (1879.8.24)

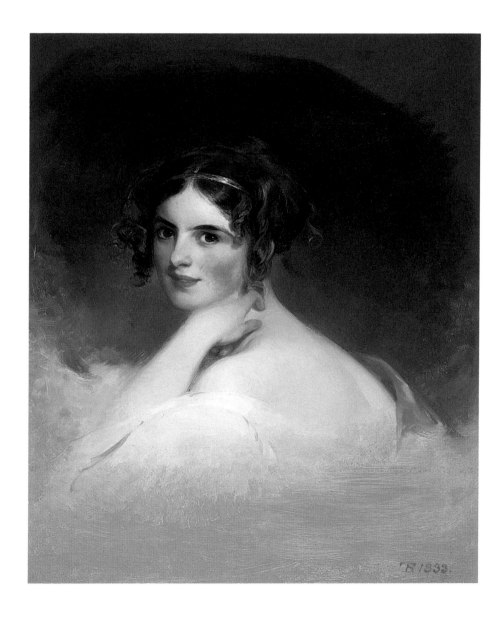

BASS OTIS (1784-1861)

Interior of a Smithy, c. 1815
Oil on canvas 50⅝ x 80½ in.
The Pennsylvania Academy of the Fine Arts, Philadelphia
Gift of the artist (1845.2)

Bass Otis (1784-1861) was born in Massachusetts. While apprenticed to a scythe-maker, Otis taught himself to paint. By 1808 he was a professional portraitist in New York. He moved in 1812 to Philadelphia, where he exhibited at the Society of Artists and became well known. In 1816 Otis was commissioned by the Philadelphia publisher Joseph Delaphaine to paint the likenesses of Jefferson, Madison, and Monroe for Delaphaine's book on famous Americans. It is for these portraits that Otis is chiefly remembered. He lived for a number of years in New York and in Boston before returning to Philadelphia in 1858. Otis exhibited at the Pennsylvania Academy until his death in 1861. Otis also invented a perspective protractor and is considered to be the first American to have produced a lithograph.

BASS OTIS (1784-1861)

Alexander Lawson (1773-1846), n.d.
Oil on canvas 30 x 25 1/16 in.
The Pennsylvania Academy of the Fine Arts, Philadelphia
Bequest of Mrs. Mary Lawson Birkhead (1898.12)

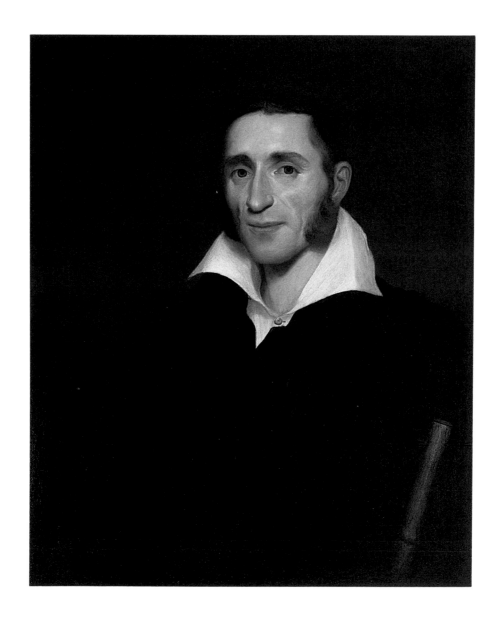

RUBENS PEALE (1784-1865)

The Old Museum, 1858-60
Oil on tin 14¹/₁₆ x 20¹/₁₆ in.
The Pennsylvania Academy of the Fine Arts, Philadelphia
Bequest of Charles Coleman Sellers (1980.9)

Rubens Peale (1784-1865) was born in Philadelphia. Although a member of a noted artistic family, Rubens did not take up painting until the 1850s, his artistic career delayed because of poor eyesight. Encouraged by his daughter, Mary Jane, who was also a painter, Peale set up a studio at the family farm near Schuylkill Haven, Pennsylvania, where he painted mainly landscapes and still lifes.

JOHN LEWIS KRIMMEL (1789-1821)

Fourth of July in Centre Square, 1812
Oil on canvas 22¾ x 29 in.
The Pennsylvania Academy of the Fine Arts, Philadelphia
Pennsylvania Academy Purchase (1845.3.1)

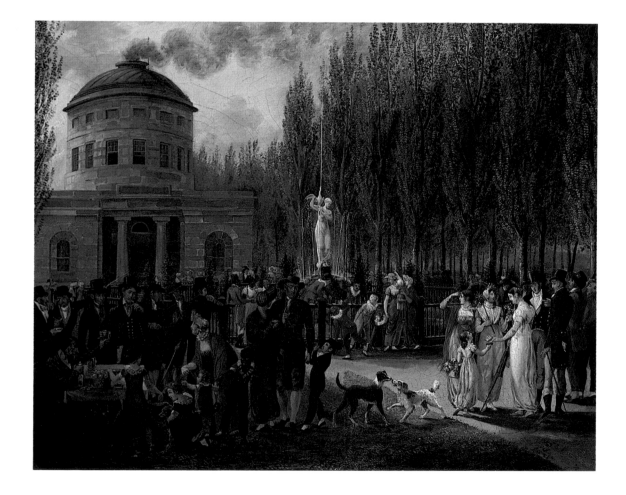

John Lewis Krimmel (1789-1821) moved in 1810 from Germany to Philadelphia to join his brother's accounting firm; he soon tired of the business world and taught himself painting by studying the engravings of European masters. Krimmel began by painting portraits for a steady income, but the success of a genre painting at an exhibition of the Society of Artists allowed him subsequently to make his reputation thereafter by his portrayal of narrative and domestic scenes. Krimmel was the first important American genre painter and is referred to as "the American Hogarth." He exhibited regularly and started his own engraving business. His budding career was cut short when he drowned at the age of 32.

THOMAS DOUGHTY (1793-1856)

PLATE P-19

Morning Among the Hills, 1829-30
Oil on canvas 15¼ x 21¹⁄₁₆ in.
The Pennsylvania Academy of the Fine Arts, Philadelphia
Bequest of Henry C. Carey (The Carey Collection) (1879.8.4)

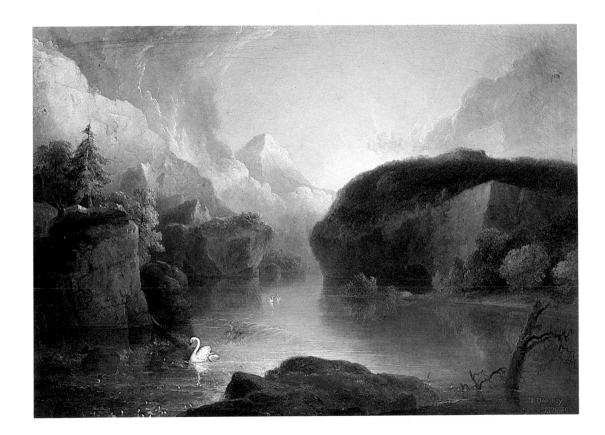

Thomas Doughty (1793-1856) was born in Philadelphia. Although Doughty was self-taught, his paintings show careful study of the European, especially the English, landscape tradition, for Doughty also lived for a time in England and Ireland. By 1822 Doughty was exhibiting regularly at the Pennsylvania Academy of the Fine Arts and the National Academy of Design. His pictures also became widely known through steel-engraved prints distributed by the American Art-Union, which purchased more than 50 of his works. After a disastrous business venture, Doughty moved in 1832 to Boston, where he produced his finest landscapes in addition to giving drawing and painting lessons. He became quite popular and influenced younger artists such as Thomas Cole. During his last years Doughty's work came under criticism for its repetitiveness, though he continued to paint until his death in 1856.

CHARLES ROBERT LESLIE (1794-1859)

Sophia Western, 1849
Oil on canvas 16⅞ x 14⁷⁄₁₆ in.
The Pennsylvania Academy of the Fine Arts, Philadelphia
Gift of Samuel P. Avery (1898.1.1)

Charles Robert Leslie (1794-1859) was born in London to American parents, who returned to Philadelphia when their son was age six. Impressed by Leslie's precocious talent, the board of directors of the Pennsylvania Academy of the Fine Arts awarded Leslie a grant in 1811 which enabled him to study at the Royal Academy in London. Leslie achieved early success in London with his genre paintings based on English literature and history. He was also a portrait painter as well as a lecturer and the author of several art and art history books, notably a biography of John Constable. For a short period in 1833, Leslie taught at the U.S. Military Academy at West Point; but he returned to London, where he exhibited and taught painting at the Royal Academy until his death in 1859.

Anna Gibbon Johnson (1809-1895), 1828
Oil on canvas 45⅝ x 33¾ in.
The Pennsylvania Academy of the Fine Arts, Philadelphia
Bequest of Helena Hubell (1929.7)

John Neagle (1796-1865) was born in Philadelphia and received drawing lessons from Pietro Ancora, an Italian still-life painter, until being apprenticed in 1810 to a coach painter, Thomas Wilson. Wilson, a former student of the established portraitist Bass Otis, encouraged Neagle also to seek Otis's instruction, which he did in 1812. By 1817 Neagle had set up his own portrait studio in Philadelphia where he settled permanently in 1819. Neagle's work was influenced by Thomas Sully, whose daughter Neagle later married, and also Gilbert Stuart, whose Boston studio Neagle visited in 1825. Neagle exhibited at the Pennyslvania Academy for several years, but his reputation was made in 1827 with the portrait *Pat Lyon at the Forge.* He was the director of the Pennsylvania Academy from 1830 to 1831 and a founder and first president of the Artists' Fund Society from 1835 to 1844.

WILLIAM SIDNEY MOUNT (1807-1868)

PLATE P-22

The Painter's Triumph, 1838
Oil on wood 19½ x 23½ in.
The Pennsylvania Academy of the Fine Arts, Philadelphia
Bequest of Henry C. Carey (The Carey Collection) (1879.8.18)

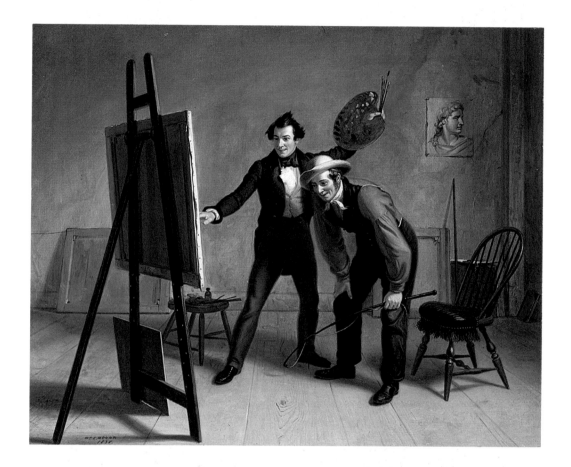

William Sidney Mount (1807-1868) grew up on a farm in Stony Brook, Long Island, and remained in the community of his boyhood throughout his life. Mount started his career by painting the history and portrait paintings typical of the 19th century. Inspired by a work of John Lewis Krimmel, Mount exhibited a genre scene at the National Academy of Design in 1830 which won him acclaim; from thereon his style rapidly matured and he concentrated on painting the lifestyles and people he knew best. Mount's later works are especially original, expressing his natural creativity – Mount was also an inventor – and love for music and the country.

JAMES HAMILTON (1819-1878)

Old Ironsides, 1863
Oil on canvas 60⅜ x 48 in.
The Pennsylvania Academy of the Fine Arts, Philadelphia
Gift of Caroline Gibson Taitt (1885.1)

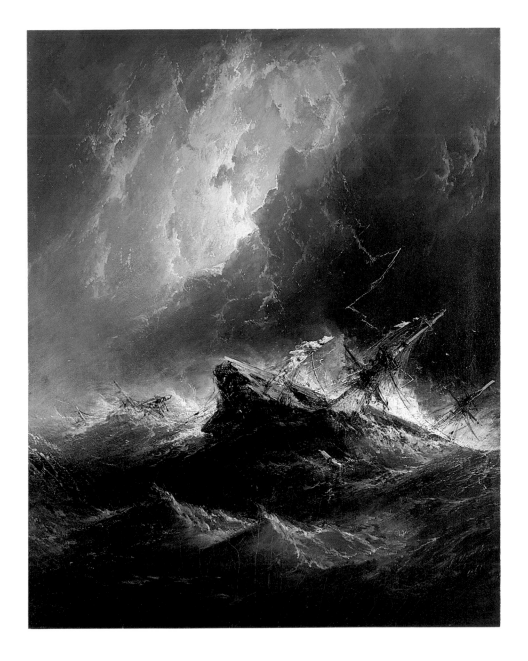

James Hamilton (1819-1878) was born near Belfast, Ireland, and immigrated to Philadelphia in 1834. Although he first attempted a career in a counting house, he was soon unhappy. When he showed his drawings to the engraver John Sartain, he was urged to dedicate himself to developing his talent. Hamilton briefly studied art in Philadelphia while earning his livelihood by teaching drawing. His first exhibition was at the Artists' Fund Society in 1840; by 1844 he was one of the Society's board members. His career steadily gained momentum; he showed frequently at the Pennsylvania Academy of the Fine Arts and the National Academy of Design. In 1854 Hamilton traveled to England to study the works of J.M.W. Turner. Turner's style influenced his landscapes and marine paintings to the extent that he was referred to as "the American Turner." Hamilton was considered an emminent painter and became especially well known through his illustrations for books published in 1853-55 by the explorer Elisha Kent Kane.

MARTIN JOHNSON HEADE (1819-1904)

PLATE P-24

Sunset Harbor at Rio, 1864
Oil on canvas 20⅛ x 35 in.
The Pennsylvania Academy of the Fine Arts, Philadelphia
Henry C. Gibson Fund (1985.10)

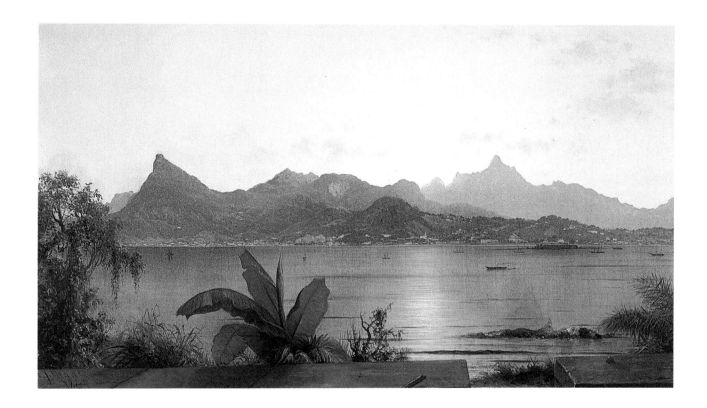

Martin Johnson Heade (1819-1904), born in Lumberville, Pennsylvania, studied with Quaker artist Edward Hicks and supported himself primarily through portrait painting while traveling extensively through Europe and the United States during the 1840s and 1850s. In 1859 he acquired a studio in the Tenth Street Studio Building in New York neighboring those of landscape painters Frederic Edwin Church, John F. Kensett, and Fitz Hugh Lane. With Church's encouragement, Heade turned to landscape painting and began to produce the views of the New England seacoast and salt marshes for which he is now best known. Heade's 1863 excursion to Brazil and succeeding trips to South America inspired his unusual still lifes of tropical flowers and hummingbirds. An intensely private man, Heade received little critical or public recognition during his lifetime and, although he exhibited work regularly in New York and elsewhere, he did not often socialize with his fellow artists. After his move to Florida in 1884, the friendship and support of land developer Henry M. Flagler enabled Heade to devote his later years to the production of some of his finest work, notably his exquisite studies of magnolia blossoms and other flora indigenous to Florida.

SANFORD ROBINSON GIFFORD (1823-1880)

St. Peter's from Pincian Hill, 1865
Oil on canvas 9¹³⁄₁₆ x 15⁹⁄₁₆ in.
The Pennsylvania Academy of the Fine Arts, Philadelphia
Gift of Mr. and Mrs. Edward Kesler (1975.20.3)

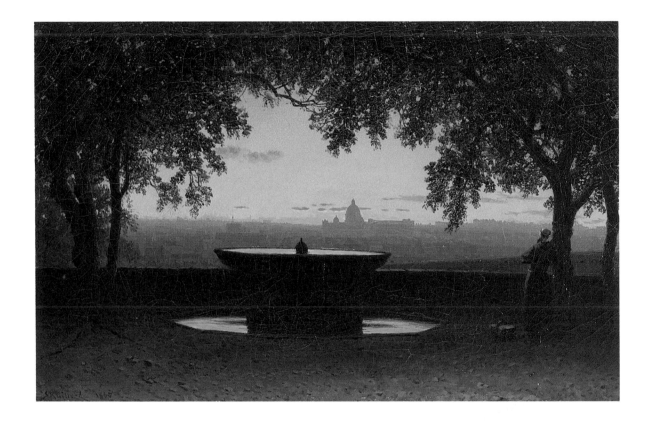

Sanford Robinson Gifford (1823-1880) began his career as a landscape painter of the Hudson River School. He was a student at the National Academy of Design where he became a devotee of Thomas Cole. During the 1840s Gifford concentrated on landscapes of the Catskill and Berkshire mountains which attracted the attention of the American Art-Union in 1847. In 1855 Gifford went to Europe, traveling for a time with Albert Bierstadt. Contact with the art of John Constable and J.M.W. Turner, as well as the Barbizon School, altered Gifford's approach to the treatment of light in his work. Upon his return to the United States in 1857, Gifford established a studio in New York; his beautifully rendered scenes of his homeland ensured Gifford's reputation as a popular and important American painter.

A Young Woman with a Guitar, n.d.
Oil on canvas 30¼ x 20¼ in.
The Pennsylvania Academy of the Fine Arts, Philadelphia
Gift of Edith Howe DeWolf, Rhoda Howe Low, Grace Howe Jordan, and Amy Howe Steel in memory of their parents Dr. and Mrs. Herbert M. Howe
and their grandparents Mr. and Mrs. J. Gillingham Fell (1924.7.3)

William Morris Hunt (1824-1879) was born in Brattleboro, Vermont. A respiratory ailment caused Hunt to travel to Europe with his mother; they settled in Rome in 1843. During 1846 Hunt studied briefly in Düsseldorf prior to returning to Paris, where he joined the atelier of Thomas Couture. Hunt joined François Millet in Barbizon from 1853 to 1855; he returned to the United States and became Boston's leading portrait painter during the 1850s to the 1870s. He is noted for his portraits, murals, and genre paintings but is more important for his influence in Boston as a proponent of the Barbizon School. In 1879 Hunt drowned at Appledore, Isles of Shoals.

GEORGE INNESS (1825-1894)

Apple Blossom Time, 1883
Oil on canvas 27⅛ x 22⅛ in.
The Pennsylvania Academy of the Fine Arts, Philadelphia
Bequest of J. Mitchell Elliot (1952.22.2)

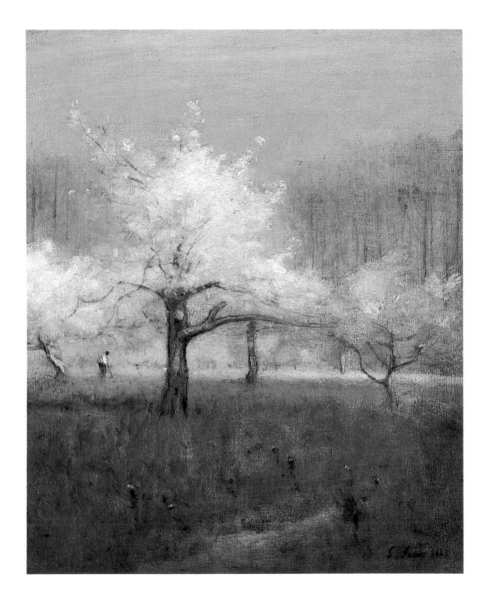

George Inness (1825-1894) spent his childhood in Newark, New Jersey. He studied art with various teachers, but accomplished most of his training himself by copying the works of famous landscape artists whom he admired, particularly Thomas Cole and Asher B. Durand. During the early 1850s Inness made two trips to Europe, where his studies of the works of the Barbizon School painters, notably Camille Corot, Jean-François Daubigny, and Théodore Rousseau, inspired his gradual move from a Hudson River School painting style to a manner more technically assured and European in nature. Inspired by the writings of Swedish philosopher Emanuel Swedenborg, and deeply affected by the Civil War, Inness brought a greater expressiveness to his work of the 1860s. A trip to Italy during a tour of Europe in the early 1870s elicited some of his most original and imaginative work. By the late 1870s Inness was a celebrated and respected leader in the American landscape school. His later work is characterized by heightened colorism and decorative simplification reminiscent of the work of J. M. W. Turner.

GEORGE H. COMEGYS (active 1836-1845)

The Little Plunderers, n.d.
Oil on canvas 17⅛ x 20¼ in.
The Pennsylvania Academy of the Fine Arts, Philadelphia
Bequest of Henry C. Carey (The Carey Collection) (1879.8.3)

George H. Comegys (active c. 1836-1845) was born in Maryland. He studied with John Neagle during the 1830s. He began exhibiting his genre, portrait, and history paintings at the Artists' Fund Society in 1837, and from 1843 to 1845 he showed yearly at the Pennsylvania Academy of the Fine Arts as well as at several other institutions and galleries. Shortly after this time, Comegys was admitted to the Pennsylvania Hospital for the Insane where he died.

WINSLOW HOMER (1836-1910)

PLATE P-29

Fox Hunt, 1893
Oil on canvas 38 x 68½ in.
The Pennsylvania Academy of the Fine Arts, Philadelphia
Joseph E. Temple Fund (1894.4)

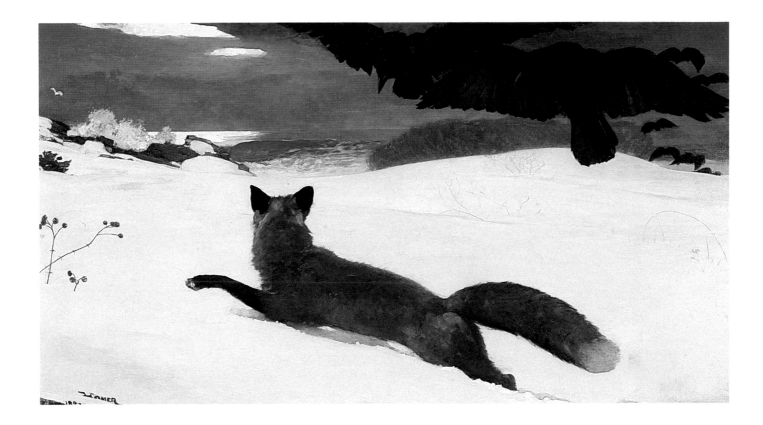

Winslow Homer (1836-1910) spent his childhood in Boston and Cambridge, Massachusetts. After serving as an apprentice to a lithographer, Homer worked as a free-lance illustrator and gained recognition for the studies of life at the battlefront he produced during the Civil War as an artist-correspondent for *Harper's Weekly* magazine. The Civil War was also the subject of Homer's first major painting, *Prisoners from the Front*, which was exhibited at the Universal Exposition in Paris in 1867. Homer had received brief training in drawing at the National Academy of Design and studied for a short time with the painter Frederick Rondel, but he was essentially self-taught. By the mid-1870s Homer had abandoned illustration to devote himself to painting and was winning widespread critical and public approval for his oil paintings and watercolors of rural America. His two-year residence at the fishing village of Cullercoats in England influenced Homer's decision to settle at Prout's Neck, Maine, in 1884, and after this date he concentrated increasingly on seascapes and views of the Maine coast. Subsequent trips to the West Indies, as well as Homer's annual fishing trips in the Adirondacks and Quebec province and the Maine coast, inspired his powerful images of nature's power.

ELIHU VEDDER (1836-1923)

The Sphinx, Egypt, 1890
Oil on canvas 20⅛ x 14¾ in.
The Pennsylvania Academy of the Fine Arts, Philadelphia
Bequest of Edgar P. Richardson (1985.44)

Elihu Vedder (1836-1923) was born in New York City; he studied painting under Thompkins H. Matteson in New York and then in 1856 with François-Edouard Picot in Paris. In 1857 Vedder moved to Florence to study with Raffaello Bonaiuti and met the Italian plein-air artists. Vedder returned to the United States in 1860 and worked as an illustrator while exhibiting his paintings. He moved to Rome in 1866 and settled there permanently except for a visit in 1869 to London, where exposure to the Pre-Raphaelites inspired Vedder's own symbolist style. During his lifetime he was a celebrated artist; he is best known today for his illustrations for a 1884 publication of the *Rubiayat of Omar Khayyam*.

THOMAS MORAN (1837-1926)

Venice, 1887
Oil on canvas 20⁵⁄₁₆ x 30¹⁄₁₆ in.
The Pennsylvania Academy of the Fine Arts, Philadelphia
Gift of Mrs. Edward H. Coates (The Edward H. Coates Memorial Collection) (1923.9.3)

Thomas Moran (1837-1926) was born in Lancashire, England, and raised in Philadelphia. Moran set up a studio with his brother Edward, a well-known marine painter, in 1855, and began to exhibit his own landscape paintings at the Pennsylvania Academy of the Fine Arts. In 1861 Moran traveled to England and studied the works in the National Gallery, where he was especially impressed by the paintings of the English landscape painter J.M.W. Turner. In 1871 Moran traveled across the United States to Yellowstone in Wyoming Territory, recording the wilderness landscape in a masterful series of watercolors and oil paintings. The purchase by Congress of his *The Grand Canyon of the Yellowstone* in 1872 established Moran's reputation and ultimately inspired the creation of the National Park Service and the designation of Yellowstone as a protected region. After 1872 Moran lived in New York, making periodic trips to the West and exhibiting with success both in the United States and Europe. In 1916 he moved to Santa Barbara, California, where he continued to paint until his death in 1926.

DANIEL RIDGWAY KNIGHT (1839-1924)

Hailing the Ferry, 1888
Oil on canvas 64½ x 83⅛ in.
The Pennsylvania Academy of the Fine Arts, Philadelphia
Gift of John H. Converse (1891.7)

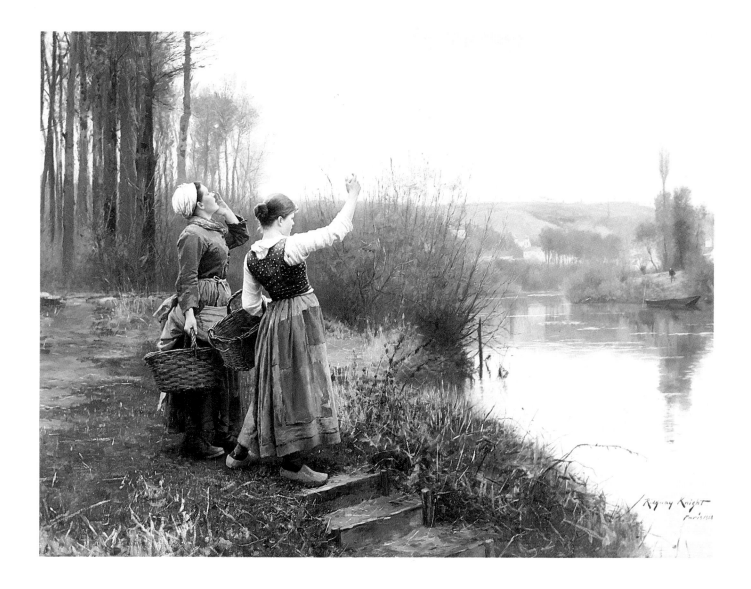

Daniel Ridgway Knight (1839-1924) was a native of Philadelphia; he attended the Pennsylvania Academy of the Fine Arts before traveling in 1861 to Paris, where he studied with Charles Gleyre. Knight returned to Philadelphia to enlist in the Union Army. He was able to resume his painting career after the war, and by the mid-1870s was back in Paris, studying with Ernest Meissonier and sending pictures to the annual Salon exhibitions. Knight's scenes of French peasant life were painted in the fashionable "naturalist" style, the leading practitioners of which were Jules Bastien- LePage and Jules Breton. Following his first honorable mention at the Salon of 1884, Knight won many awards and his paintings became very popular in Germany and the United States as well as in France. Knight retained his American citizenship, but lived in France until his death in 1924.

Walt Whitman (1819-1892), 1887
Oil on canvas 30⅛ x 24¼ in.
The Pennsylvania Academy of the Fine Arts, Philadelphia
General Fund (1917.1)

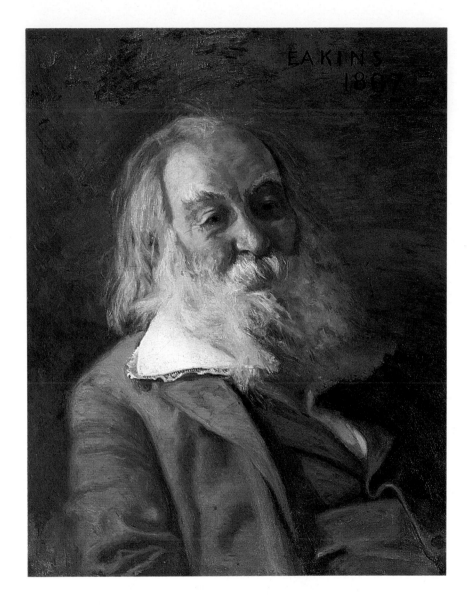

Thomas Eakins (1844-1916) was born in Philadelphia and studied initially at the Pennsylvania Academy of the Fine Arts. In 1866 Eakins departed for a four-year stay in Europe, where he joined the atelier of Jean-Léon Gérôme. He also worked for a brief time with Léon Bonnat prior to touring in Spain in 1869 and 1870 where he studied the works of Velázquez and Ribera. Eakins exhibited frequently in the United States during the 1870s and early 1880s, and he sent two paintings to the Paris Salon in 1875. However, although critics recognized Eakins's talent, his frank realism did not make him a success with the public. Eakins

The Cello Player, 1896
Oil on canvas 64¼ x 48⅛ in.
The Pennsylvania Academy of the Fine Arts, Philadelphia
Joseph E. Temple Fund (1897.3)

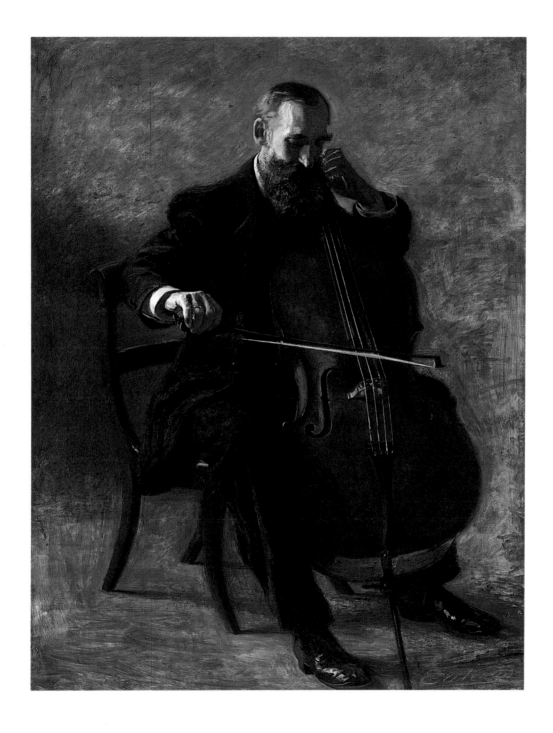

was also a gifted teacher and was appointed director of schools at the Pennsylvania Academy in 1882. His teaching methods, insistence on detailed anatomical study, and the photography of nude models led to his forced resignation in 1886. Thereafter, although Eakins continued to exhibit (primarily portraits) and did some teaching, he no longer took a leading role in the Philadelphia art community and had withdrawn almost totally from public view by the time of his death. Many 20th-century American artists have credited Eakins's work with having exerted a powerful influence on their own art.

FRANK DUVENECK (1848-1919)

PLATE P-35

The Turkish Page, 1876
Oil on canvas 42 x 58¼ in.
The Pennsylvania Academy of the Fine Arts, Philadelphia
Joseph E. Temple Fund (1894.1)

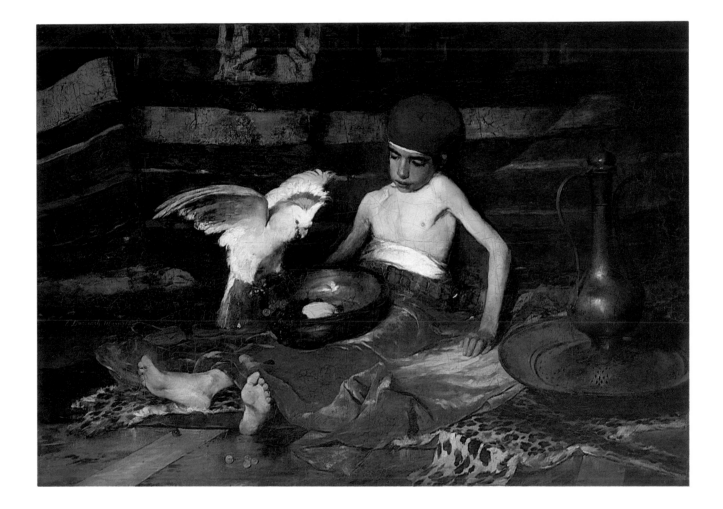

Frank Duveneck (1848-1919) was born in Kentucky. Although he worked as a professional painter in Ohio and Kentucky from the early 1860s, it was not until 1870 that Duveneck left the United States for the Munich Academy, where he studied with Wilhelm von Diez. Like fellow student William Merritt Chase, Duveneck was a virtuoso who painted with a broad, energetic touch. His "dark" chiaroscuro style was an attempt to combine the painterly realism of the German master Wilhelm Liebl with the dramatic elegance of Velázquez and forthright design of Edouard Manet. Duveneck was also a talented teacher; in 1878 he established his own painting school in Munich which attracted a significant number of American students who became known as the "Duveneck Boys," among them John White Alexander, William Merritt Chase, Joseph Rodefer De Camp, and John H. Twachtman. During the early 1880s Duveneck spent much of his time working in Florence and Venice. In 1886, after a long courtship, he married fellow artist Elizabeth Boott. Her death two years later devastated the artist and he returned to the United States soon after, settling in Cincinnati. Although he did not altogether abandon painting, in later years Duveneck devoted most of his energies to teaching and serving on various exhibition juries throughout the United States.

"Keying Up" – The Court Jester, 1875
Oil on canvas 39¾ x 25 in.
The Pennsylvania Academy of the Fine Arts, Philadelphia
Gift of the Chapellier Galleries, New York (1969.37)

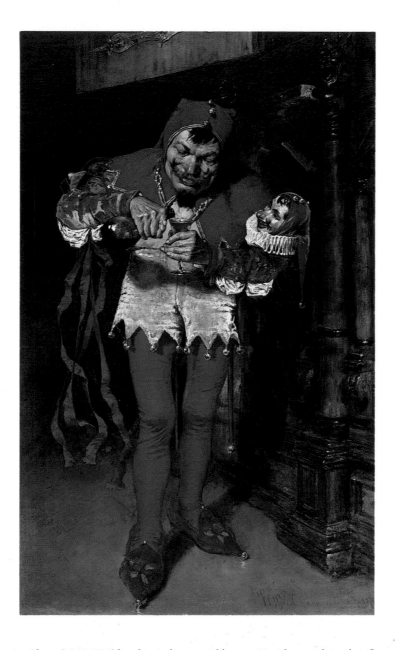

William Merritt Chase (1849-1916) lived in Indiana until he was 21. After studying briefly at the National Academy of Design in New York, he worked in St. Louis as a still-life painter. Interested local collectors and patrons provided Chase with enough money to attend the Munich Academy and he left America in 1872 to pursue his studies. Even before his return to New York in 1878, Chase was sending works to exhibitions in the United States. A handsome, charismatic man who was also a virtuoso painter, Chase became a leading personality in the New York art community and, by the early 1880s his apartments in the Tenth Street Studio Building had become a gathering place for artists and famous personalities. Chase was also a well-known and respected art teacher. For many years he was on the faculties of the Art Students' League and the Pennsylvania Academy of the Fine Arts. During the 1890s he even started two schools of his own: the Chase School in New York and a summer school at Shinnecock, Long Island. Among his students were Marsden Hartley, Edward Hopper, Georgia O'Keeffe, and Charles Sheeler. His style and technique were as eclectic as was his exuberant lifestyle, but they manifested the virtuosity and polish that made him a much-sought-after instructor and artist.

Portrait of Mrs. C. (Lady with a White Shawl), 1893
Oil on canvas 75 x 52 in.
The Pennsylvania Academy of the Fine Arts, Philadelphia
Joseph E. Temple Fund (1895.1)

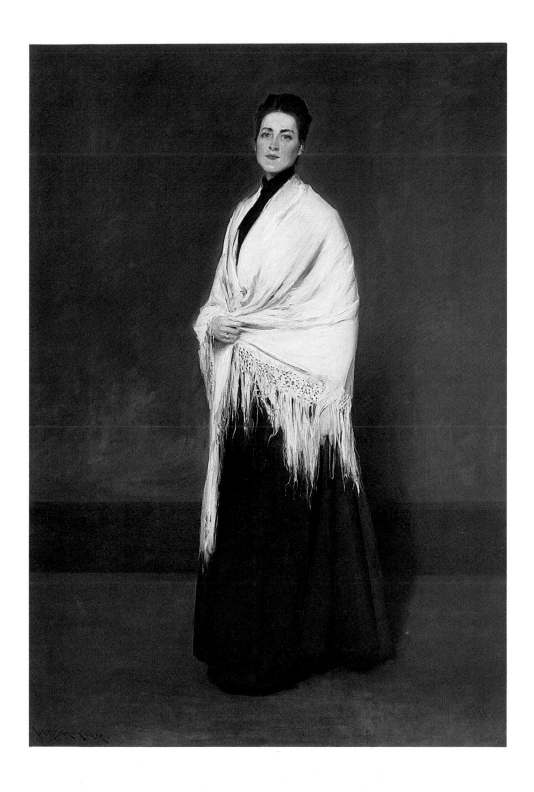

WILLIAM HENRY LIPPINCOTT (1849-1920)

Childish Thoughts, 1895
Oil on canvas 32¼ x 45¹¹⁄₁₆ in.
The Pennsylvania Academy of the Fine Arts, Philadelphia
Gift of Mary H. Rice (1976.3)

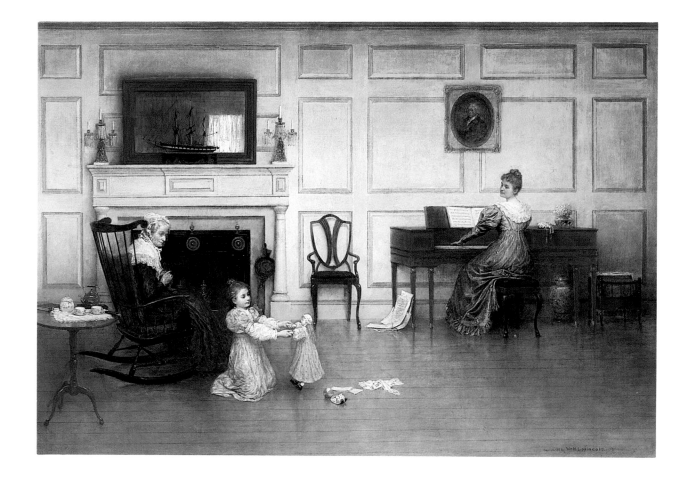

William Henry Lippincott (1849-1920) was born in Philadelphia and attended the Pennsylvania Academy of the Fine Arts. In 1874 Lippincott moved to Paris where he studied with Léon Bonnat. He spent eight years studying and exhibiting in the Salons before returning in 1882 to Portland, Maine. He eventually moved to New York and taught at the National Academy of Design for three years. Lippincott showed his portraits, landscapes, and figure compositions at American art exhibitions on a regular basis. Resemblances to the painting style of John Singer Sargent can be found in Lippincott's work. In addition, Lippincott was an illustrator, etcher, and scenery designer.

PLATE P-39

The Incense Burner (Rebecca H. Whelan), c. 1905
Oil on canvas 64 x 40 in.
The Pennsylvania Academy of the Fine Arts, Philadelphia
Henry D. Gilpin Fund (1940.11)

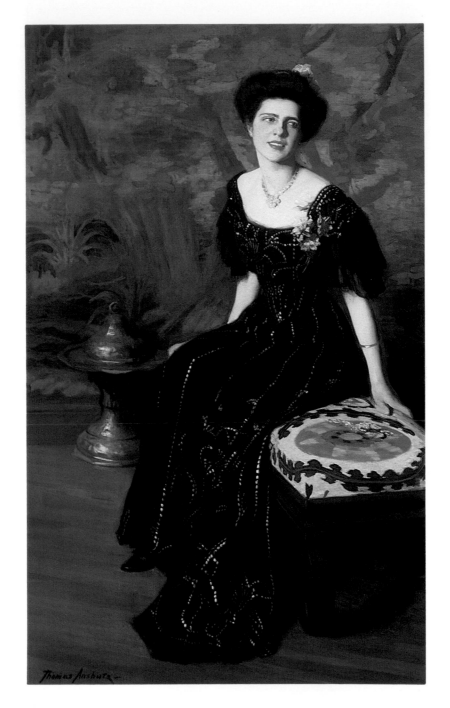

Thomas Pollock Anshutz (1851-1912) was born in Newport, Kentucky. In 1871 he received his first art training at New York's National Academy of Design, but left after five years to study at the Pennsylvania Academy of the Fine Arts. He became a pupil of Thomas Eakins and was greatly influenced by Eakins's work and teaching methods. In 1886, following Eakins's resignation from the school, Anshutz succeeded him as primary instructor at the Academy. In 1892 he went to Paris to study at the Académie Julian. He returned to Philadelphia in 1893 and resumed teaching and exhibiting. Although he received numerous awards, Anshutz did not gain significant public recognition until relatively late in his career; nevertheless, he was influential through his teaching at the Pennsylvania Academy as well as his own Darby School.

THEODORE ROBINSON (1852-1896)

Port Ben, Delaware and Hudson Canal, 1893
Oil on canvas 28¼ x 32¼ in.
The Pennsylvania Academy of the Fine Arts, Philadelphia
Gift of the Society of American Artists as a memorial to Theodore Robinson (1900.5)

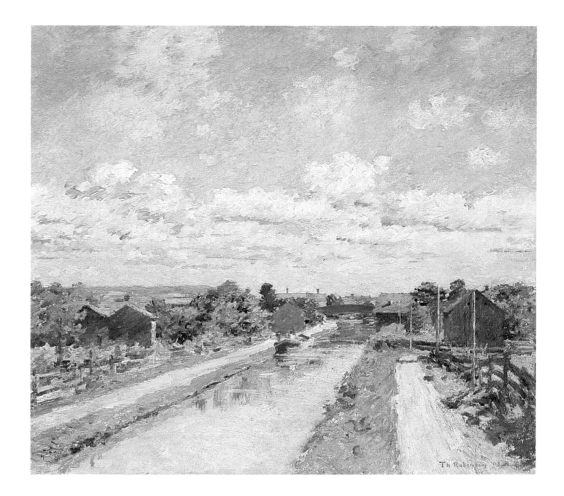

Theodore Robinson (1852-1896) spent his childhood in Evansville, Wisconsin. Robinson studied for a year at The School of the Art Institute of Chicago when he was 18, but asthma forced him to move to Denver for medical treatment. After two years' study at the National Academy of Design from 1874 to 1876, Robinson departed for Paris where he studied with Carolus-Duran and Jean-Léon Gérôme. Robinson worked at various jobs in New York during the early 1880s, finally returning to Paris in 1884. Summer trips to the village of Giverny and Robinson's encounter with Claude Monet in 1888 resulted in the American's conversion to Impressionism. Robinson's colleagues recognized his talent, yet in spite of support and encouragement from fellow artists, he was unable to gain widespread public recognition. He died suddenly only four years after his return to the United States.

ALEXANDER HARRISON (1853-1930)

The Wave, c. 1885
Oil on canvas 39¼ x 118 in.
The Pennsylvania Academy of the Fine Arts, Philadelphia
Joseph E. Temple Fund (1891.5)

James Alexander Harrison (1853-1930) was a native of Philadelphia and studied at the Pennsylvania Academy of the Fine Arts before traveling to Paris in 1879 to study with Jules Bastien-Lepage and Jean-Léon Gérôme. He exhibited landscapes and seascapes at successive Salons during the 1880s and became a leading painter of the artists' colony at Pont-Aven, Brittany. Harrison's later works show some affinities to the "Nocturnes" of his friend, James Abbott McNeill Whistler. Harrison maintained studios both in New York and in Paris where students eagerly sought instruction. An international artist, he was honored with exhibitions in London, Munich, New York, and Philadelphia. He died in Paris in 1930.

WILLIAM LAMB PICKNELL (1853-1897)

PLATE P-42

Road to Nice, 1896
Oil on canvas 58¼ x 83¼ in.
The Pennsylvania Academy of the Fine Arts, Philadelphia
Bequest of Gertrude Flagg (1906.5)

William Lamb Picknell (1853-1897) was born in Vermont and raised in Boston. When he was twenty-one years old, he traveled to Europe where he studied for two years with George Inness in Rome. After worrking for a time with Jean-Léon Gérôme at the Ecole des Beaux-Arts in Paris, Picknell joined the artists' colony at Pont-Aven, Brittany, where he lived until the mid-1880s. Despite his continued residence in Europe, Picknell was very successful in the United States and was elected to both the Society of American Artists and the National Academy of Design. Picknell returned to France in 1890. He died while visiting relatives in New England.

JOHN FREDERICK PETO (1854-1907)

The Fish House Door, c. 1895-1900
Oil on canvas 63⅛ x 40⅛ in.
The Pennsylvania Academy of the Fine Arts, Philadelphia
Collections Fund (1958.15)

John Frederick Peto (1854-1907) was born in Philadelphia. In 1878 he attended the Pennsylvania Academy of the Fine Arts, where he became friends with William Harnett, who provided the major influence on his art. Peto's work was often confused with the more popular Harnett still lifes and, after Peto's death, many of his paintings were sold with forged Harnett signatures. During 1880-86 Peto exhibited at the Pennsylvania Academy, but he stopped painting professionally in 1889. He moved to the seaside village of Island Heights, New Jersey, where he settled permanently. He continued to paint, producing souvenir pictures for summer tourists. His remarkable still lifes, however, did not receive recognition until more than 40 years after his death.

CECILIA BEAUX (1855-1942)

PLATE P-44

Mother and Daughter (Mrs. Clement Acton Griscom, 1850-1925 and Miss Frances C. Griscom, 1879-1974), 1898
Oil on canvas 83 x 44 in.
The Pennsylvania Academy of the Fine Arts, Philadelphia
Gift of Frances C. Griscom (1950.15)

Cecilia Beaux (1855-1942) was born in Philadelphia and began her art training with her aunt, Catherine Drinker Janvier, later working with a Dutch émigré artist, Adolf van der Whelen. Her talent for drawing led to a commission in 1873 to do studies of fossils for a United States Geological Survey. Beaux may have studied at the Pennsylvania Academy during the late 1870s (she later denied this) and by the mid-1880s was working on full-scale paintings: her *Jours d'enfance* was exhibited at the Paris Salon of 1887. The next year Beaux herself traveled to Paris where she enrolled at the Académie Julian to work with Tony Robert-Fleury and William-Adolph Bouguereau. By 1892, when she returned to Philadelphia, she had already achieved recognition in Paris and her portraits gained increasing popularity in the United States as well. Beaux's portraits were often compared to those of John Singer Sargent and her friend and admirer William Merritt Chase. In 1895 Beaux became a painting critic at the Philadelphia Academy of the Fine Arts, a position she held until 1916, when all her time became occupied by painting and exhibiting in New York, traveling abroad, and summering at her beloved home in Gloucester, Massachusetts.

JOHN WHITE ALEXANDER (1856-1915)

PLATE P-45

A Quiet Hour, c. 1901-2
Oil on canvas 48⅜ x 35⅝ in.
The Pennsylvania Academy of the Fine Arts, Philadelphia
Joseph E. Temple Fund (1904.6)

John White Alexander (1856-1915) was born in Allegheny, Pennsylvania. After three years in New York working as an illustrator for *Harper's Weekly*, Alexander left for Europe in 1877. While studying in Munich he came under the influence of fellow American Frank Duveneck; as one of a group of Duveneck's cronies, he accompanied him to Venice where the young artists befriended James Abbott McNeill Whistler and Henry James. Alexander returned to the United States in 1879 and established a studio in New York where he accepted portrait commissions and painted many of the famous personalities of his day. While on assignment for *Century* magazine, Alexander moved briefly to London and then spent several years in Paris, where he exhibited frequently. In 1905, upon being elected president of the National Academy of Design, he returned to New York. Alexander also was an accomplished muralist and undertook commissions for the Library of Congress and the Carnegie Institute in Pittsburgh. This latter project was interrupted by his death in 1915.

ROBERT W. VONNOH (1858-1933)

PLATE P-46

November, 1890
Oil on canvas 32 x 39⅜ in.
The Pennsylvania Academy of the Fine Arts, Philadelphia
Joseph E. Temple Fund (1894.5)

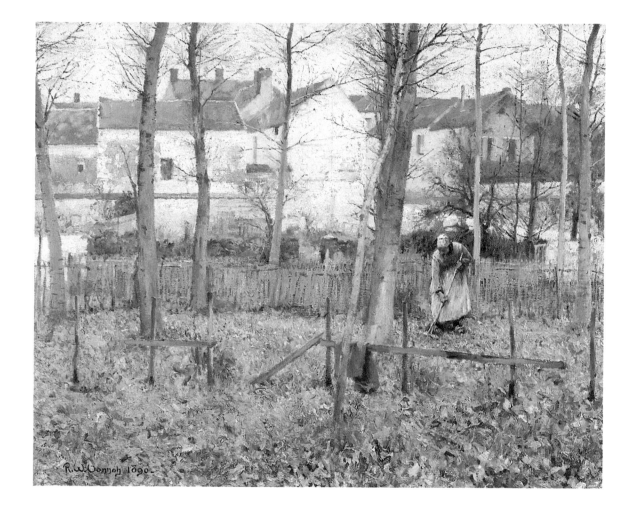

Robert W. Vonnoh (1858-1933) was raised in Boston and received his first art training at the Massachusetts Normal Art School in 1875-77. In 1881 he departed for France to work with Gustave Boulanger and Jules Lefebvre at the Académie Julian. He would become a convert to the Impressionist style during a subsequent trip to France later in the decade. Vonnoh specialized in portraiture, especially of children, as well as landscape; he exhibited his paintings frequently in various American cities. A resident of Boston for most of his career, Vonnoh taught at several local art schools and, during the early 1890s, at the Pennsylvania Academy of the Fine Arts.

PLATE P-47

Cat Boats: Newport, 1901
Oil on canvas 24⅛ x 26⅛ in.
The Pennsylvania Academy of the Fine Arts, Philadelphia
Joseph E. Temple Fund (1902.2)

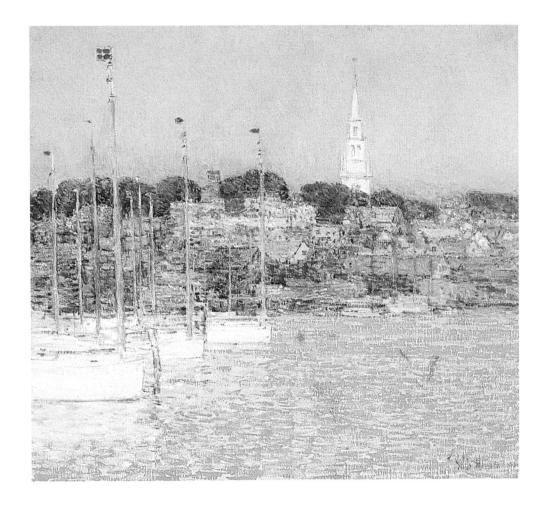

Frederick Childe Hassam (1859-1935) was born in Boston. When a fire destroyed the family business, Hassam dropped out of school to work for a wood engraver; he quickly advanced to staff artist. Later, Hassam illustrated for various magazines while taking night classes from a local artist and at the Boston Art Club. In 1883 Hassam was able to go to Europe and make the Grand Tour. He eventually studied for three years in Paris at the Académie Julian under academicians Gustave Boulanger and Jules Lefebvre, but he was chiefly influenced by the Impressionists. Hassam brought the new style with him when he returned to the United States in 1889; he gained recognition for his landscapes. In 1898 Hassam joined "The Ten," which included Impressionist artists Edmund Tarbell, John H. Twachtman, and Julian Alden Weir. Until his death in 1935, Hassam exhibited regularly at the National Academy of Design, the Pennsylvania Academy of the Fine Arts, and the Corcoran Gallery of Art, in addition to the 1893 World's Columbian Exposition in Chicago and the 1913 Armory Show.

PLATE P-48

The Breakfast Room, n.d.
Oil on canvas 25 x 30 in.
The Pennsylvania Academy of the Fine Arts, Philadelphia
Gift of Clement B. Newbold (1973.25.3)

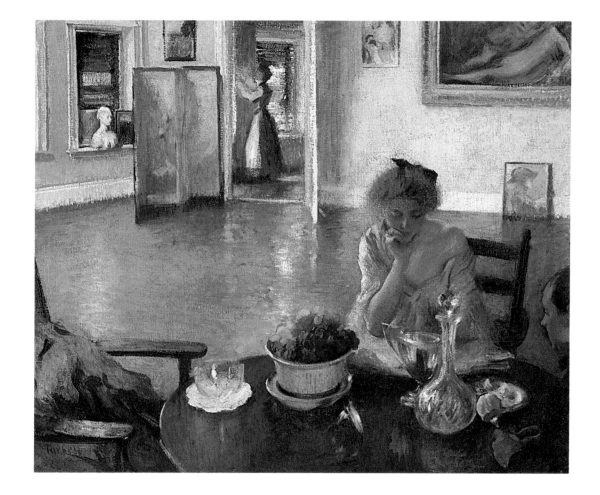

Edmund Charles Tarbell (1862-1938) began his career by working for a lithography firm in Boston before attending the School of the Museum of Fine Arts. After his graduation, Tarbell departed for Paris where he studied at the Académie Julian. In 1888 he returned to Boston and was appointed to the faculty of the Museum School, a post he held until 1913. Tarbell exhibited with "The Ten" in 1898 and hosted several one-person shows during his career. Although his subject matter remained conservative, Tarbell was known for his adept application of the Impressionist aesthetic; through his teaching he influenced more than a generation of Boston artists.

PLATE P-49

The Golden Screen, n.d.
Oil on canvas 77½ x 43¼ in.
The Pennsylvania Academy of the Fine Arts, Philadelphia
Joseph E. Temple Fund (1899.4)

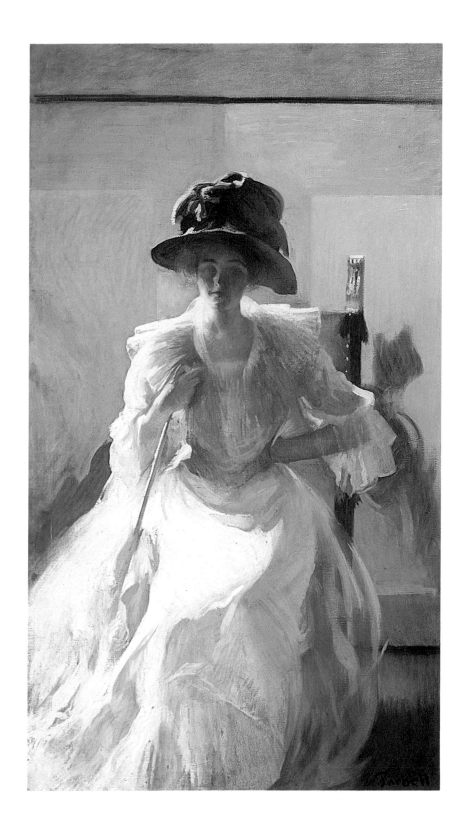

PHILIP LESLIE HALE (1865-1931)

The Crimson Rambler, n.d.
Oil on canvas 25¼ x 30³⁄₁₆ in.
The Pennsylvania Academy of the Fine Arts, Philadelphia
Joseph E. Temple Fund (1909.12)

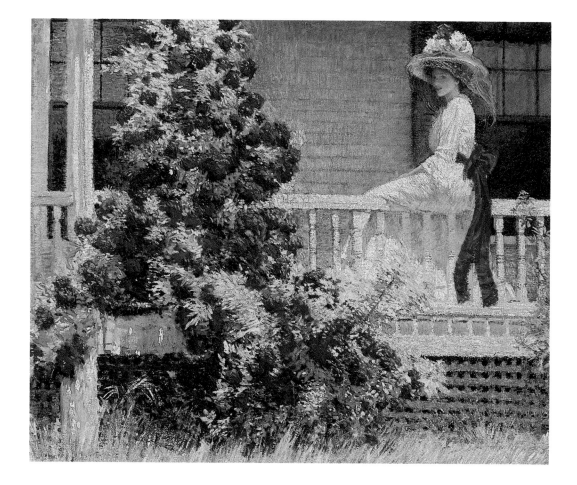

Philip Leslie Hale (1865-1931) was born in Boston. He received his first art instruction from his sister, Ellen Day Hale. After private lessons from Julian Alden Weir in New York, he attended a number of academies: the School of the Museum of Fine Arts, Boston; the Art Students' League; the Académie Julian; and the Ecole des Beaux-Arts. Hale was a regular exhibitor at shows across the United States during the first two decades of this century, supplementing his income by writing art criticism for the *Boston Herald* and the *Boston Evening Transcript*. He also taught at the School of the Museum of Fine Arts for over 30 years.

ROBERT HENRI (1865-1929)

Ruth St. Denis in the Peacock Dance (1878-1968), 1919
Oil on canvas 85 x 49 in.
The Pennsylvania Academy of the Fine Arts, Philadephia
Gift of the Sameric Corporation in memory of Eric Shapiro (1976.1)

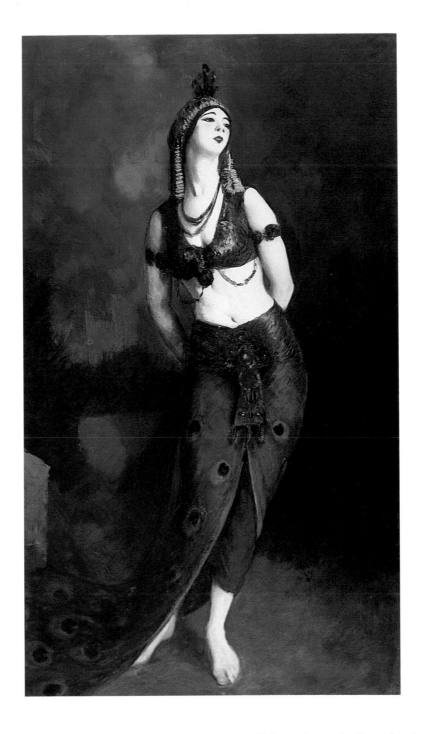

Robert Henri (1865-1929) was born in Cincinnati. He received his training at the Pennsylvania Academy of the Fine Arts with Thomas Anshutz from 1886 to 1888 before moving to Paris to work at the Académie Julian until 1891. He returned to the continent in 1895 and again in 1898. While his early work shows the influence of Impressionism, by the late 1890s Henri was painting portraits and genre studies in a darker, more dramatic realist style derived from the Spanish masters Velázquez and Ribera, and the Dutch painter Frans Hals, as well as the work of Philadelphian Thomas Eakins. After living in Philadelphia and teaching at the Pennsylvania Academy for several years, Henri moved in 1900 to New York, where he became an influential, and inspirational, member of that city's community. Henri was an exceptional

PLATE P-52

Wee Maureen, 1926
Oil on canvas 24 x 20 in.
The Pennsylvania Academy of the Fine Arts, Philadelphia
Gift of Mrs. Herbert Cameron Morris (1962.17.1)

teacher, at the New York School of Art and later at the Art Students' League, as well as at his own Henri School. His students included George Bellows, Patrick Henry Bruce, Edward Hopper, and Stuart Davis. Henri was also a leading critic of the conservative art establishment. In 1908 he organized the exhibition of "The Eight" in protest against the National Academy; he was later involved in the organization of the Armory Show and the founding of the Society of Independent Artists. Although not entirely unsympathetic to the growing influence of modernism and abstraction after the Armory Show, Henri lessened his involvement in art politics thereafter, choosing to devote the final years of his life to travel, painting, and art theory.

WILLIAM SERGEANT KENDALL (1869-1938)

PLATE P-53

Beatrice, 1906
Oil on canvas 30 x 25⅛ in.
The Pennsylvania Academy of the Fine Arts, Philadelphia
Joseph E. Temple Fund (1907.1)

William Sergeant Kendall (1869-1938) was born in Hot Springs, Virginia. He began his art studies in 1884 at the Pennsylvania Academy of the Fine Arts with Thomas Eakins, then moved to Paris in 1886 to continue his work at the Académie Julian and the Ecole des Beaux-Arts. After exhibiting work at the Paris Salon, Kendall moved to New York in 1892 and taught at the Cooper Union. His wife and three daughters provided the major source of inspiration for mother and child studies and portraits of young nudes. From the years 1897 to 1906, Kendall exhibited regularly in both the United States and Europe, winning many prizes. In search of a more isolated atmosphere in which to paint, in 1910 Kendall moved to Newport, Rhode Island. In 1913 he became head of the department of fine arts at Yale University, a position he held until 1922.

EDWARD WILLIS REDFIELD (1869-1965)

New Hope, n.d.
Oil on canvas 50⅛ x 56⅛ in.
The Pennsylvania Academy of the Fine Arts, Philadelphia
Joseph E. Temple Fund (1927.7)

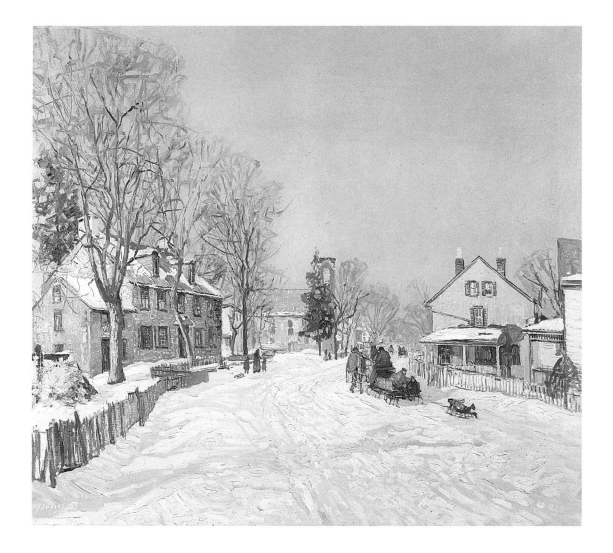

Edward Willis Redfield (1869-1965) was raised in rural Pennsylvania. A precocious talent, when only seven years old Redfield exhibited his *Study of a Cow* at the 1876 Centennial Exposition in Philadelphia. Redfield later attended the Pennsylvania Academy of the Fine Arts and in 1889 worked in the ateliers of William-Adolphe Bouguereau and Tony Robert-Fleury in Paris. However, like his close friend Robert Henri, Redfield found his greatest inspiration and training while working "en plein air" in the French countryside during his holidays away from the academic studios. After his return to the United States, Redfield became an important member of the second generation of American Impressionists. In 1898 he moved his home and studio to a farm north of Philadelphia and there founded the "New Hope" artists' colony which later attracted such painters as Walter Schofield and Daniel Garber.

PLATE P-55

Jefferson Market, 1922
Oil on canvas 32 x 26⅛ in.
The Pennsylvania Academy of the Fine Arts, Philadelphia
Henry D. Gilpin Fund (1944.10)

John Sloan (1871-1951) grew up in Philadelphia. Sloan's formal training was brief; by 1891 he was already working as a commercial illustrator and newspaper artist. He would continue to illustrate throughout his career, and later became an important contributor to the socialist magazine *The Masses* during the teens. Sloan's studies at the Pennsylvania Academy lasted less than a year (1892), but during that time he met his friend and mentor Robert Henri and resumed his friendship with boyhood acquaintance William Glackens. Sloan never traveled to Europe, but by 1900 he was receiving critical and public attention as a painter in oils. In 1904 he moved to New York and soon became well known for his unidealized views of the city's street life and slums. In 1908 Sloan joined Henri in forming "The Eight," a group of artists who sought to mount a protest exhibition against the conservative National Academy of Design. Sloan began his 25-year teaching career at the Art Students' League in 1914; notes from his lectures were later compiled and published. Sloan continued to paint, etch, and illustrate until his death in 1951.

ERNEST LAWSON (1873-1939)

Peggy's Cove, Nova Scotia, 1924(?)
Oil on canvas 25³⁄₁₆ x 30¹⁄₁₆ in.
The Pennsylvania Academy of the Fine Arts, Philadelphia
Joseph E. Temple Fund (1935.4)

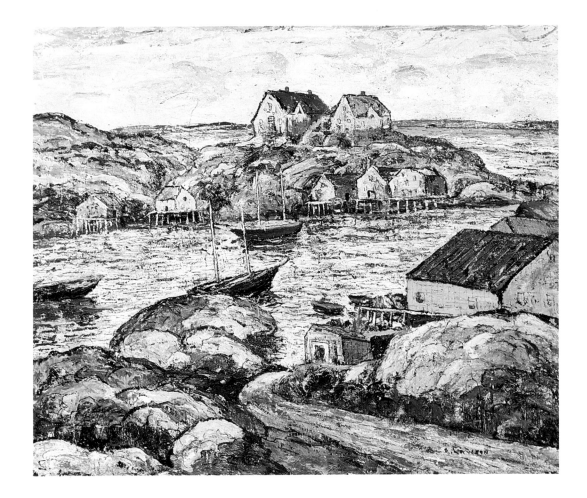

Ernest Lawson (1873-1939) was born in Nova Scotia. After working as a draftsman for an English engineering firm in Mexico, Lawson moved to New York in 1892. There he studied with John H. Twachtman and Julian Alden Weir at the Art Students' League and later at the summer school founded by Twachtman and Weir at Cos Cob, Connecticut. Thanks to his early association with Twachtman, Lawson was already well-versed in the Impressionist style when he left for study in France, first in 1893 and again the following year. He remained in Paris only two years, however, and by 1898 had settled in New York, where he began his celebrated series of views along the nearby Harlem River. Known for his thickly brushed canvases and surprisingly effective color combinations, Lawson often produced several versions of his landscape compositions, varying the color scheme or design only slightly in emulation of Claude Monet's series paintings. A regular exhibitor with such established organizations as the National Academy of Design and the Pennsylvania Academy of the Fine Arts throughout his career, Lawson was also associated with independent artists' groups, notably "The Eight," and sent work to the Armory Show in 1913.

The Pennsy Train Shed, n.d.
Oil on canvas 28 x 32 in.
The Pennsylvania Academy of the Fine Arts, Philadelphia
John Lambert Fund (1918.11)

Morris Hall Pancoast (1877-1963) was born in Salem, New Jersey. He was a pupil of Thomas Anshutz at the Pennsylvania Academy of the Fine Arts and of Jean-Paul Laurens at the Académie Julian in Paris. He held memberships at the Connecticut Academy of Fine Arts as well as at the Salmagundi Club in New York. Although Pancoast is known to have exhibited at Pennsylvania Academy Annuals, the National Academy of Design, and the Corcoran Gallery of Art, he did so infrequently; consequently little is known about him.

DANIEL GARBER (1880-1958)

Lowry's Hill, 1922
Oil on canvas 50 x 61 in.
The Pennsylvania Academy of the Fine Arts, Philadelphia
Gift of the Locust Club, Philadelphia (1955.1.1)

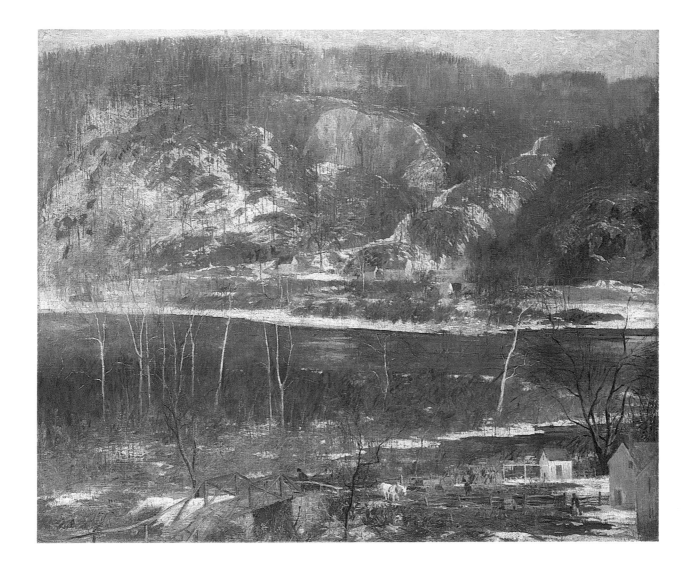

Daniel Garber (1880-1958), a native of Indiana, studied first at the Cincinnati Academy in 1897, and later at the Pennsylvania Academy of the Fine Arts with Thomas Anshutz. A Cresson Traveling Scholarship enabled Garber to spend two years touring Europe from 1905 to 1907. Upon his return to the United States, Garber's colorful renderings of the Delaware Valley landscape north of Philadelphia quickly won him recognition as one of the country's best young Impressionist painters and, with Edward Willis Redfield, he became a leading member of the group of landscape painters known as the "New Hope School." Garber returned to the Pennsylvania Academy as a faculty member in 1909. He taught there for more than 40 years.

North River, c. 1908
Oil on canvas 32⅞ x 43 in.
The Pennsylvania Academy of the Fine Arts, Philadelphia
Joseph E. Temple Fund (1909.2)

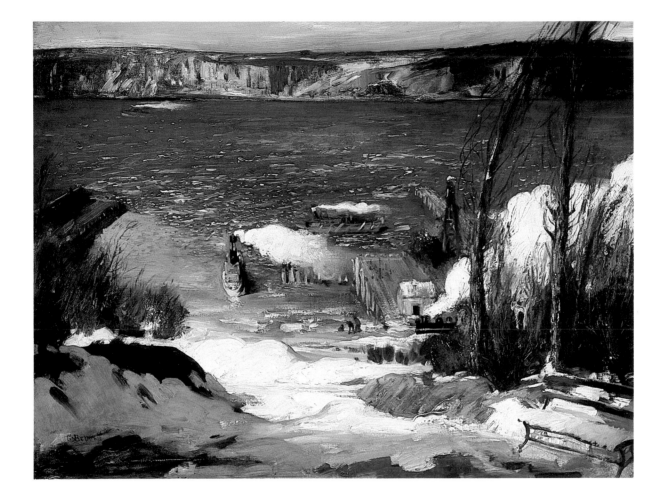

George Bellows (1882-1925) was a native of Columbus, Ohio. He attended Ohio State University, where he excelled in art and athletics. In 1904 he left college to study art under Robert Henri at the New York School of Art. Like other associates of Henri such as William Glackens, George Luks, Everett Shinn, and John Sloan, Bellows was interested in a realistic portrayal of American society and urban life. Characteristic of his style is a vigorous physicality conveyed not only by subject matter but also by color and brush stroke. Bellows had the distinction of being the youngest artist to be awarded associate membership in the National Academy of Design. He was very active on the New York art scene, founding the Society of Independent Artists and assisting in the staging of the Armory Show of 1913. In an age of expatriate artists, Bellows never went abroad, and the very Americanness of his paintings and lithographs contributed to his popularity among his native public and critics. He continued his successful career in New York until his premature death of appendicitis in 1925.

ARTHUR BEECHER CARLES, JR. (1882-1952)

PLATE P-60

An Actress as Cleopatra, 1914
Oil on canvas 30³⁄₁₆ x 25⅛ in.
The Pennsylvania Academy of the Fine Arts, Philadelphia
John Lambert Fund (1915.3)

Arthur Beecher Carles, Jr. (1882-1952) was born in Philadelphia and studied with Thomas Anshutz and William Merritt Chase at the Pennsylvania Academy of the Fine Arts. Carles visited Europe twice, in 1905 and in 1907, eventually residing in Paris for three years. Best known for combining abstract design with a Fauve-influenced palette in his still lifes and landscapes, in 1912 Carles hosted his first one-person show at Steiglitz's gallery "291," and the following year participated in the Armory Show. From 1917 to 1925 Carles devoted himself to gaining a wider audience for modern art in the United States by arranging for exhibits of his own and others' works while teaching at the Pennsylvania Academy. Assisted financially by friends, he was able to live in France from 1929 to 1931. After Carles's return to Philadelphia, the collector Carroll Tyson provided him with a studio where he produced some of his best work. Although little recognized outside of his native Philadelphia, Carles was influential in his advisory role to collectors such as Tyson, who, under Carles's direction, acquired works by many modern masters, notably Paul Cézanne.

PLATE P-61

White Callas, 1925-27
Oil on canvas 50¾ x 37¾ in.
The Pennsylvania Academy of the Fine Arts, Philadelphia
Gift of Harry G. Sundheim, Jr. (1958.25.1)

An Extraordinary Vision:
Terra Museum of American Art

The Terra Museum of American Art has in less than a decade of operations achieved international recognition for its collection, exhibitions, and educational activities. The story of its phenomenal growth and subsequent popular success begins with a dream of its founders, Adeline and Daniel J. Terra, who felt the overwhelming desire to share their collection and enthusiasm for American art with the public.

Adeline Terra, an art historian and artist, initially encouraged her husband, a self-made industrialist and entrepreneur, to look at the art of 19th-century American painters. Together the Terras decided to concentrate on American art; they acquired works by American Impressionists such as Frederick Carl Freiseke, John Singer Sargent, Ernest Lawson, Theodore Robinson, John H. Twachtman, and Maurice Prendergast. As their interest intensified and broadened, 19th-century genre paintings and portraits by William Sidney Mount, George Caleb Bingham, Frederic Edwin Church, Winslow Homer, and James Abbott McNeill Whistler found their way into the collection.

In the mid-1970s the Terras began seriously to look for a public repository for their holdings. Although a number of existing institutions were explored, it became quickly apparent to Daniel Terra that there was no museum devoted solely to American art within a 400-mile range of Chicago. He determined to remedy this lack. Late in 1978 a site was located in Evanston just north of Chicago. After extensive renovation the Terra Museum of American Art opened its doors in the spring of 1980 with a major exhibition of American Impressionism. A week later over 600 people attended a symposium on the subject; the course was set. What followed in the first years were a series of important, often thematic, exhibitions organized by the Museum on American subject matter, as well as major new acquisitions to the Daniel J. Terra Collection.

Appointed by President Ronald Reagan in 1981 as Ambassador at Large for Cultural Affairs, Daniel Terra became the official spokesman for American art. Everywhere he has gone in this role, he has seen a growing desire on the part of the American public to learn more about its cultural heritage. This interest fed Ambassador Terra's own commitment.

The year 1982 witnessed the acquisition by the Museum of its first property on Chicago's Magnificent Mile: North Michigan Avenue. It was apparent to Daniel Terra that this additional distinguished and central location would provide the

public great exposure to a museum of American art. That same year the Terras' acquisition of Samuel F. B. Morse's *Gallery of the Louvre* made headlines around the world. Since then this icon of American art has in its own way served as an "ambassador," traveling to major museums in the United States and in France as an exhibition that draws record crowds.

Following the death of Mrs. Terra, Ambassador Terra and the Museum board continued to plan for its future. In 1985 and 1986 major steps were taken to acquire additional property on North Michigan Avenue that would allow for future expansion. The Terra Museum now owns the equivalent of greater than a city block of frontage on both the north and southwest side of Michigan Avenue and Erie Street which is central to the boulevard. In the spring of 1986 construction began on a portion of the property. In April 1987 the Museum will begin operations with over 60,000 square feet of newly designed galleries, a bookstore, education facilities, and administrative offices.

Plans are underway to involve the public in the subsequent growth in stages of the Museum's remaining property. Uniquely situated to reach large numbers of people, the Terra Museum of American Art affords the opportunity for a broad base of community and national involvement, while maintaining sound fiscal operations and creative financial planning. When the architecture is completed, the Museum will manifest a functional vertical design in harmony with its urban surroundings, and will retain base-level retail space, thus producing taxable income to assist future operations.

In the meantime, The Daniel J. Terra Collection has continued to grow and at present numbers over 800 works. Early 20th-century works by such artists as Stuart Davis, Arthur G. Dove, Lyonel Feininger, Edward Hopper, and Joseph Stella have significantly increased the holdings. Thus, with its new location on one of the country's most famous avenues, and its ever richer holdings, the Terra Museum of American Art, a tribute to the vision of its founders and namesakes, has a unique opportunity to offer the American public a view of its heritage and an inspiration for its future.

Michael Sanden
Director, Terra Museum of American Art

PIETER VANDERLYN (c. 1687-1778)

PLATE T-1

Portrait of Mrs. Myndert Myndertse (Jannetje-Persen) and Her Daughter Sara, n.d.
Oil on canvas 39½ x 32¼ in.
Daniel J. Terra Collection
Terra Museum of American Art, Chicago (33.1984)

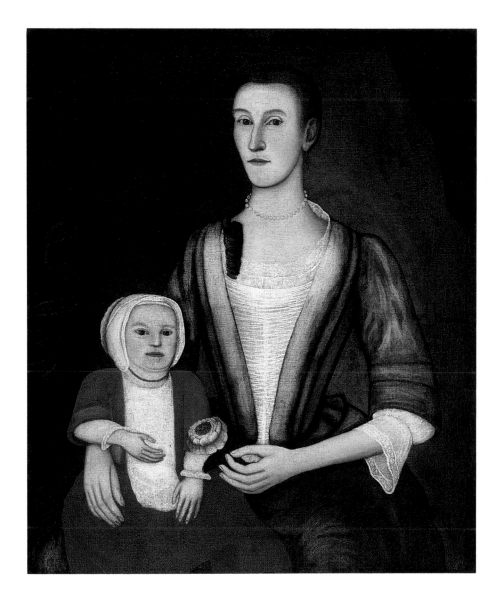

Pieter Vanderlyn (1687-1778) was a Dutch-born artist who immigrated to New York in 1718. After 1722 Vanderlyn settled in the area of Kingston and Albany, New York, where he earned his living by painting portraits that show the influence of his Dutch heritage. Although all his works are unsigned, art historians have been able to attribute to him a series of well-known portraits of the Gansevoort family of Albany, earning Vanderlyn the name of the "Gansevoort Limner."

JOHN SINGLETON COPLEY (1738-1815)

PLATE T-2

Portrait of a Lady in a Blue Dress, 1763
Oil on canvas 50¼ x 39¾ in.
Daniel J. Terra Collection
Terra Museum of American Art, Chicago (6.1981)

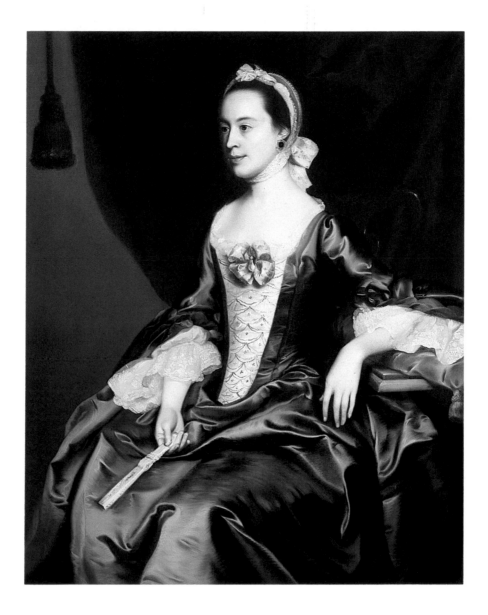

John Singleton Copley (1738-1815) studied painting with his step-father, the Boston painter and engraver Peter Pelham. A professional artist by the age of 19, Copley achieved some notoriety in London when *Boy with a Squirrel*, a portrait of his step-brother, Henry Pelham, was accepted for exhibition at the Society of Artists in 1765. The celebrated English portraitist and president of the Royal Academy Sir Joshua Reynolds declared Copley's painting to be the best work in the show. Copley became the leading portraitist of fashionable New England during the years preceding the American Revolution. Although indifferent to politics, Copley left America for permanent residence in England in 1775. A tour of the continent at this time enabled him to fulfill his dream of studying the Old Masters. After his move to London, Copley began to produce large historical paintings as well as portraits. He became a friend of Benjamin West's and was elected to the Royal Academy.

WILLIAM GROOMBRIDGE (1748-1811)

View of a Manor House on the Harlem River, 1793
Oil on canvas 39¾ x 49 in.
Daniel J. Terra Collection
Terra Museum of American Art, Chicago (32.1984)

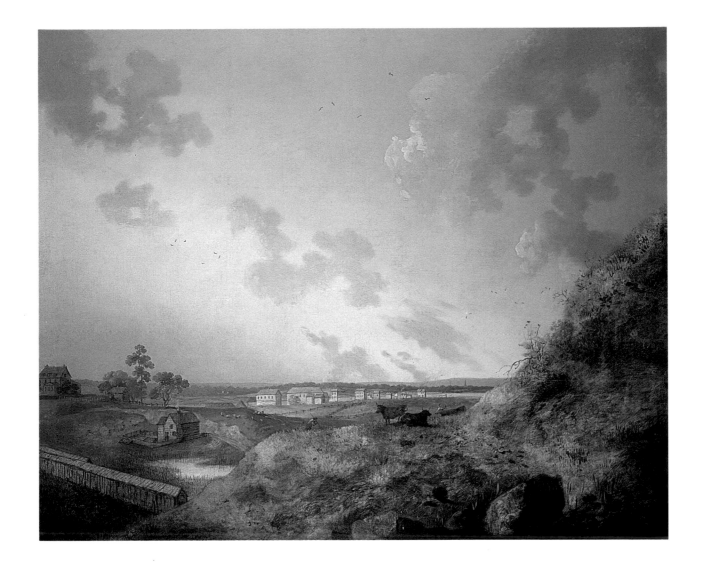

William Groombridge (1748-1811) was born in Tunbridge, Kent, England. He may have received his training at the Royal Academy in London, for he exhibited there from 1773 to 1790. Little is known about his life other than that he immigrated to the United States in the 1790s and painted in New York and Philadelphia while making his permanent residence in Baltimore. Although once categorized as a miniature painter, Groombridge concentrated primarily on landscapes, usually executed in high color. He is believed to have been one of America's first professional landscape painters.

George Washington, Porthole Portrait, n.d.
Oil on canvas 36³⁄₁₆ x 29³⁄₁₆ in.
Daniel J. Terra Collection
Terra Museum of American Art, Chicago (4.1985)

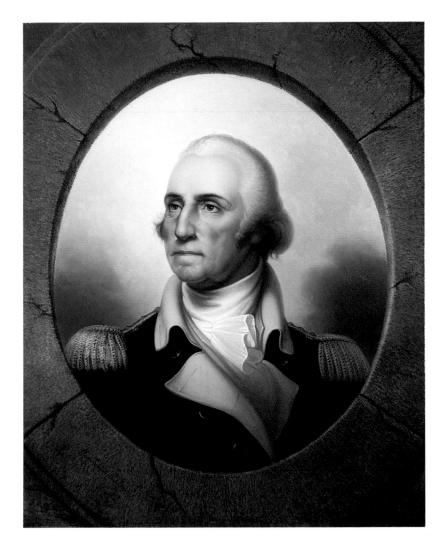

Rembrandt Peale (1778-1860) came from a family of artists; his father, Charles Willson Peale, was a well-known portrait painter, as were Rembrandt's brothers, Raphaelle, Titian Ramsey, and Rubens, and his sister, Margaretta Angelica. Peale's ambition to be a portrait painter was encouraged by his father, and at age 17 he was given the enviable opportunity to paint George Washington. In 1802 Peale went to London and studied under Benjamin West at the Royal Academy. He traveled to France in 1808 and again in 1809-10, where he painted the portraits of distinguished Frenchmen (including the painter Jacques-Louis David) for his father's museum. Disappointed by the poor reception given the monumental history paintings he endeavored to exhibit for profit during the 1820s, Peale found his most lucrative activity in producing replicas of the Washington portrait he had painted as a youth. Rembrandt Peale, like his father, was an entrepreneur as well as an artist and played many roles in the young American artistic community during his career. He was a founder of the Pennsylvania Academy of the Fine Arts in 1805, and later served on the board of directors of that institution. A prodigious writer on art as well, Peale wrote a textbook on drawing, called *Graphics*, which became a standard textbook in American schools after its publication in 1835.

JOHN JAMES AUDUBON (1785-1851)

PLATE T-5

American White Pelican, n.d.
Hand-colored aquatint 38⅛ x 25 in. (sheet)
Engraved by Robert Havell, Jr. (1793-1878)
From *The Birds of America* (Double Elephant Folio)
Published in London, 1827-38
Daniel J. Terra Collection
Terra Museum of American Art, Chicago (1984.3.311)

John James Audubon (1785-1851) was born in Haiti but grew up in Coueron, France, where his interest in wildlife was encouraged by the naturalist Charles-Marie d'Orbigny. At the age of 18, Audubon came to the United States. In 1807 he moved to Kentucky, where he met Alexander Wilson, whose work and accomplishments in publishing a book on American ornithology inspired Audubon to do the same. Audubon supported his family by portrait painting and taxidermy before moving in 1820 to St. Louis, where he turned his attention exclusively to the study and depiction of birds; by 1824 he was showing his drawings to publishers in New York and Philadelphia. In 1826 Audubon departed for England, where he

PLATE T-6

Common American Swan, n.d.
Hand-colored aquatint 38⅛ x 25 in. (sheet)
Engraved by Robert Havell, Jr. (1793-1878)
From *The Birds of America* (Double Elephant Folio)
Published in London, 1827-38
Daniel J. Terra Collection
Terra Museum of American Art, Chicago (1984.3.411)

and his drawings became famous overnight after an exhibition at the Royal Institute: his 435-plate book *The Birds of America* went into publication. Audubon spent the next ten years traveling to France and England and also making extended trips in Canada and the United States, promoting his work while collecting and drawing more specimens. The republication of *The Birds of America* in New York and an expedition down the Missouri River occupied Audubon during the 1840s. Failing health prevented Audubon from finishing his last major work, *The Viviparous Quadrupeds*; he died in New York in 1851.

Great Horned Owl, n.d.
Hand-colored aquatint 38⅛ x 25 in. (sheet)
Engraved by Robert Havell, Jr. (1793-1878)
From *The Birds of America* (Double Elephant Folio)
Published in London, 1827-38
Daniel J. Terra Collection
Terra Museum of American Art, Chicago (1984.3.61)

Wild Turkey, n.d.
Hand-colored aquatint 38¼ x 25 in. (sheet)
Engraved by William H. Lizars (1788-1859)
Retouched by Robert Havell, Jr. (1793-1878)
From *The Birds of America* (Double Elephant Folio)
Published in London, 1827-38
Daniel J. Terra Collection
Terra Museum of American Art, Chicago (1984.3.1)

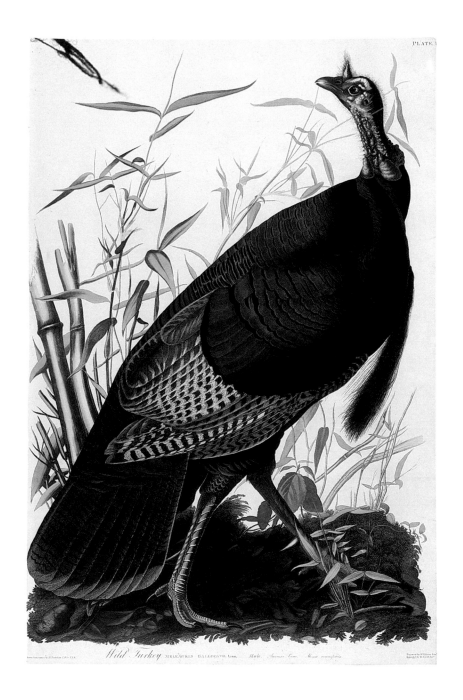

Blind Man's Buff, 1814
Oil on canvas 16⅝ x 22⅛ in.
Daniel J. Terra Collection
Terra Museum of American Art, Chicago (31.1983)

John Lewis Krimmel (1789-1821) moved in 1810 from Germany to Philadelphia to join his brother's accounting firm; he soon tired of the business world and taught himself painting by studying the engravings of European masters. Krimmel began by painting portraits for a steady income, but the success of a genre painting at an exhibition of the Society of Artists allowed him subsequently to make his reputation thereafter by his portrayal of narrative and domestic scenes. Krimmel was the first important American genre painter and is referred to as "the American Hogarth." He exhibited regularly and started his own engraving business. His budding career was cut short when he drowned at the age of 34.

AMMI PHILLIPS (1788-1865)

Mary Elizabeth Smith, 1827
Oil on canvas 25½ x 20¾ in.
Daniel J. Terra Collection
Terra Museum of American Art, Chicago (6.1985)

Ammi Phillips (1788-1865) grew up in Colebrook, Connecticut, and remained in the New England area all his life as an itinerant painter. During his active career, Phillips went through a number of stylistic changes, possibly reflecting his exposure to and familiarity with other naive painters such as Ezra Ames, J. Brown, and Reuben Moulthrop. Another influence apparent in Phillips's increasingly sculptural likenesses after 1840 was photography. Some 500 portraits from Phillips's hand are known.

AMMI PHILLIPS (1788-1865)

Portrait of a Girl in a Red Dress, n.d.
Oil on canvas 32½ x 27½ in.
Daniel J. Terra Collection
Terra Museum of American Art, Chicago (18.1985)

SAMUEL F. B. MORSE (1791-1872)

PLATE T-12

Gallery of the Louvre, 1831-33
Oil on canvas 73¾ x 108 in.
Daniel J. Terra Collection
Terra Museum of American Art, Chicago (9.1982)

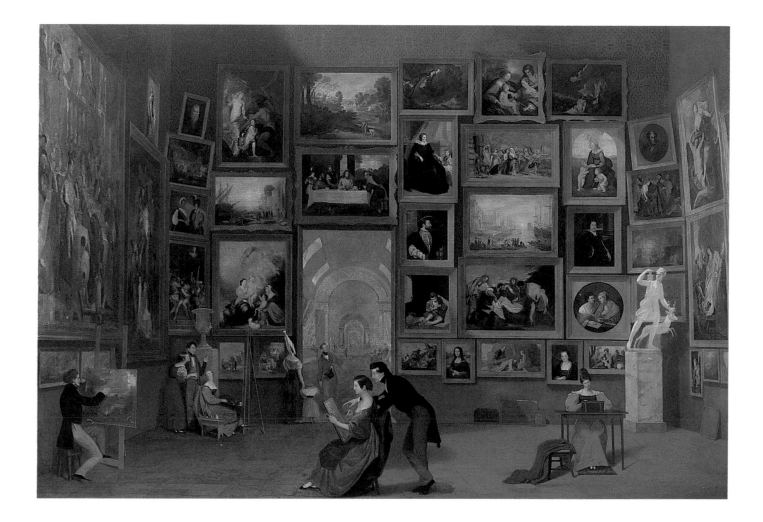

Samuel F. B. Morse (1791-1872) was born in Charleston, Massachusetts. After graduating from Yale University in 1810, Morse became a student of the Boston artist Washington Allston. In 1811 Morse accompanied Allston to London; he was admitted into the Royal Academy and studied for a time with Benjamin West. Morse returned to Boston in 1815 and devoted himself to portrait commissions, working in a style similar to those of Thomas Sully and Gilbert Stuart. After moving to New York in 1824, Morse became a founding member of the National Academy of Design, and its first president. From 1829 to 1832 he traveled abroad, visiting London, France, Italy, and Switzerland, where he studied the works of the European masters and painted his famous *Gallery of the Louvre*. After 1835 Morse became increasingly involved with politics and telegraphy and he is now best known for his scientific contributions: the introduction of photography to America in 1834, and the invention of the telegraph and Morse code in 1838.

FITZ HUGH LANE (1804-1865)

Brace's Rock, Brace's Cove, 1864
Oil on canvas 10¼ x 15¼ in.
Daniel J. Terra Collection
Terra Museum of American Art, Chicago (3.1983)

Fitz Hugh Lane (1804-1865) was born in the fishing village of Gloucester, Massachusetts. He received his only training from his employer, William S. Pendleton, who ran a lithography firm in Boston. He later began his own business in lithography with the painter John W. A. Scott. Lane did not start painting himself until his business folded in 1847. His early mentor was marine painter Robert Salmon and most of Lane's works depict ships and coastal scenes. By the 1840s his paintings and lithographs reached a high level of technical expertise. Lane's sensitivity to color and the effects of light made him much respected during his time and a leading Luminist. He was also important for his influence on other artists, specifically Frederic Edwin Church.

WILLIAM MATTHEW PRIOR (1806-1873)

Double Portrait of Mary Cary and Susan Elizabeth Johnson, 1848
Oil on board mounted on panel 16½ x 23½ in.
Daniel J. Terra Collection
Terra Museum of American Art, Chicago (5.1984)

William Matthew Prior (1806-1873) was born in Bath, Maine. Wholly self-taught, Prior earned his living as an itinerant portrait painter in New England, producing likenesses in a variety of styles according to the price his clients were willing to pay. He was also well-known for his copies on glass of Gilbert Stuart's famous "Vaughan" portrait of George Washington. Prior was related to the Hamblin family of painters, which included Joseph, Nathaniel, and Sturtevant Hamblin, with whom he worked in Boston.

WILLIAM MATTHEW PRIOR (1806-1873)
and STURTEVANT HAMBLIN (active 1837-1856)

Portrait of Young Boy Holding a Bow and Arrow with a Drum on the Floor, n.d.
Oil on canvas 41 x 34⅝ in.
Daniel J. Terra Collection
Terra Museum of American Art, Chicago (11.1984)

WILLIAM SIDNEY MOUNT (1807-1868)

PLATE T-16

The Trap Sprung (The Dead Fall), 1844
Oil on panel 12⅛ x 17 in.
Daniel J. Terra Collection
Terra Museum of American Art, Chicago (30.1983)

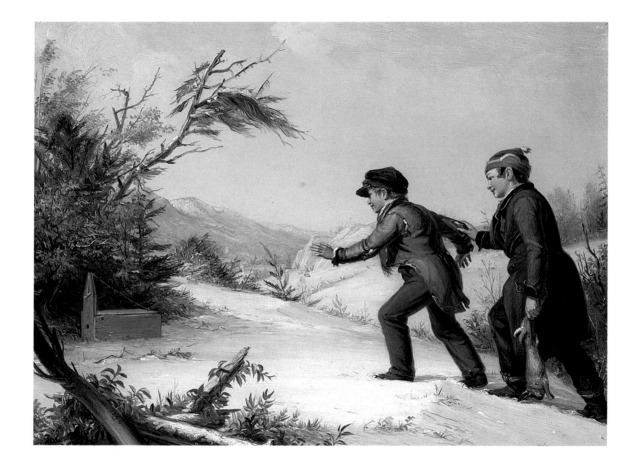

William Sidney Mount (1807-1868) grew up on a farm in Stony Brook, Long Island, and remained in the community of his boyhood throughout his life. Mount started his career by painting the history and portrait paintings typical of the 19th century. Inspired by a work of John Lewis Krimmel, Mount exhibited a genre scene at the National Academy of Design in 1830 which won him acclaim; from thereon his style rapidly matured and he concentrated on painting the lifestyles and people he knew best. Mount's later works are especially original, expressing his natural creativity – Mount was also an inventor – and love for music and the country.

WILLIAM SIDNEY MOUNT (1807-1868)

Fruit Piece: Apples on Tin Cups, 1864
Oil on board 6½ x 9 in.
Daniel J. Terra Collection
Terra Museum of American Art, Chicago (35.1984)

PLATE T-18

The Jolly Flatboatmen, 1848
Oil on canvas 26 x 36¼ in.
Daniel J. Terra Collection
Terra Museum of American Art, Chicago (1.1980)

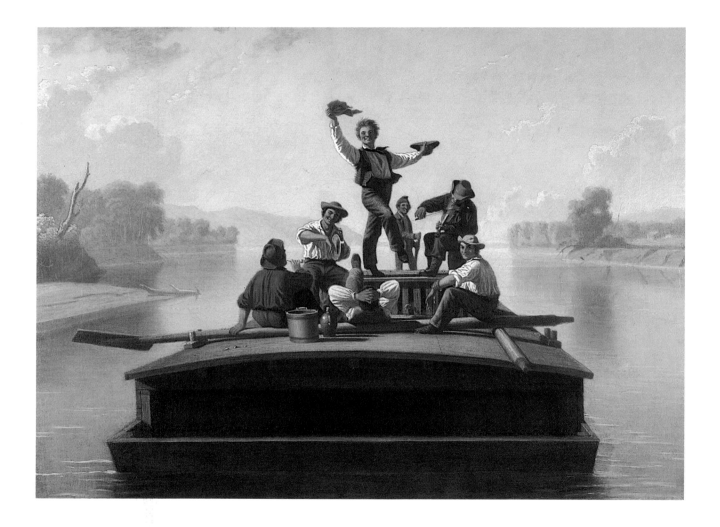

George Caleb Bingham (1811-1879) was born on a plantation in Virginia, but moved to Missouri as a child. He studied and worked with the famous frontier portraitist Chester Harding and in 1837 spent a year at the Pennsylvania Academy of the Fine Arts. Initially a portrait painter, Bingham became dissatisfied with the progress of his career in the urban East and he returned to Missouri in 1845. Painting the scenes and way of life that he knew best established Bingham's fame. The painting *The Jolly Flatboatmen,* of which there are three versions, became a national favorite in 1846 when it was reproduced as an etching and distributed widely by the American Art-Union. Bingham, also an active politician, was elected to the Missouri legislature in 1848 and subsequently held many offices, which limited his productivity as an artist. After working in Düsseldorf during the years 1856-59, Bingham changed his style, which became more European. His earlier works of frontier life remain his signature style – a happy integration of aesthetic formalism with social historical realism.

PLATE T-19

Rail Shooting, 1856-59
Oil on canvas 13¾ x 19¾ in.
Daniel J. Terra Collection
Terra Museum of American Art, Chicago (8.1982)

William Ranney (1813-1857) was born in Middletown, Connecticut. In his early 20s, Ranney fought for Texas in its war for independence from Mexico and this experience had a strong influence on his art. Ranney was fascinated with frontier life and the tales and adventures of the trappers and mountain men. However, only during the last decade of his life, beginning in 1843, did he begin painting the genre scenes that earned him fame.

JOSEPH WHITING STOCK (1815-1855)

Captain J.L. Gardener's Son at Age 2½, 1842
Oil on canvas 45 x 36 in.
Daniel J. Terra Collection
Terra Museum of American Art, Chicago (10.1984)

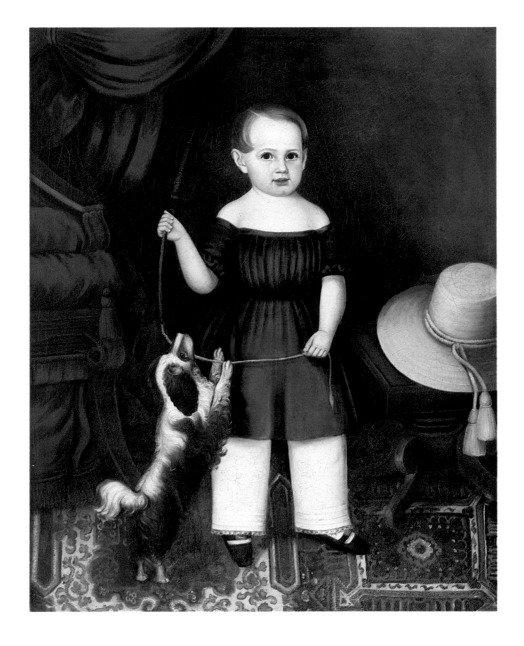

Joseph Whiting Stock (1815-1855) resided in Springfield, Massachusetts. Stock, who was confined to a wheelchair, took up painting in 1832 on the advice of his doctor. Entirely self-taught, Stock managed to earn a comfortable living painting portraits. He was a remarkably prolific artist, as his diary records the production and sale of over 900 works. The majority of Stock's portraits are of children, and in his paintings he often repeated compositions, props, and backgrounds.

JOHN FREDERICK KENSETT (1816-1872)

PLATE T-21

Almy Pond, Newport, c. 1850
Oil on canvas 12⅝ x 22⅛ in.
Daniel J. Terra Collection
Terra Museum of American Art, Chicago (24.1984)

John Frederick Kensett (1816-1872) was born in Cheshire, Connecticut, and received training from his father in the art of engraving. At the age of 24, Kensett traveled to Europe, where he remained until 1847, moving between London and Paris before visiting Italy in 1845. Within a year of his return to New York, Kensett had been elected an associate of the National Academy of Design and he became an acknowledged leader of the second-generation Hudson River School. He journeyed frequently throughout the United States to find appropriate scenes for his landscapes. His controlled use of color and his concern for changing light and atmospheric qualities made Kensett a leading Luminist painter, along with such contemporaries as Sanford Robinson Gifford, Martin Johnson Heade, and Worthington Whittredge.

JONATHAN ADAMS BARTLETT (1817-1902)

PLATE T-22

Portrait of Harriet, n.d.
Oil on canvas 28 x 24 in.
Daniel J. Terra Collection
Terra Museum of American Art, Chicago (12.1985)

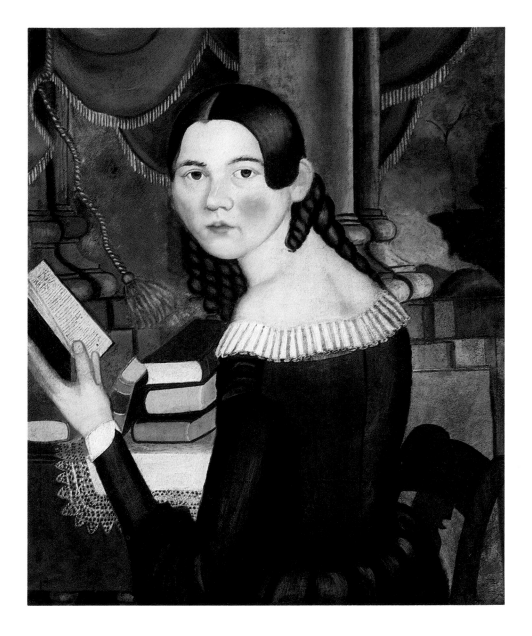

Jonathan Adams Bartlett (1817-1902), a talented naive artist, spent his lifetime in Rumford, Maine. Bartlett came to be called the "Versatile Yankee" for his adeptness in many occupations: farming, soldiering, cabinetmaking, inventing, music, acting, photography, portrait painting, lecturing, and the teaching of drawing and penmanship. His liberal involvement with life is evident in his portraits, which display vitality and directness, giving them a sense of reality unusual in naive paintings.

JAMES EDWARD BUTTERSWORTH (1817-1894)

The Yacht "Magic" Defending America's Cup, 1870
Oil on canvas 29¾ x 49¾ in.
James D. Terra Collection
Terra Museum of American Art, Chicago (5.1981)

James Edward Buttersworth (1817-1894) was trained by his father in the manner of English marine painting. The family immigrated to the United States in 1845 and Buttersworth later opened a studio in West Hoboken, New Jersey. Buttersworth dealt almost exclusively with maritime scenes. In particular, he recorded yacht races, such as the *America* race of 1851 and the America's Cup race during the years 1870-79.

MARTIN JOHNSON HEADE (1819-1904)

Newburyport Marshes: Approaching Storm, 1865-70
Oil on canvas 15 x 30 in.
Daniel J. Terra Collection
Terra Museum of American Art, Chicago (1.1984)

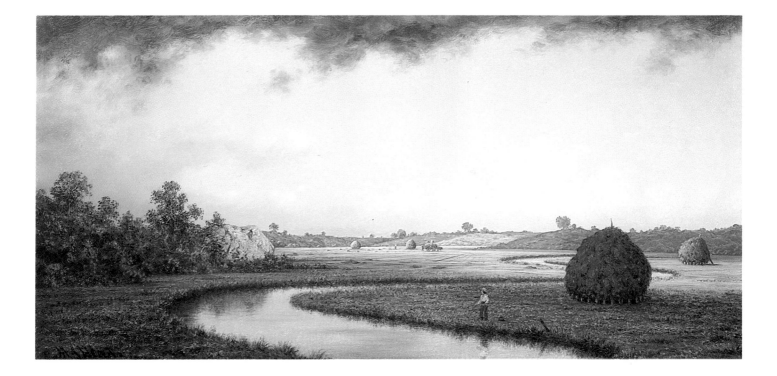

Martin Johnson Heade (1819-1904), born in Lumberville, Pennsylvania, studied with Quaker artist Edward Hicks and supported himself primarily through portrait painting while traveling extensively through Europe and the United States during the 1840s and 1850s. In 1859 he acquired a studio in the Tenth Street Studio Building in New York neighboring those of landscape painters Frederic Edwin Church, John F. Kensett, and Fitz Hugh Lane. With Church's encouragement, Heade turned to landscape painting and began to produce the views of the New England seacoast and salt marshes for which he is now best known. Heade's 1863 excursion to Brazil and succeeding trips to South America inspired his unusual still lifes of tropical flowers and hummingbirds. An intensely private man, Heade received little critical or public recognition during his lifetime and, although he exhibited work regularly in New York and elsewhere, he did not often socialize with his fellow artists. After his move to Florida in 1884, the friendship and support of land developer Henry M. Flagler enabled Heade to devote his later years to the production of some of his finest work, notably his exquisite studies of magnolia blossoms and other flora indigenous to Florida.

MARTIN JOHNSON HEADE (1819-1904)

Orchids and Hummingbirds in a Brazilian Jungle, c. 1871-72
Oil on canvas 17 x 21 in.
James D. Terra Collection
Terra Museum of American Art, Chicago (3.1984)

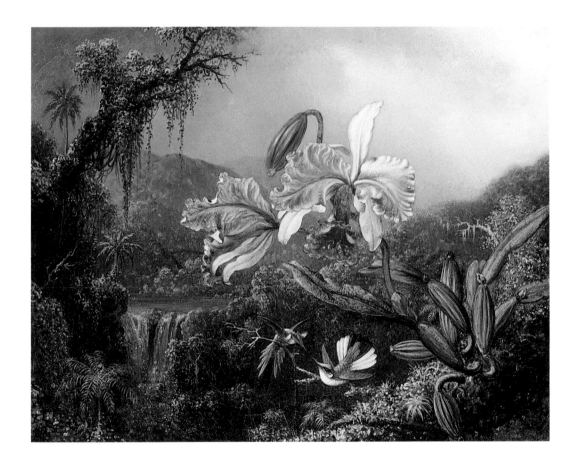

SANFORD ROBINSON GIFFORD (1823-1880)

Hunter Mountain, Twilight, 1866
Oil on canvas 30½ x 54 in.
Daniel J. Terra Collection
Terra Museum of American Art, Chicago (5.1983)

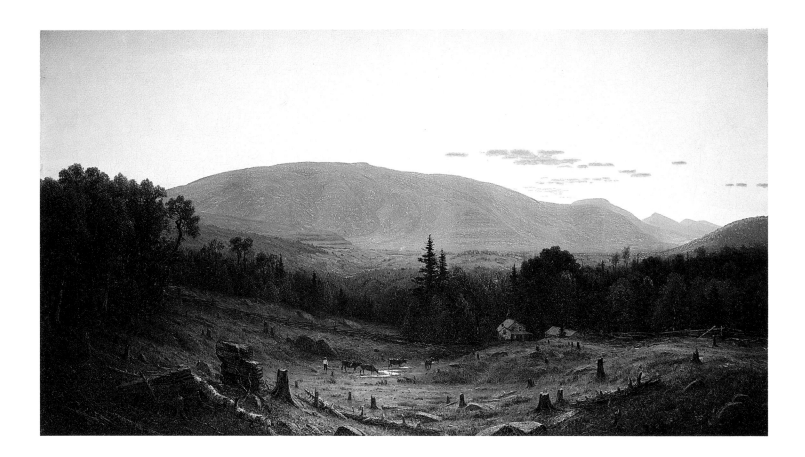

Sanford Robinson Gifford (1823-1880) began his career as a landscape painter of the Hudson River School. He was a student at the National Academy of Design where he became a devotee of Thomas Cole. During the 1840s Gifford concentrated on landscapes of the Catskill and Berkshire mountains which attracted the attention of the American Art-Union in 1847. In 1855 Gifford went to Europe, traveling for a time with Albert Bierstadt. Contact with the art of John Constable and J.M.W. Turner, as well as the Barbizon School, altered Gifford's approach to the treatment of light in his work. Upon his return to the United States in 1857, Gifford established a studio in New York; his beautifully rendered scenes of his homeland ensured Gifford's reputation as a popular and important American painter.

GEORGE INNESS (1825-1894)

Summer, Montclair, 1877
Oil on canvas 42½ x 33½ in.
Daniel J. Terra Collection
Terra Museum of American Art, Chicago (44.1980)

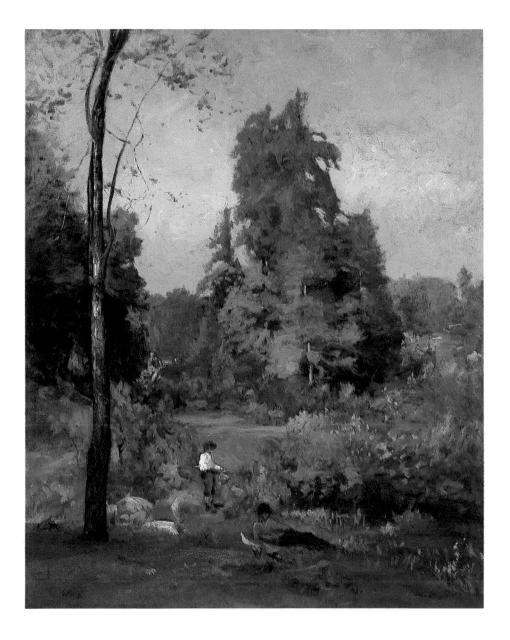

George Inness (1825-1894) spent his childhood in Newark, New Jersey. He studied art with various teachers, but accomplished most of his training himself by copying the works of famous landscape artists whom he admired, particularly Thomas Cole and Asher B. Durand. During the early 1850s Inness made two trips to Europe, where his studies of the works of the Barbizon School painters, notably Camille Corot, Jean-François Daubigny, and Théodore Rousseau, inspired his gradual move from a Hudson River School painting style to a manner more technically assured and European in nature. Inspired by the writings of Swedish philosopher Emanuel Swedenborg, and deeply affected by the Civil War, Inness brought a greater expressiveness to his work of the 1860s. A trip to Italy during a tour of Europe in the early 1870s elicited some of his most original and imaginative work. By the late 1870s Inness was a celebrated and respected leader in the American landscape school. His later work is characterized by heightened colorism and decorative simplification reminiscent of the work of J. M.W. Turner.

FREDERIC EDWIN CHURCH (1826-1900)

PLATE T-28

Our Banner in the Sky, 1861
Oil on paper mounted on cardboard 7¼ x 11 in. (sight)
Daniel J. Terra Collection
Terra Museum of American Art, Chicago (1.1983)

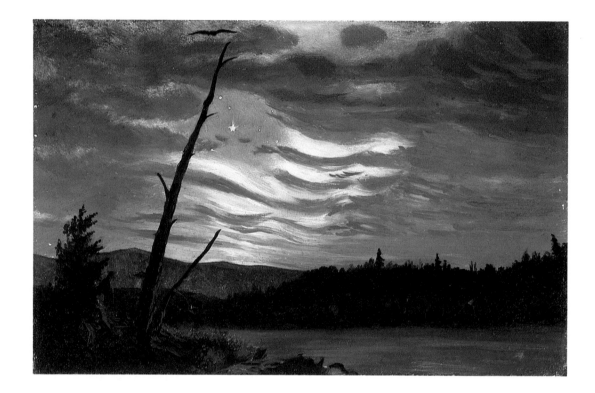

Frederic Edwin Church (1826-1900) grew up in Hartford, Connecticut, where from 1844 to 1848 he studied with Thomas Cole, the father of American landscape. By 1850 Church was an established artist in New York and acknowledged as Cole's successor. A devoted student of the wilderness and natural wonders, Church roamed the United States, Europe, and South America for dramatic and heroic landscape subjects. His monumental view *Niagara*, exhibited in 1857, established Church as this country's foremost American landscape painter. Two years later Church's *Heart of the Andes* was sold for the highest price ever obtained for a work of art by a living American. Church's passionate and theatrical paintings expressing the power and sublimity of Nature, particularly those referring to the Civil War, had a lasting effect on the American public; he is much respected for his contribution to the landscape tradition.

ROBERT SPEAR DUNNING (1829-1905)

Harvest of Cherries, 1866
Oil on canvas 19½ x 26 in.
Daniel J. Terra Collection
Terra Museum of American Art, Chicago (42.1984)

Robert Spear Dunning (1829-1905) was born in Westport, Maine. The family later moved to Fall River, Massachusetts, where Dunning worked in a textile mill before spending three years as a sailor. In 1844 he studied painting with James Roberts and from 1849 to 1852 worked with the noted history painter Daniel Huntington in New York. After his return to Fall River in 1852, Dunning became a leading personality in that community's artistic life; subsequently he organized a drawing school. At his death in 1905, Dunning was the acknowledged leader of the Fall River still-life movement.

ROBERT SPEAR DUNNING (1829-1905)

PLATE T-30

Still Life with Fruit, 1868
Oil on canvas 25 x 30¼ in.
Daniel J. Terra Collection
Terra Museum of American Art, Chicago (27.1984)

The Cider Mill, 1880
Oil on canvas 30 x 24 in.
Daniel J. Terra Collection
Terra Museum of American Art, Chicago (41.1984)

John George Brown (1831-1913) was born in Durham, England. While employed as a glass-cutter, Brown studied evenings at a government art school in Newcastle-upon-Tyne under William Bell Scott, and later at the drawing academy in Edinburgh. In 1853 he moved to New York, where his designs for the Brooklyn Flint Glass Company attracted attention that encouraged him to take lessons from the miniature painter Thomas Seir Cummings. Two years later Brown rented a studio in the Tenth Street Studio Buliding and in 1858 began exhibiting at the National Academy of Design. In subsequent years Brown became the most famous American genre painter of the late 19th century. He idolized Winslow Homer, naming a son after him, and semblances of Homer's art in both subject and formal considerations can be found in the best of Brown's works. After the 1870s Brown specialized in paintings of street urchins, which earned him the name of "bootblack Raphael."

SAMUEL COLMAN, JR. (1832-1920)

Ships Unloading, New York, 1868
Oil on canvas mounted on board 42 x 30⅛ in.
Daniel J. Terra Collection
Terra Museum of American Art, Chicago (4.1984)

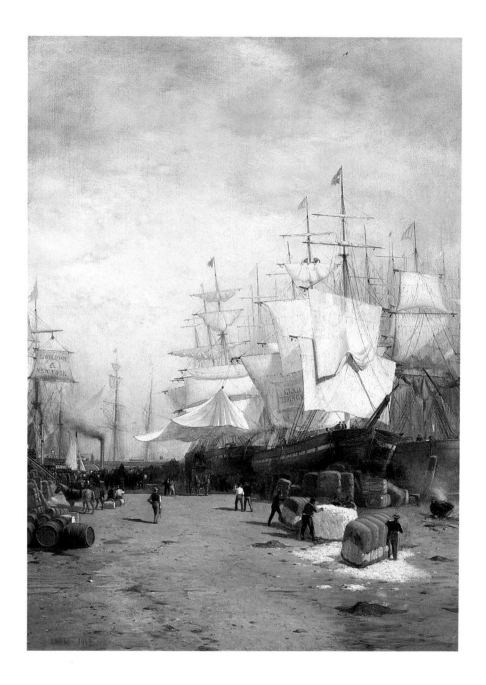

Samuel Colman, Jr. (1832-1920) came originally from Portland, Maine, but his family moved to New York when he was still a child. He showed unusual talent as an adolescent and became a student of Asher B. Durand. By the age of 18, he had already exhibited at the National Academy of Design. He spent a total of six years painting and studying in Europe prior to taking residence in Rhode Island. Prior to his time abroad, Colman's work is identified with the landscape painting of the Hudson River School; however, in the years following 1870, his style became much freer and his paint application thicker. Also known as an innovative interior decorator and furniture designer, Colman frequently collaborated with Louis Comfort Tiffany.

JAMES ABBOTT MC NEILL WHISTLER (1834-1903)

The Zattere: Harmony in Blue and Brown, 1879-80
Pastel on brown paper 11⅛ x 7¾ in. (sight)
Daniel J. Terra Collection
Terra Museum of American Art, Chicago (21.1985)

James Abbott McNeill Whistler (1834-1903) was born in Lowell, Massachusetts, but spent much of his childhood in Russia where his father was supervising construction of the Trans-Siberian Railroad. After dropping out of West Point, Whistler left to pursue his art studies in Paris in 1855; he never returned to the United States. Whistler thrived in the bohemian community of Paris and befriended such avant-garde French contemporaries as Henri Fantin-Latour, Alphonse Legros, and Edouard Manet. After 1859 Whistler made his home in London, and his work began to show the influence of the English Pre-Raphaelites. His fame was assured when, in 1863, his *Symphony in White Number 1; The White Girl*

JAMES ABBOTT MC NEILL WHISTLER (1834-1903)

Beach Scene with Rocks, c. 1880s
Watercolor with Chinese white on paper 7 x 10 in.
Daniel J. Terra Collection
Terra Museum of American Art, Chicago (23.1983)

caused a sensation at the Salon des Réfusés, an exhibition of works rejected from the official French government-sponsored Salon. A colorful, if eccentric, personality whose butterfly monogram described his character as well as inscribing his art, Whistler was an original and prolific etcher as well as painter. Inspired by the dictum of "art for art's sake," he produced paintings and prints of remarkable beauty that inspired many younger American and European artist adherents of the "Aesthetic Movement," which dominated the fine and decorative arts during the last quarter of the 19th century.

JAMES ABBOTT MC NEILL WHISTLER (1834-1903)

Note in Red: The Siesta, 1882-83
Oil on panel 9 x 12 in.
Daniel J. Terra Collection
Terra Museum of American Art, Chicago (44.1982)

JAMES ABBOTT MC NEILL WHISTLER (1834-1903)

A Freshening Breeze, c. 1883
Oil on board 9¼ x 5⅜ in.
Daniel J. Terra Collection
Terra Museum of American Art, Chicago (30.1985)

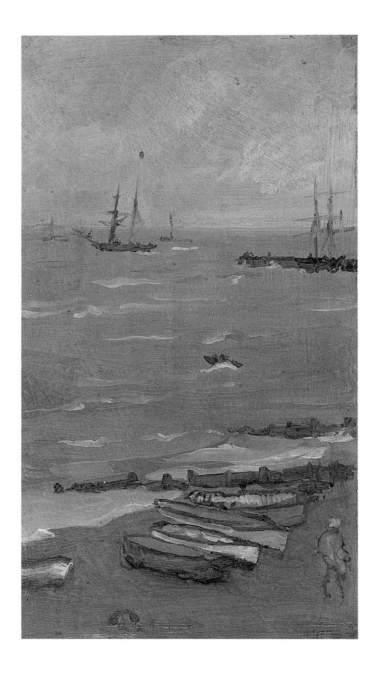

Maud on a Stairway, c. 1884-85
Watercolor on paper 10⅝ x 8 in. (sight)
Daniel J. Terra Collection
Terra Museum of American Art, Chicago (3.1986)

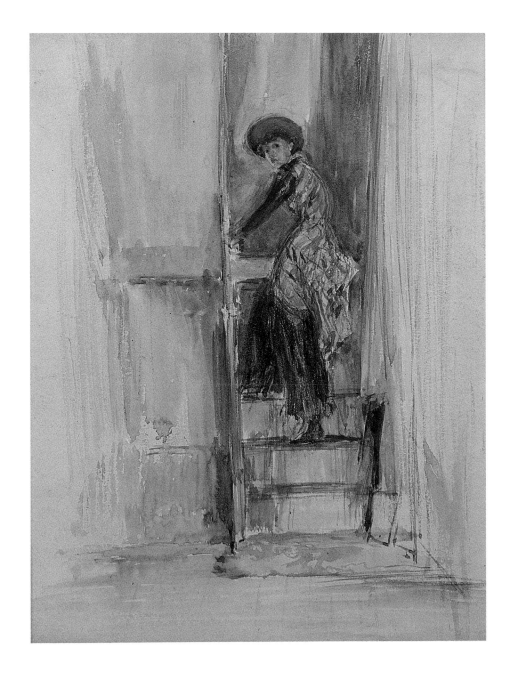

JAMES ABBOTT MC NEILL WHISTLER (1834-1903)

Carlyle's Sweetstuff Shop, 1885-89
Oil on wood panel 5¼ x 8½ in.
Daniel J. Terra Collection
Terra Museum of American Art, Chicago (20.1985)

JAMES ABBOTT MC NEILL WHISTLER (1834-1903)

A Red Note: Fete on the Sands, Ostend, 1887
Oil on wood panel 7⅞ x 11⅝ in.
Daniel J. Terra Collection
Terra Museum of American Art, Chicago (32.1983)

JAMES ABBOTT MC NEILL WHISTLER (1834-1903)

PLATE T-40

A Brittany Shop with Shuttered Windows, c. 1888
Watercolor on paper 4¾ x 8¼ in. (sight)
Daniel J. Terra Collection
Terra Museum of American Art, Chicago (4.1986)

Rose et Vert, L'Iris: Portrait of Miss Kinsella, 1893-1902
Oil on canvas 75¼ x 35¼ in.
Daniel J. Terra Collection
Terra Museum of American Art, Chicago (26.1983)

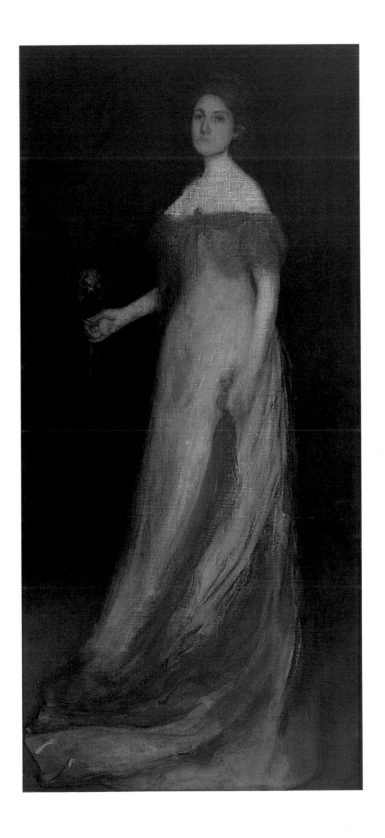

JAMES ABBOTT MC NEILL WHISTLER (1834-1903)

A Chelsea Shop, c. 1894-95
Oil on wood panel 5¼ x 8¹¹⁄₁₆ in.
Daniel J. Terra Collection
Terra Museum of American Art, Chicago (42.1980)

JAMES ABBOTT MC NEILL WHISTLER (1834-1903)

The Sea, Pourville, 1899
Oil on panel 5⅜ x 9 in. (sight)
Daniel J. Terra Collection
Terra Museum of American Art, Chicago (2.1985)

JAMES ABBOTT MC NEILL WHISTLER (1834-1903)

The Golf Links, Gray and Silver; Dublin, c. 1900
Watercolor on paper 5½ x 9½ in.
Daniel J. Terra Collection
Terra Museum of American Art, Chicago (14.1981)

JAMES ABBOTT MC NEILL WHISTLER (1834-1903)

The Beach at Marseilles, c. 1901
Oil on wood panel 8½ x 13⅞6 in.
Daniel J. Terra Collection
Terra Museum of American Art, Chicago (25.1983)

WILLIAM STANLEY HASELTINE (1835-1900)

PLATE T-46

Rocks at Nahant, 1864
Oil on canvas 22¼ x 40¼ in.
Daniel J. Terra Collection
Terra Museum of American Art, Chicago (2.1983)

William Stanley Haseltine (1835-1900) was born and studied in Philadelphia. At the age of 15 Haseltine studied under Paul Weber, a landscape painter whom Haseltine eventually followed to Germany. Haseltine studied in Düsseldorf from 1854 to 1857 with a number of other Americans, including Albert Bierstadt and Worthington Whittredge. The influence of Haseltine's training in Düsseldorf and the various sketching tours he took in Europe during this time are apparent in his palette and in the fine draftsmanship of his landscapes. Haseltine returned in 1858 to New York, where he married and exhibited at the National Academy of Design. Despite his growing popularity in the United States, he yearned to return to Europe, which he did in 1864, finally settling in Italy in 1869. From there he frequently sent his views of the Italian countryside to exhibitions in the United States. He is best remembered for founding the American School of Architecture and the American Academy in Rome.

Ten Pound Island, Gloucester, n.d.
Oil on canvas 14 x 24 in.
Daniel J. Terra Collection
Terra Museum of American Art, Chicago (37.1984)

Francis A. Silva (1835-1886) was born in New York where he worked as a sign painter before enlisting in the Civil War. After serving in the Union Army, at the close of the war, Silva returned to New York where he established himself as a painter of marine subjects. He exhibited annually at the National Academy of Design, the Brooklyn Art Academy, and the American Institute until his death in 1886.

WINSLOW HOMER (1836-1910)

Croquet Match, 1867-69
Oil on panel 9¾ x 15¾ in.
Daniel J. Terra Collection
Terra Museum of American Art, Chicago (32.1985)

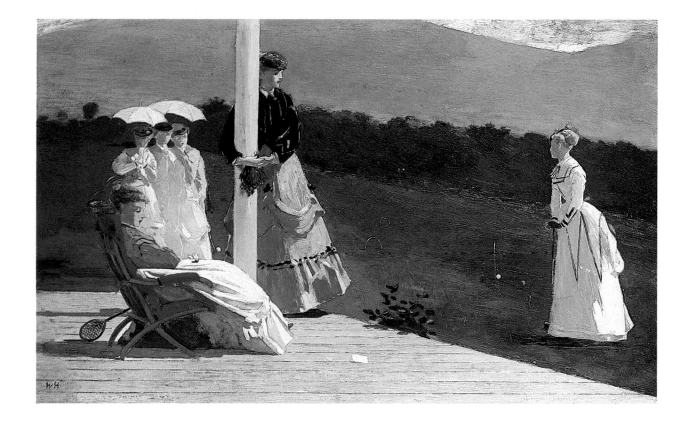

Winslow Homer (1836-1910) spent his childhood in Boston and Cambridge, Massachusetts. After serving as an apprentice to a lithographer, Homer worked as a free-lance illustrator and gained recognition for the studies of life at the battlefront he produced during the Civil War as an artist-correspondent for *Harper's Weekly* magazine. The Civil War was also the subject of Homer's first major painting, *Prisoners from the Front*, which was exhibited at the Universal Exposition in Paris in 1867. Homer had received brief training in drawing at the National Academy of Design and studied for a short time with the painter Frederick Rondel, but he was essentially self-taught. By the mid-1870s Homer had abandoned illustration to devote himself to painting and was winning widespread critical and public approval for his oil paintings and watercolors of rural America. His two-year residence at the fishing village of Cullercoats in England influenced Homer's decision to settle at Prout's Neck, Maine, in 1884, and after this date he concentrated increasingly on seascapes and views of the Maine coast. Subsequent trips to the West Indies, as well as Homer's annual fishing trips in the Adirondacks and Quebec province and the Maine coast, inspired his powerful images of nature's power.

WINSLOW HOMER (1836-1910)

Three Boys on the Shore, 1873
Gouache and watercolor on paper 7½ x 13¼ in. (sight)
Daniel J. Terra Collection
Terra Museum of American Art, Chicago (6.1982)

WINSLOW HOMER (1836-1910)

Weary, c. 1878
Watercolor and pencil on paper 8⅝ x 11¼ in. (sight)
Daniel J. Terra Collection
Terra Museum of American Art, Chicago (18.1980)

ALFRED THOMPSON BRICHER (1837-1908)

PLATE T-51

Lake George from Bolton's Landing, 1867
Oil on canvas 27 x 50¼ in.
Daniel J. Terra Collection
Terra Museum of American Art, Chicago (18.1981)

Alfred Thompson Bricher (1837-1908) was born in Portsmouth, New Hampshire. After studying painting intermittently at the Lowell Institute in Boston, in his early 20s Bricher became a professional artist and spent a decade sketching and painting the coast between Newburyport and Boston. In 1868 he made New York his permanent residence. While retaining a studio in New York, Bricher moved to Staten Island in 1890 to be closer to the sea, remaining there until his death in 1908. Bricher was one of the last proponents of the American tradition of Romantic marine and landscape painting begun by Thomas Cole; his paintings of ships, ports, and the coastline are some of the best of that genre. Bricher, a Luminist, shared with contemporaries Frederic Edwin Church, Martin Johnson Heade, and William Stanley Haseltine similar concerns in the depiction of light and atmosphere.

ALFRED THOMPSON BRICHER {1837-1908}

The Sidewheeler "The City of St. Paul" on the Mississippi River, Dubuque, Iowa, 1872
Oil on canvas mounted on panel 20 x 37⅞ in.
Daniel J. Terra Collection
Terra Museum of American Art, Chicago {17.1981}

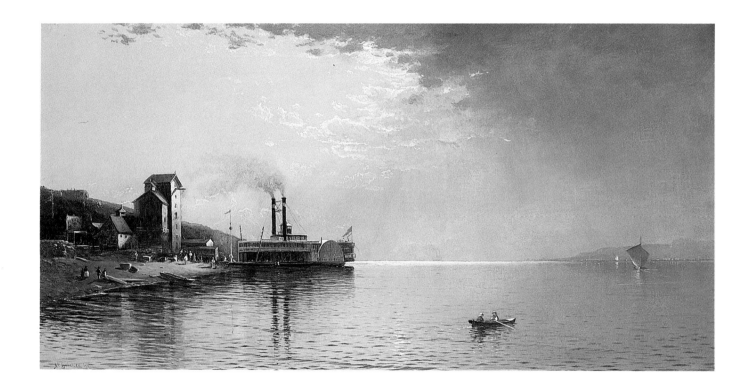

PLATE T-53

In My Neighbor's Garden, 1883
Oil on canvas 24 x 44¼ in.
Daniel J. Terra Collection
Terra Museum of American Art, Chicago (2.1980)

SAMUEL S. CARR (1837-1908)

PLATE T-54

Small Yacht Racing, 1881
Oil on canvas 14⅛ x 24 in.
Daniel J. Terra Collection
Terra Museum of American Art, Chicago (4.1980)

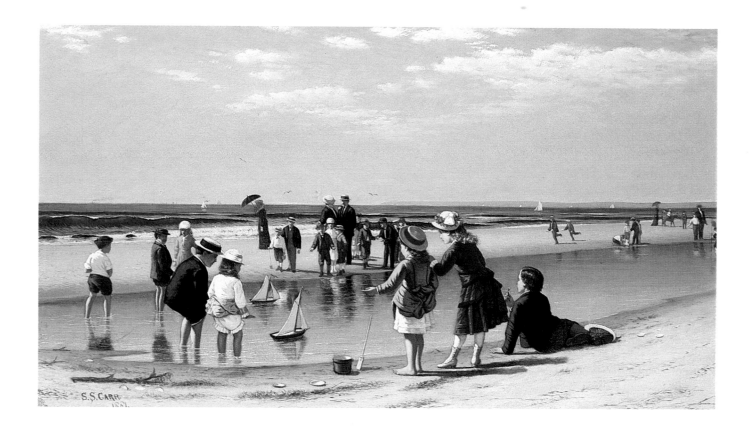

Samuel S. Carr (1837-1908) was born in England and immigrated to the United States in the 1860s. Carr was probably trained in England, for it is recorded that he took only one mechanical drawing class at the Cooper Union art school in New York. He is best known for the series of seaside scenes which he painted at Coney Island and elsewhere on Long Island during the years 1879-89. During this period Carr shared a studio with the landscape painter Clinton Loveridge, whose influence is reflected in Carr's linear style.

SAMUEL S. CARR (1837-1908)

Pic-Nic Prospect Park, Brooklyn, 1883
Oil on canvas 22 x 36¼ in.
Daniel J. Terra Collection
Terra Museum of American Art, Chicago (19.1985)

Watching for Crows, 1880
Oil on wood panel 11 x 8⁹⁄₁₆ in.
James D. Terra Collection
Terra Museum of American Art, Chicago (9.1981)

Edward Lamson Henry (1841-1919) was born in Charleston, South Carolina, but grew up in New York. When he was 16 years old, he began his art studies with the landscape painter Walter M. Oddie, and worked for a time at the Pennsylvania Academy of the Fine Arts before traveling in 1860 to Paris, where he enrolled in the atelier of Charles Gleyre. Henry settled in New York in 1869, and became known for his genre paintings of American rural life. He returned to Europe intermittently later in his career and exhibited in London and in Paris as well as in the United States.

EDWARD LAMSON HENRY (1841-1919)

Butler Hard Rubber Factory, 1882
Oil on canvas 27⅜ x 55¼ in.
Daniel J. Terra Collection
Terra Museum of American Art, Chicago (38.1984)

In the Omnibus, c. 1891
Color aquatint with etching and drypoint 14¼ x 10½ in. (image)
Daniel J. Terra Collection
Terra Museum of American Art, Chicago (29.1985)

Mary Cassatt (1844-1926) was raised in Philadelphia and studied at the Pennsylvania Academy of the Fine Arts from 1861 to 1865, before leaving to continue her studies in Paris. A precocious talent, Cassatt exhibited works at the Salon beginning in 1868. She based her painting style on a thorough study of the works of Correggio, Rubens, and Velázquez, which she had seen during tours of the continent in the early 1870s, and subsequently upon her astute recognition and appreciation of the work of Edouard Manet and the Impressionists. Invited to exhibit with the Impressionists in 1877, she became a close confidante of Edgar Degas. In the United States, Cassatt remained a relative unknown until she was commissioned to paint a mural for the 1893 World's Columbian Exposition in Chicago. Through her connection with and advisory capacity to collectors of consequence such as Louise Havemeyer and Mrs. Potter Palmer, Cassatt also played an influential, albeit indirect, role in molding the direction of American art.

MARY CASSATT (1844-1926)

Jenny and Her Sleepy Child, c. 1891
Oil on canvas 28⅞ x 23⅝ in.
Daniel J. Terra Collection
Terra Museum of American Art, Chicago (16.1986)

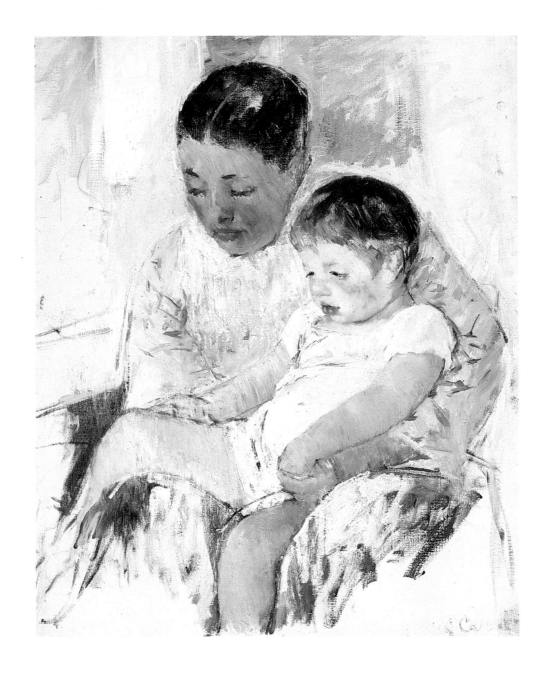

PLATE T-60

The Lamp, c. 1891
Color aquatint with etching and drypoint 12½ x 9⅞ in. (plate)
Daniel J. Terra Collection
Terra Museum of American Art, Chicago (47.1985)

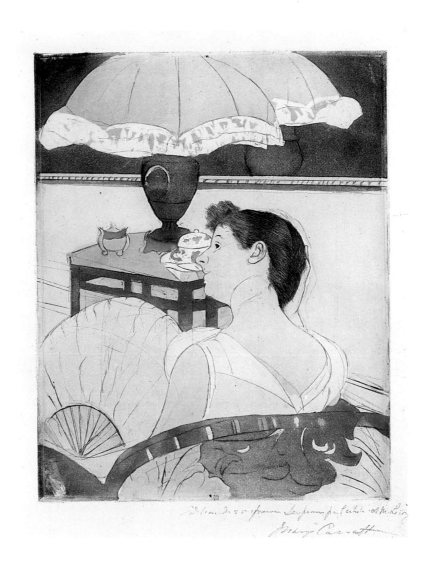

PLATE T-61

The Banjo Lesson, 1894
Color drypoint 11⅝ x 9⅜ in. (image)
Daniel J. Terra Collection
Terra Museum of American Art, Chicago (36.1986)

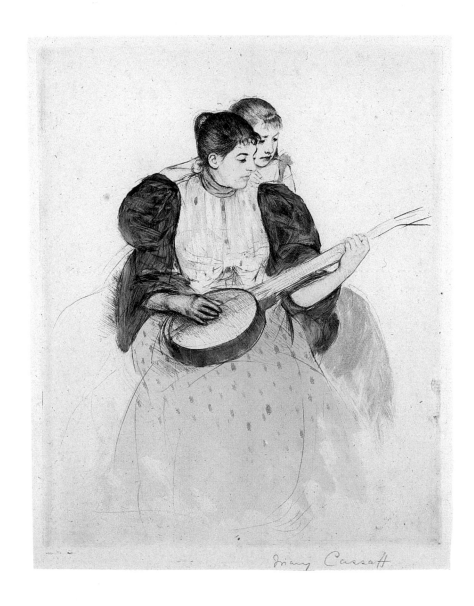

MARY CASSATT (1844-1926)

Summertime, 1894
Oil on canvas 42 x 30 in.
Daniel J. Terra Collection
Terra Museum of American Art, Chicago (45.1985)

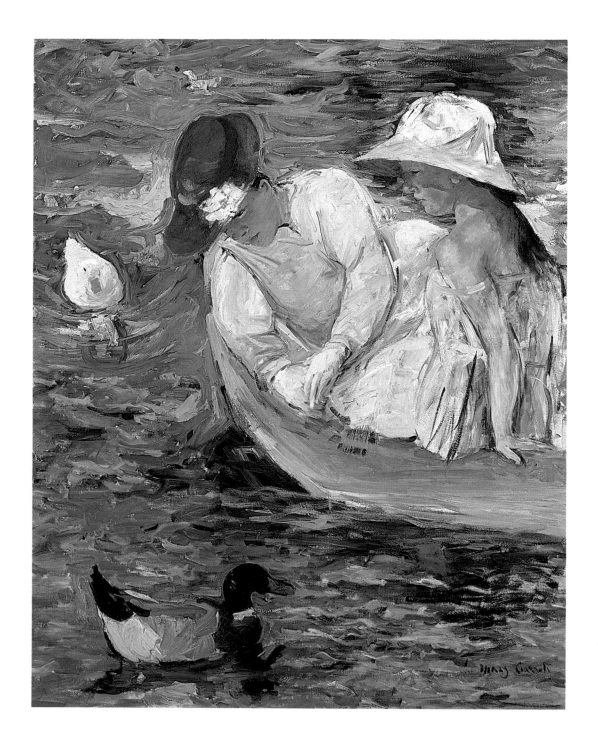

Feeding the Ducks, c. 1894
Color aquatint with etching and drypoint 11⅝ x 15½ in. (plate)
Daniel J. Terra Collection
Terra Museum of American Art, Chicago (46.1985)

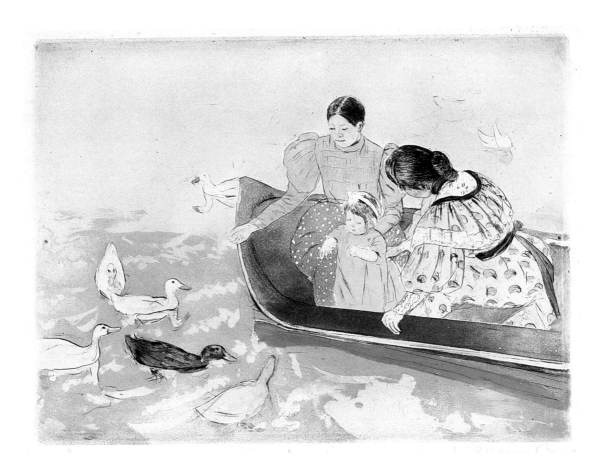

MARY CASSATT (1844-1926)

The Cup of Chocolate, 1898
Pastel on paper mounted on canvas 20⅝ x 29⅛ in.
Daniel J. Terra Collection
Terra Museum of American Art, Chicago (30.1986)

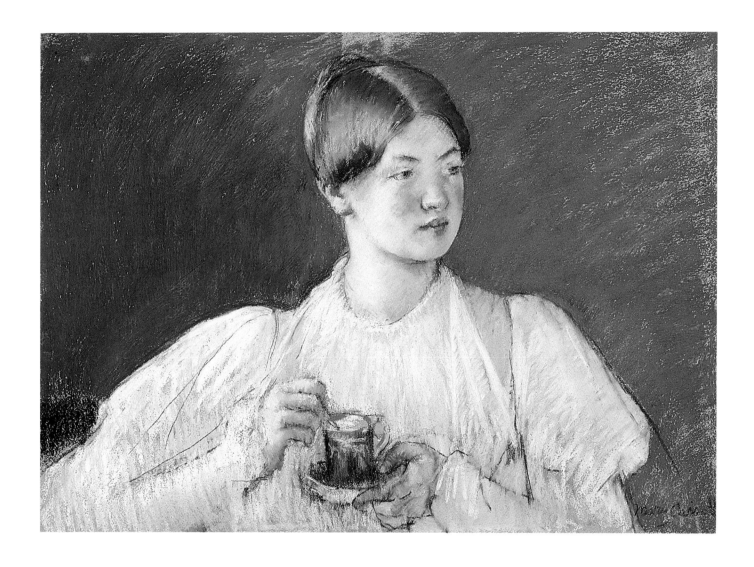

FRANK DUVENECK (1848-1919)

Reclining Nude, n.d.
Oil on canvas 22¾ x 49 in.
Daniel J. Terra Collection
Terra Museum of American Art, Chicago (26.1985)

Frank Duveneck (1848-1919) was born in Kentucky. Although he worked as a professional painter in Ohio and Kentucky from the early 1860s, it was not until 1870 that Duveneck left the United States for the Munich Academy, where he studied with Wilhelm von Diez. Like fellow student William Merritt Chase, Duveneck was a virtuoso who painted with a broad, energetic touch. His "dark" chiaroscuro style was an attempt to combine the painterly realism of the German master Wilhelm Liebl with the dramatic elegance of Velázquez and forthright design of Edouard Manet. Duveneck was also a talented teacher; in 1878 he established his own painting school in Munich which attracted a significant number of American students who became known as the "Duveneck Boys," among them John White Alexander, William Merritt Chase, Joseph Rodefer De Camp, and John H. Twachtman. During the early 1880s Duveneck spent much of his time working in Florence and Venice. In 1886, after a long courtship, he married fellow artist Elizabeth Boott. Her death two years later devastated the artist and he returned to the United States soon after, settling in Cincinnati. Although he did not altogether abandon painting, in later years Duveneck devoted most of his energies to teaching and serving on various exhibition juries throughout the United States.

The Visit, 1899
Oil on canvas 25⁵⁄₁₆ x 31½ in.
Daniel J. Terra Collection
Terra Museum of American Art, Chicago (29.1986)

Lilla Cabot Perry (1848-1933) was born in Boston and studied at the Cowles Art School with Dennis Miller Bunker and Robert W. Vonnoh from 1885 to 1888. Perry then attended the Julian and Colarossi academies before visiting in Giverny in 1889. There she established a firm friendship with Claude Monet; her landscape paintings evidence strong parallels to Monet's work in both subject and style. Perry spent the next two decades living in Boston and summering in Giverny, except for the years 1898-1901, during which she and her husband lived in Tokyo. Owing to her articles and active exhibiting in Boston, Perry played a significant role in spreading Impressionism in America and establishing cultural ties between American artists and Giverny.

LILLA CABOT PERRY (1848-1933)

PLATE T-67

By the Brook, Giverny, France, 1909
Oil on canvas 45⅝ x 35⅛ in.
Daniel J. Terra Collection
Terra Museum of American Art, Chicago (14.1986)

LILLA CABOT PERRY (1848-1933)

Autumn Afternoon, Giverny, n.d.
Oil on canvas 25¾ x 31¾ in.
Terra Museum of American Art, Chicago (38.1986)

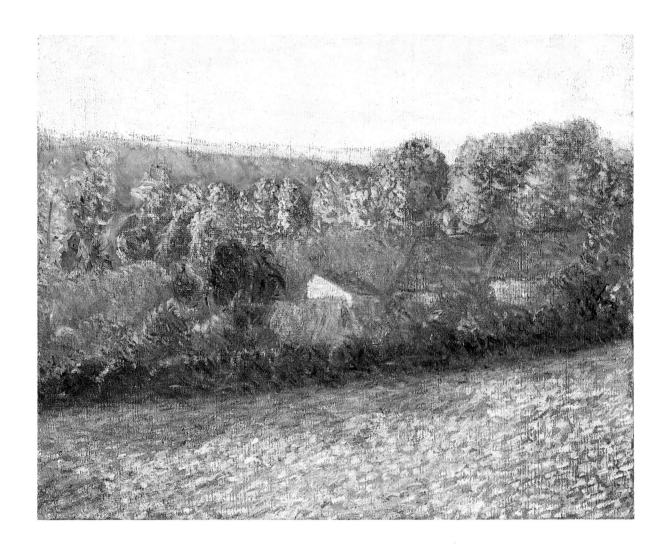

Alice Dieudonnee, c. 1892
Watercolor on paper mounted on board 9 x 8¹¹⁄₁₆ in. (sight)
Daniel J. Terra Collection
Terra Museum of American Art, Chicago (25.1986)

William Merritt Chase (1849-1916) lived in Indiana until he was 21. After studying briefly at the National Academy of Design in New York, he worked in St. Louis as a still-life painter. Interested local collectors and patrons provided Chase with enough money to attend the Munich Academy and he left America in 1872 to pursue his studies. Even before his return to New York in 1878, Chase was sending works to exhibitions in the United States. A handsome, charismatic man who was also a virtuoso painter, Chase became a leading personality in the New York art community and, by the early 1880s his apartments in the Tenth Street Studio Building had become a gathering place for artists and famous personalities. Chase

Shinnecock Hall, 1892
Pastel on canvas 32 x 41 in.
Daniel J. Terra Collection
Terra Museum of American Art, Chicago (41.1985)

was also a well-known and respected art teacher. For many years he was on the faculties of the Art Students' League and the Pennsylvania Academy of the Fine Arts. During the 1890s he even started two schools of his own: the Chase School in New York and a summer school at Shinnecock, Long Island. Among his students were Marsden Hartley, Edward Hopper, Georgia O'Keeffe, and Charles Sheeler. His style and technique were as eclectic as was his exuberant lifestyle, but they manifested the virtuosity and polish that made him a much-sought-after instructor and artist.

WILLIAM MERRITT CHASE (1849-1916)

Morning at Breakwater, Shinnecock, 1897
Oil on canvas 40 x 50 in.
Daniel J. Terra Collection
Terra Museum of American Art, Chicago (5.1980)

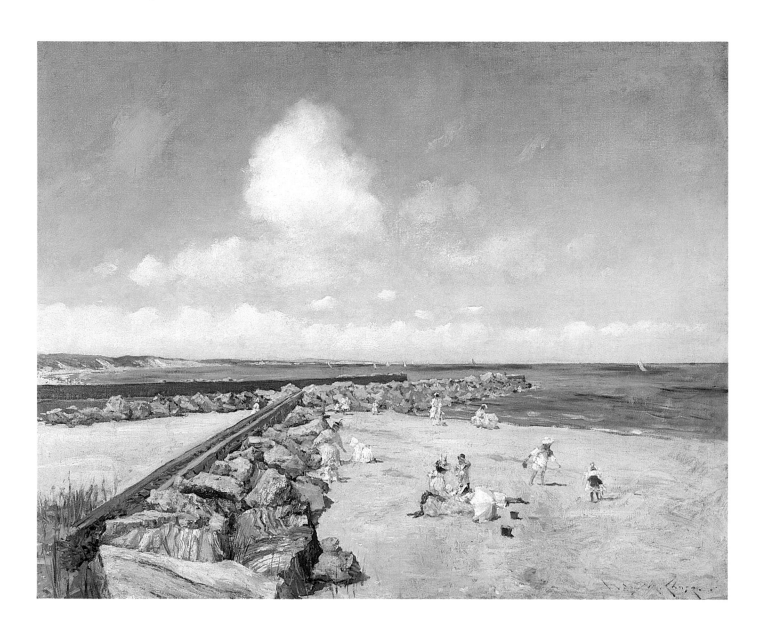

A Young Roman, c. 1907
Oil on canvas 29½ x 22⅝ in.
Daniel J. Terra Collection
Terra Museum of American Art, Chicago (36.1984)

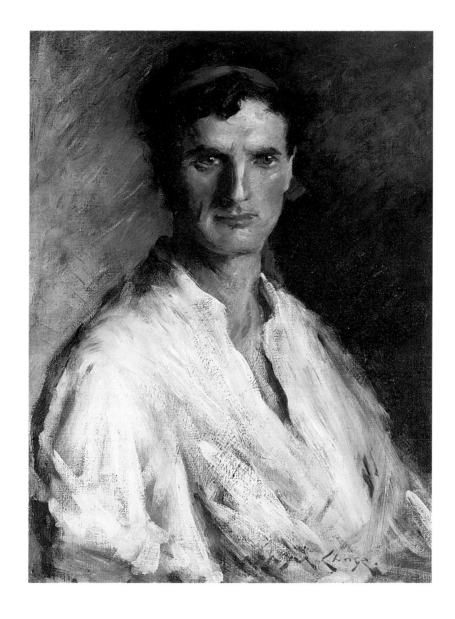

WILLIAM MERRITT CHASE (1849-1916)

The Olive Grove, c. 1910
Oil on canvas mounted on panel 23⅜ x 33⅜ in.
Daniel J. Terra Collection
Terra Museum of American Art, Chicago (6.1980)

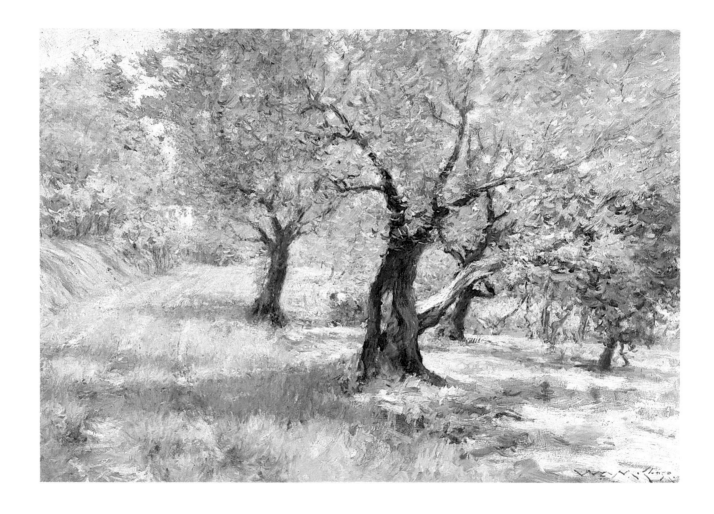

PLATE T-74

Madeline, c. 1890
Oil on canvas 22¼ x 19⅛ in.
Daniel J. Terra Collection
Terra Museum of American Art, Chicago (13.1980)

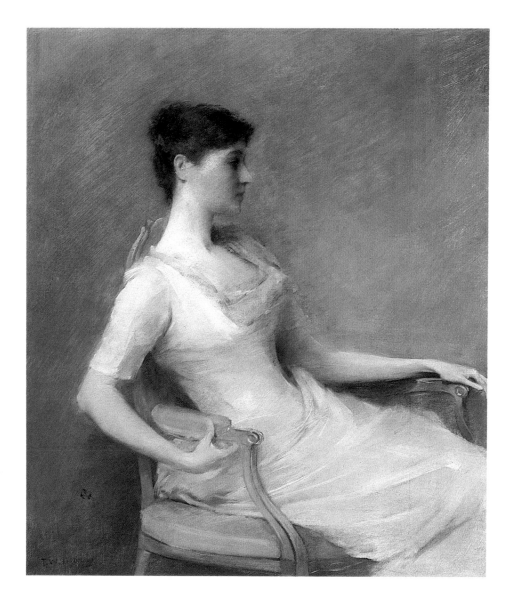

Thomas Wilmer Dewing (1851-1938), a Bostonian, studied with Gustave Boulanger and Jules Lefebvre at the Académie Julian in Paris before moving to the Munich Academy in 1878 where he joined the group of young Americans associated with the charismatic young artist-teacher Frank Duveneck. Within a year of Dewing's return to the United States in 1879, he had become a well-known member of New York's community. He exhibited at the National Academy of Design and was appointed instructor at the Art Students' League, a position he held for seven years. In 1898 Dewing was one of the artists who formed "The Ten," along with Joseph Rodefer De Camp, Childe Hassam, John H. Twachtman, Willard Leroy Metcalf, and Julian Alden Weir. Dewing specialized in ethereal female figures painted in rich, muted colors.

THOMAS WILMER DEWING (1851-1938)

Portrait of a Lady in Green, c. 1910-15
Oil on canvas 21⅛ x 16⅛ in.
Daniel J. Terra Collection
Terra Museum of American Art, Chicago (8.1985)

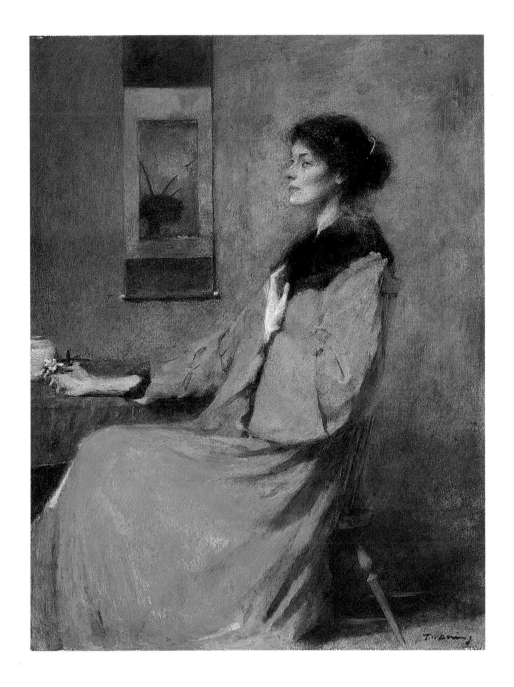

THEODORE ROBINSON (1852-1896)

PLATE T-76

Winter Landscape, 1889
Oil on canvas 18¼ x 22 in.
Daniel J. Terra Collection
Terra Museum of American Art, Chicago (34.1980)

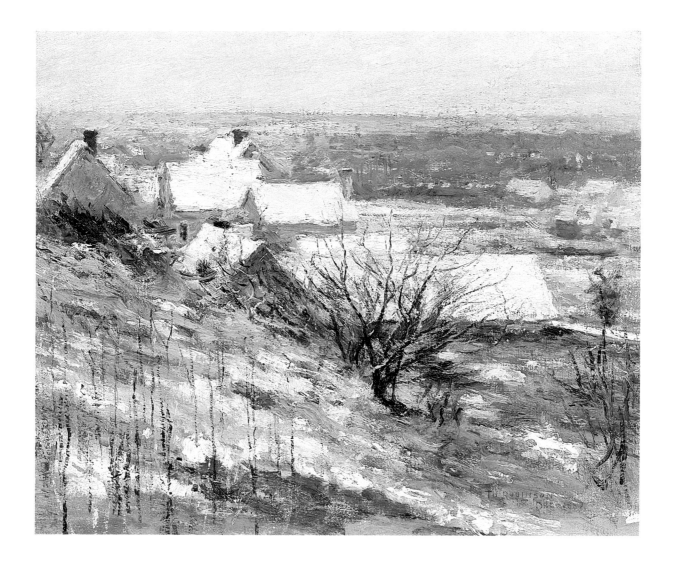

Theodore Robinson (1852-1896) spent his childhood in Evansville, Wisconsin. Robinson studied for a year at The School of the Art Institute of Chicago when he was 18, but asthma forced him to move to Denver for medical treatment. After two years' study at the National Academy of Design from 1874 to 1876, Robinson departed for Paris where he studied with Carolus-Duran and Jean-Léon Gérôme. Robinson worked at various jobs in New York during the early 1880s, finally returning to Paris in 1884. Summer trips to the village of Giverny and Robinson's encounter with Claude Monet in 1888 resulted in the American's conversion to Impressionism. Robinson's colleagues recognized his talent, yet in spite of support and encouragement from fellow artists, he was unable to gain widespread public recognition. He died suddenly only four years after his return to the United States.

PLATE T-77

Blossoms at Giverny, 1891
Oil on canvas 21⅝ x 20⅛ in.
Daniel J. Terra Collection
Terra Museum of American Art, Chicago (8.1984)

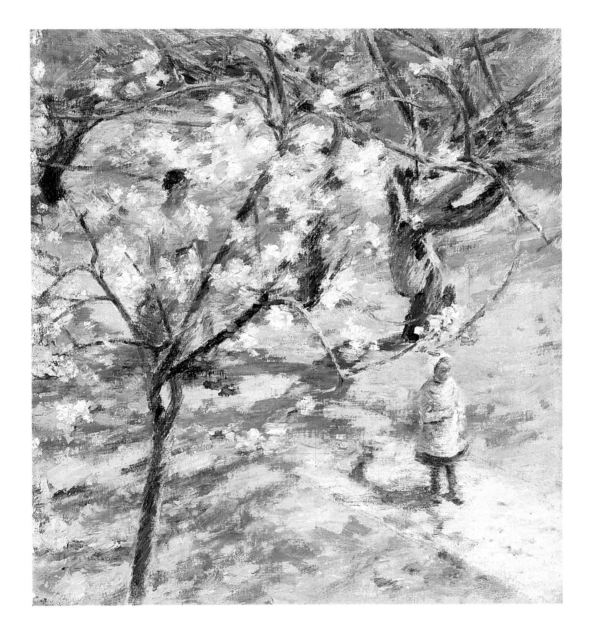

Père Trognon and His Daughter at the Bridge, 1891
Oil on canvas 18¼ x 22 in.
Daniel J. Terra Collection
Terra Museum of American Art, Chicago (15.1986)

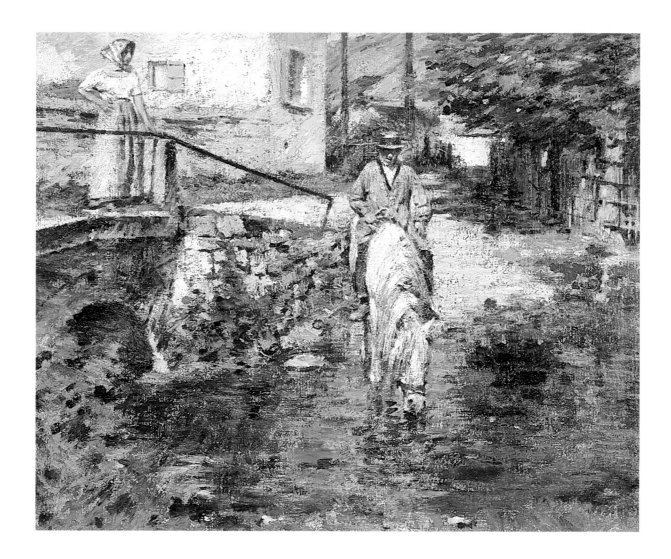

THEODORE ROBINSON (1852-1896)

The Wedding March, 1892
Oil on canvas 22⅛ x 26¼ in.
Daniel J. Terra Collection
Terra Museum of American Art, Chicago (35.1980)

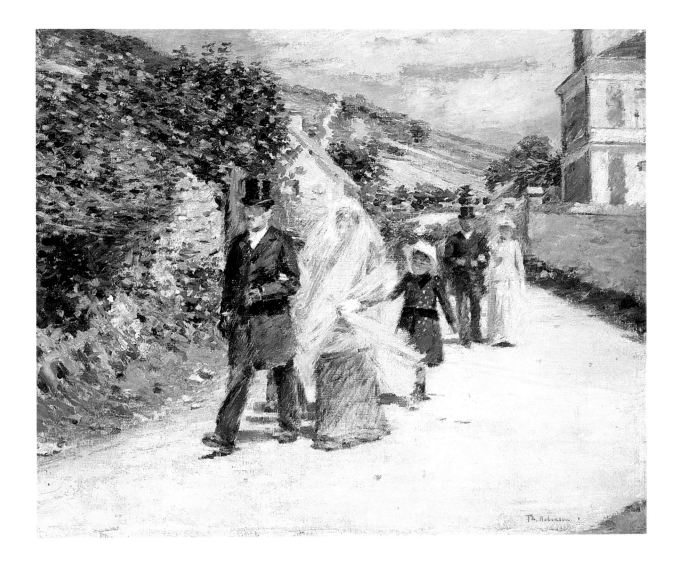

PLATE T-80

Canal Scene, 1893
Oil on canvas 16¾ x 22⅜ in.
Daniel J. Terra Collection
Terra Museum of American Art, Chicago (33.1980)

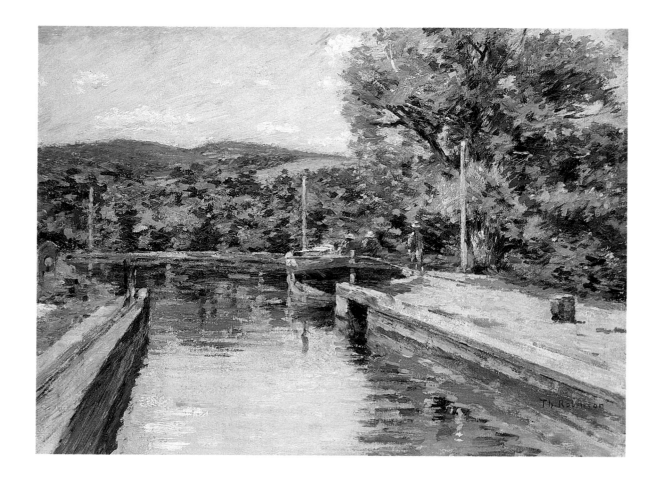

EDWARD EMERSON SIMMONS (1852-1931)

Boston Public Gardens, 1893
Oil on canvas 18¼ x 26 in.
Daniel J. Terra Collection
Terra Museum of American Art, Chicago (34.1984)

Edward Emerson Simmons (1852-1931) was born in Concord, Massachusetts, and from 1870 to 1874 attended Harvard University, graduating with an English degree. After traveling and teaching for two years, Simmons returned to Boston and enrolled at the School of the Museum of Fine Arts in Boston. In 1879 Simmons left for Europe, studying at the Académie Julian prior to moving to the artists' colony at Concarneau in Brittany. From 1886 to 1891 Simmons worked at St. Ives on the coast of Cornwall in England, where he produced primarily marine subjects. He settled in New York in 1891, and henceforth worked primarily as a muralist and decorative painter. However, Simmons's association with "The Ten" reflected his continuing interest in easel painting and his commitment to landscape.

JOSEPH DECKER (1853-1924)

Squirrel with Nuts, n.d.
Oil on canvas 16 x 24 in.
Daniel J. Terra Collection
Terra Museum of American Art, Chicago (11.1985)

Joseph Decker (1853-1924) was born in Germany. He immigrated to the United States in 1867 and worked as an apprentice to a house painter. Decker took evening classes at New York's National Academy of Design. In 1879 he became a student of Wilhelm Lindenschmidt, a respected history painter at the Munich Academy. Decker exhibited regularly at the National Academy of Design during the 1880s, though his still lifes of fruit with their surprisingly modern cropping and ambiguous space were criticized by the reviewers. Despite this rejection Decker continued to produce his unusual still lifes, in addition to landscapes containing stylistic elements of his favorite painter, George Inness, and depictions of his pet squirrel, Bonnie. The noted American collector Thomas B. Clark assisted Decker financially, and hired the artist to maintain his porcelain collection. In 1911 Decker ceased painting; he returned frequently to his native Germany until he suffered a fatal stroke in 1924.

Winter Landscape, c. 1891
Oil on canvas 30 x 30 in.
Daniel J. Terra Collection
Terra Museum of American Art, Chicago (11.1982)

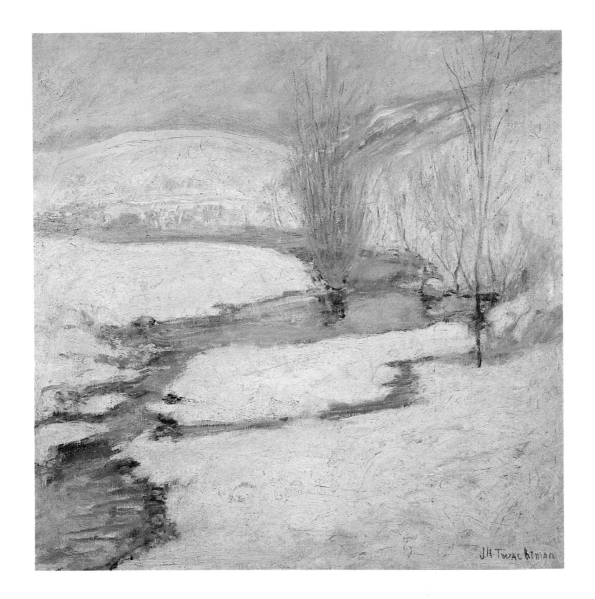

John H. Twachtman (1853-1902) grew up in Cincinnati where he attended the Ohio Mechanics Institute before enrolling at the McMicken School of Design in 1871. In 1874 Twachtman studied with Frank Duveneck and accompanied him to Munich (1875) and to Venice (1877). For the next five years, Twachtman traveled around Europe and the United States, eventually ending his studies at the Académie Julian in Paris. After his stay in Paris, Twachtman's painting underwent a stylistic change. He moved from the dark tones and thick brushwork of the Munich School to a Whistlerian, Impressionist mode. Upon his return to the United States in 1886, Twachtman became a leading member of the American Impressionist movement. A founding member of "The Ten" in 1898, Twachtman also ran a school for landscape painters at his home in Cos Cob, Connecticut, the site of many of Twachtman's own pictures.

LOUIS RITTER (1854-1892)

Willows and Stream, Giverny, 1887
Oil on canvas 25⅞ x 21⅜ in.
Daniel J. Terra Collection
Terra Museum of American Art, Chicago (17.1986)

Louis Ritter (1854-1892) was born in Alsace, France, and in his early 20s moved to Cincinnati, Ohio. He attended the Cincinnati Art Academy from 1877 to 1878 and studied with Frank Duveneck in Munich and in Italy. He is also recorded as living in Giverny with his friend Willard Leroy Metcalf during 1887, where he painted in an Impressionist manner. Ritter later returned to the United States; he exhibited in Boston until his premature death in 1892.

PLATE T-85

The Weaver, 1889
Oil on canvas 12 x 15 in.
Daniel J. Terra Collection
Terra Museum of American Art, Chicago (43.1985)

George De Forest Brush (1855-1941) was born in Tennessee and raised in Connecticut. In 1871 Brush entered the National Academy of Design in New York, then continued his studies in 1874 under Jean-Léon Gérôme at the Ecole des Beaux-Arts in Paris. When Brush returned to the United States in 1880, he lived for brief periods over the next several years in Indian villages in Wyoming and the foothills of the Rockies. These experiences dictated the direction of Brush's work; he became known for his beautifully finished depictions of the Plains Indians. A trip to Europe in 1890 stimulated Brush's admiration and emulation of Italian Renaissance paintings and he incorporated the theme of the Madonna and Christ child into his oeuvre. Brush exhibited many times from 1890 onward. He was the recipient of various awards and positions as well as teaching at the Art Students' League in New York.

JOHN SINGER SARGENT (1856-1925)

PLATE T-86

Breton Girl with a Basket, Sketch for "The Oyster Gatherers of Cancale," 1877
Oil on canvas 19 x 11½ in.
Daniel J. Terra Collection
Terra Museum of American Art, Chicago (37.1980)

John Singer Sargent (1856-1925) was born in Italy of American parents and educated in France; he spent most of his life as an expatriate. He began his career in Paris, studying with the fashionable portrait painter Carolus-Duran, from whom Sargent learned his rapid bravura painting method, later refining the technique after extensive study of the work of Diego de Velázquez, Frans Hals, and Edouard Manet. Sargent was a regular exhibitor at the Paris Salons before the scandal surrounding his portrait called *Madam X*, exhibited in 1884, prompted Sargent to move to England where he remained for the rest of his life, making occasional visits to the United States. During the 1890s Sargent executed a major series of mural decorations in the newly completed Boston Public Library. A handsome and convivial man, Sargent was most famous for his elegant portraits of English aristocracy and society Americans.

JOHN SINGER SARGENT (1856-1925)

Girl on the Beach, Sketch for "The Oyster Gatherers of Cancale," 1877
Oil on canvas 18¾ x 11¼ in.
Daniel J. Terra Collection
Terra Museum of American Art, Chicago (15.1981)

Young Boy on the Beach, Sketch for "The Oyster Gatherers of Cancale," 1877
Oil on canvas 17 x 10 in.
Daniel J. Terra Collection
Terra Museum of American Art, Chicago (38.1980)

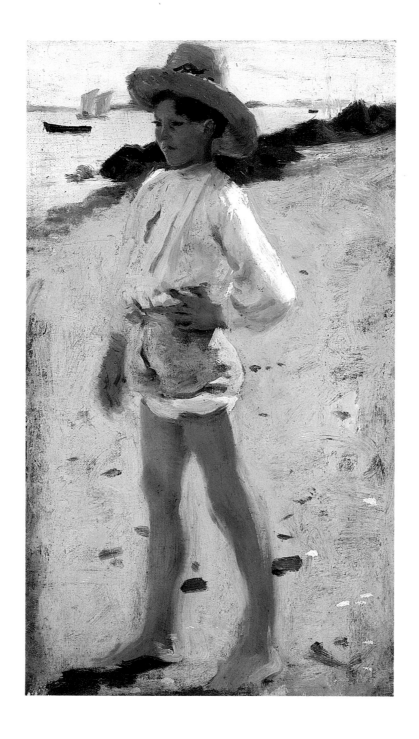

JOHN SINGER SARGENT (1856-1925)

PLATE T-89

Dennis Miller Bunker Painting at Calcot, c. 1888
Oil on canvas mounted on masonite 26¾ x 25 in.
Daniel J. Terra Collection
Terra Museum of American Art, Chicago (36.1980)

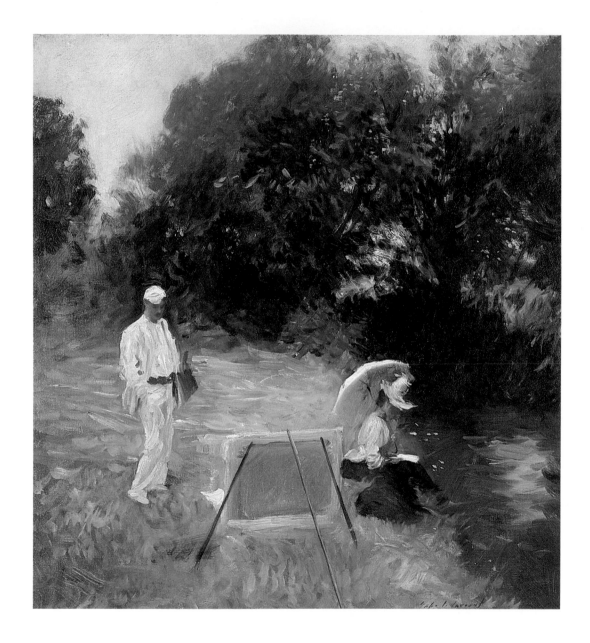

JOHN SINGER SARGENT (1856-1925)

Sally Fairchild, c. 1888
Oil on canvas 30 x 25¼ in.
Daniel J. Terra Collection
Terra Museum of American Art, Chicago (33.1985)

JOHN SINGER SARGENT (1856-1925)

PLATE T-91

In a Garden at Corfu, 1909
Oil on canvas 36 x 28 in.
Daniel J. Terra Collection
Terra Museum of American Art, Chicago (40.1985)

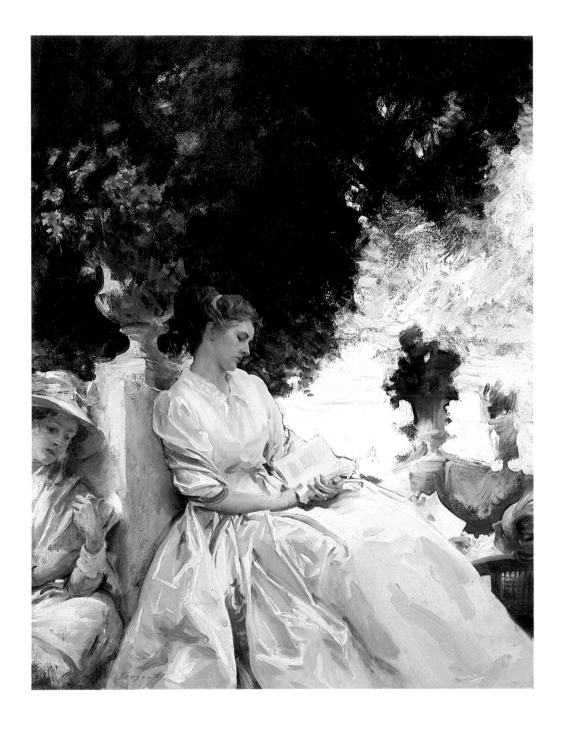

FRANCIS COATES JONES (1857-1932)

PLATE T-92

Mother and Child Reading, c. 1885
Oil on canvas 19 x 16 in.
Daniel J. Terra Collection
Terra Museum of American Art, Chicago (7.1981)

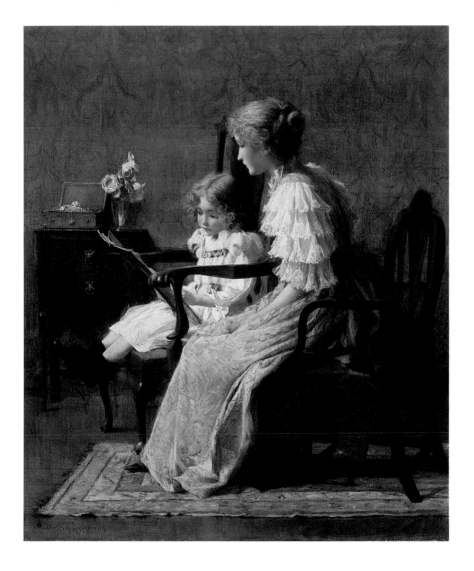

Francis Coates Jones (1857-1932) was born in Baltimore, Maryland. His brother, Hugh Bolton Jones, was a landscape painter, and the two traveled to Europe together in 1876. This trip initiated Jones's interest in a career in art and he stayed on in Pont-Aven in France as part of a community of expatriate artists. He subsequently studied with several teachers in Paris, notably William-Adolphe Bouguereau and Jules Lefebvre, before returning to Baltimore in 1881. Jones made another short trip to France two years later, and by 1884 had settled in New York. Best known for his paintings of lushly decorated domestic interiors, Jones also worked as an illustrator and mural painter.

Ring Around the Rosy, n.d.
Oil on panel 11⅜ x 15½ in. (sight)
Daniel J. Terra Collection
Terra Museum of American Art, Chicago (19.1981)

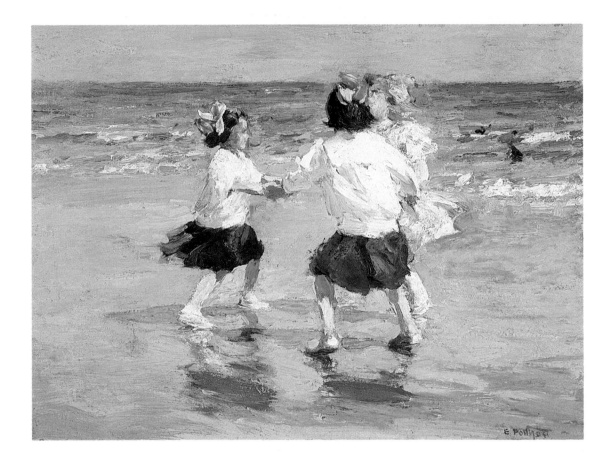

Edward Henry Potthast (1857-1927) was born in Cincinnati. Potthast was employed as a lithographer while still a teenager, and this helped to finance his art training at the McMicken School of Design in Cincinnati and later trips to Europe during the early and mid-1880s. Potthast first established a reputation as an illustrator and, during the 1890s, worked for such magazines as *Scribner's* and *Century*. After the turn of the century, inspired by the work of the French Impressionists he studied while on a third trip to Europe, Potthast abandoned illustration for oil painting. A prolific painter, Potthast is best known for his colorful beach scenes, of which he is said to have produced hundreds before his death.

PLATE T-94

Girl Seated by a Pond, n.d.
Oil on canvas 25⅛ x 30 in.
Daniel J. Terra Collection
Terra Museum of American Art, Chicago (26.1986)

Theodore Wendel (1859-1932) was born in Cincinnati, Ohio, where he studied at the School of Design and the McMicken School of Art before moving to Munich in 1878 to study with Frank Duveneck. By the mid-1880s, Wendel was studying in Paris and had made the acquaintance of compatriot artists Willard Leroy Metcalf and Theodore Robinson. In 1887 a summer spent at Giverny, the home of Claude Monet and a colony of young Impressionist artists, prompted Wendel to adopt the Impressionist style in his own work. In 1888 Wendel returned to the United States, and in a joint exhibition with Robinson, helped to introduce Impressionism to Boston. Wendel became one of the city's leading landscape painters and was an instructor at the Cowles school. In 1899 he moved to Ipswich, Massachusetts, but because of illness painted only infrequently thereafter.

JOSEPH RODEFER DE CAMP (1858-1923)

PLATE T-95

Jetty at Low Tide, n.d.
Oil on canvas 22 x 30 in.
Daniel J. Terra Collection
Terra Museum of American Art, Chicago (12.1981)

Joseph Rodefer De Camp (1858-1923) grew up in Cincinnati and attended the Cincinnati Academy, where he met Frank Duveneck. De Camp followed Duveneck's example in his studies and, in 1875, enrolled at the Munich Academy. The following year he traveled to Florence and Venice with Duveneck and the other young Americans studying in Munich known familiarly as "Duveneck's Boys." De Camp established himself as a portrait painter in Boston during the 1880s. He was a founding member of "The Ten," a group of artists who included Thomas Wilmer Dewing, Childe Hassam, Willard Leroy Metcalf, John H. Twachtman, and Julian Alden Weir, who seceded from the Society of American Artists in 1898 in order to exhibit as a group, believing that their work was complementary and their paintings would receive better viewing. As a result of his association with The Ten, De Camp incorporated into his landscapes and portraits many of the aspects of Impressionism. Unfortunately, his work in landscape is not as well known as his portraits because many of his landscape paintings were destroyed by a studio fire in the early 1890s.

WILLARD LEROY METCALF (1858-1925)

Havana Harbor, 1902
Oil on canvas 18¼ x 26⅛ in.
Daniel J. Terra Collection
Terra Museum of American Art, Chicago (28.1985)

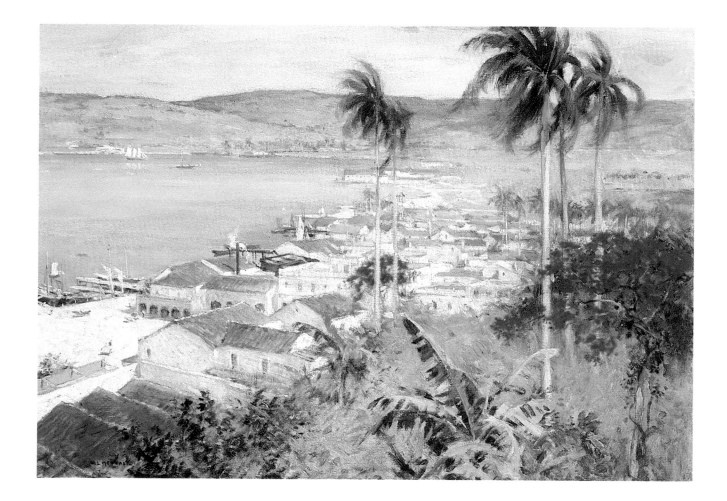

Willard Leroy Metcalf (1858-1925) was born in Lowell, Massachusetts, and first received training from landscapist George Loring Brown at the School of the Museum of Fine Arts, Boston. After working for some years as a wood engraver and illustrator, Metcalf moved to the Southwest for health reasons in 1881. In 1883 Metcalf went to Paris where he studied with Gustave Boulanger and Jules Lefebvre at the Académie Julian. Along with fellow painters Theodore Robinson and John H. Twachtman, Metcalf was among the first American artists to visit Giverny and to establish contact with Claude Monet. During the 1890s and after the turn of the century, Metcalf was an active participant in the American Impressionist movement, first as a member of the Society of American Artists and later as a founding member of "The Ten." A member of the artists' colonies at Old Lyme, Connecticut, and Cornish, New Hampshire, Metcalf exhibited regularly at various galleries and academies, and taught sporadically at the Art Students' League and the Cooper Union during the remainder of his career.

WILLARD LEROY METCALF (1858-1925)

My Wife and Daughter, c. 1917-18
Oil on canvas 29⅛ x 33 in.
Daniel J. Terra Collection
Terra Museum of American Art, Chicago (42.1985)

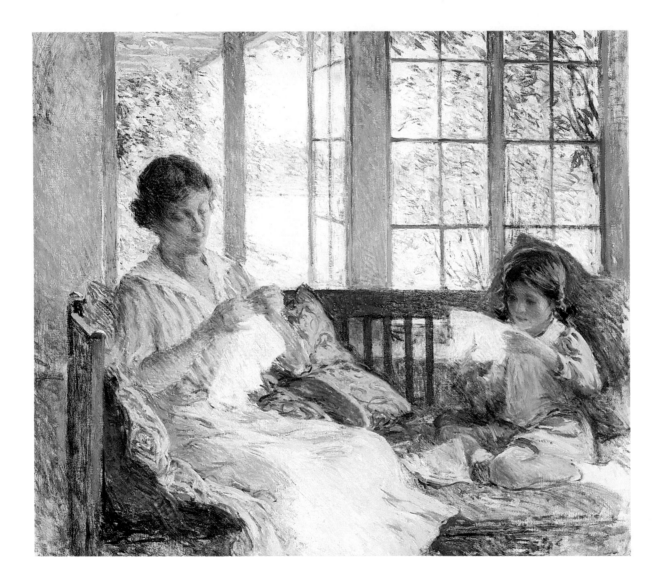

WILLARD LEROY METCALF (1858-1925)

Brook in June, 1919
Oil on canvas 26 x 29 in.
Daniel J. Terra Collection
Terra Museum of American Art, Chicago (24.1980)

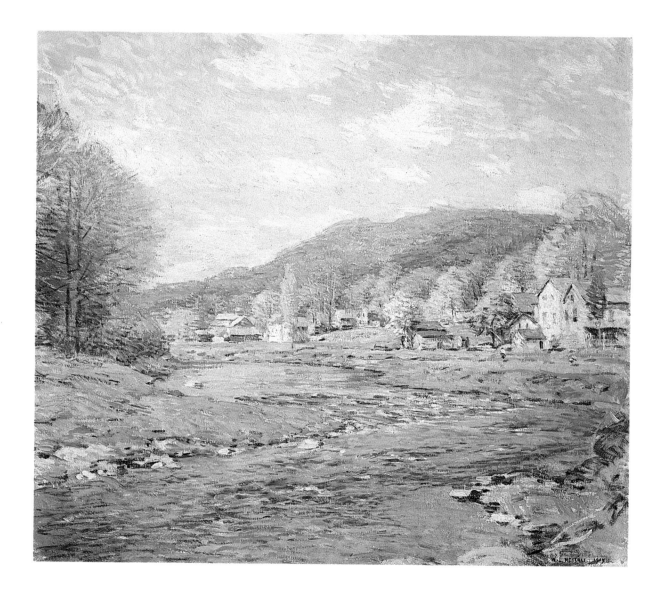

PLATE T-99

Green Dress, c. 1891-94
Monotype 9⅞ x 5 in. (plate)
Daniel J. Terra Collection
Terra Museum of American Art, Chicago (31.1982)

Maurice Brazil Prendergast (1858-1924) was born in Newfoundland and raised in Boston. In 1891 Prendergast traveled to Paris where he worked at the Académie Julian and the Académie Colarossi, and befriended several young artists of the French avant-garde. Prendergast would make five trips to Europe during his career, visiting Italy in 1898, and then in 1907, 1911, and 1914, returning to Paris to view the latest innovations of Europe's young modernists. Following his return to Boston in 1895, Prendergast began to send his work – primarily watercolors and monotypes – to various exhibitions. By the turn of the century, he was well known for his studies of bustling parks and boulevards. After 1904 Prendergast increasingly focused on large-scale works in oils and produced some of his best known, and most innovative paintings. Although a shy and rather reclusive individual, Prendergast was well acquainted with the more progressive elements in the American art community. He exhibited with "The Eight" in 1908, and later sent works to the Armory Show in 1913.

208

MAURICE BRAZIL PRENDERGAST (1858-1924)

Street Scene, c. 1891-94
Monotype 8⁹⁄₁₆ x 12⅜ in. (image)
Daniel J. Terra Collection
Terra Museum of American Art, Chicago (26.1982)

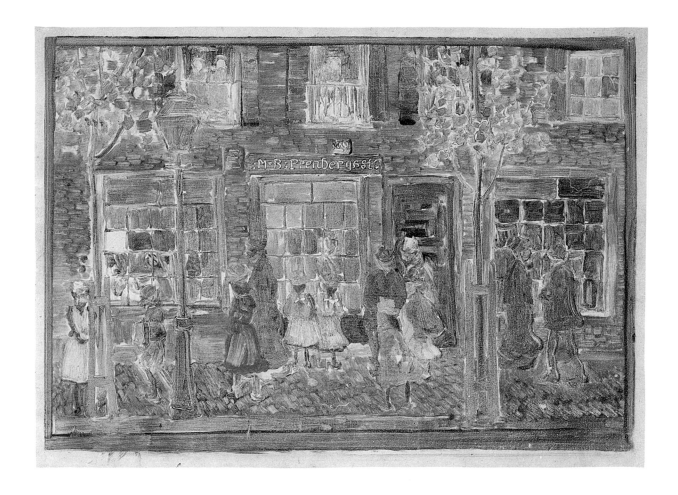

Lady on the Boulevard (The Green Cape), c. 1892
Oil on wood panel 13⅝ x 7⅛ in.
Daniel J. Terra Collection
Terra Museum of American Art, Chicago (27.1980)

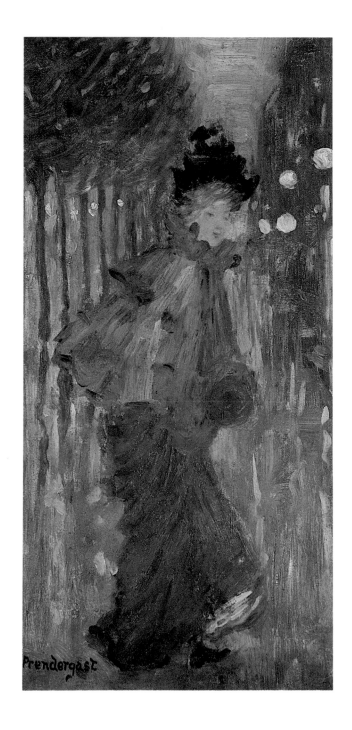

MAURICE BRAZIL PRENDERGAST (1858-1924)

Skipping Rope, c. 1892-95
Monotype 5 1/16 x 10 1/8 in.
Daniel J. Terra Collection
Terra Museum of American Art, Chicago (34.1982)

PLATE T-103

Spring in Franklin Park, 1895
Monotype 10 x 7⅞ in. (image)
Daniel J. Terra Collection
Terra Museum of American Art, Chicago (19.1982)

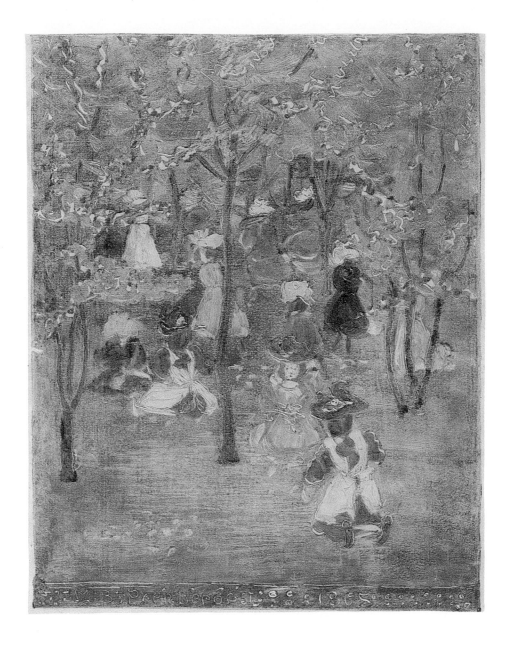

MAURICE BRAZIL PRENDERGAST (1858-1924)

Children at Play, c. 1895
Monotype 6³⁄₁₆ x 4⁵⁄₁₆ in. (image)
Daniel J. Terra Collection
Terra Museum of American Art, Chicago (35.1983)

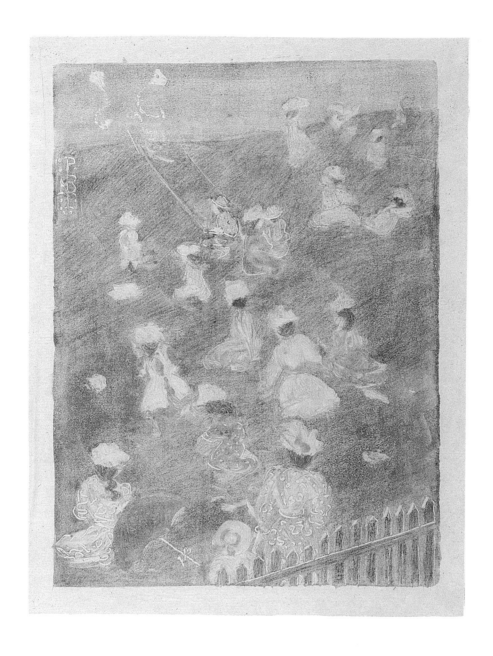

Franklin Park, Boston, c. 1895
Oil on panel 13 x 16½ in.
Daniel J. Terra Collection
Terra Museum of American Art, Chicago (45.1980)

PLATE T-106

The Tuileries Gardens, Paris, c. 1895
Oil on canvas 12⅞ x 9⅝ in.
Daniel J. Terra Collection
Terra Museum of American Art, Chicago (46.1980)

PLATE T-107

The Breezy Common, c. 1895-97
Monotype 8 5/16 x 6 3/8 in. (image)
Daniel J. Terra Collection
Terra Museum of American Art, Chicago (14.1982)

MAURICE BRAZIL PRENDERGAST (1858-1924)

Marine Park, c. 1895-97
Monotype 7⁷⁄₁₆ x 10⅛ in. (sight)
Daniel J. Terra Collection
Terra Museum of American Art, Chicago (39.1983)

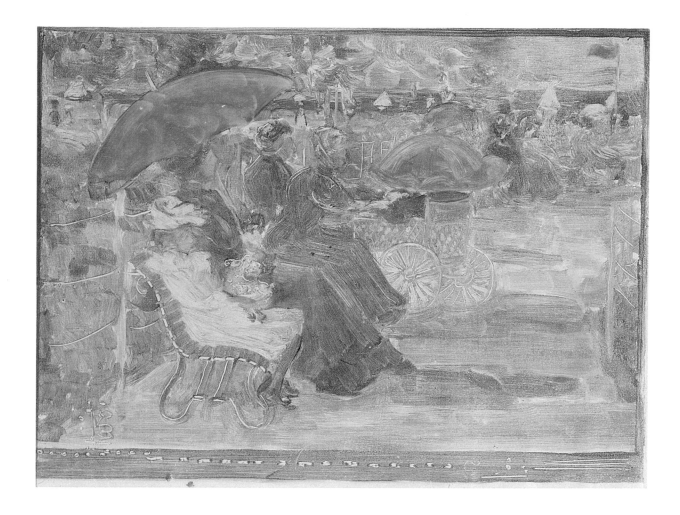

MAURICE BRAZIL PRENDERGAST (1858-1924)

Evening on a Pleasure Boat, 1895-98
Oil on canvas 14⅛ x 22 in.
Daniel J. Terra Collection
Terra Museum of American Art, Chicago (28.1980)

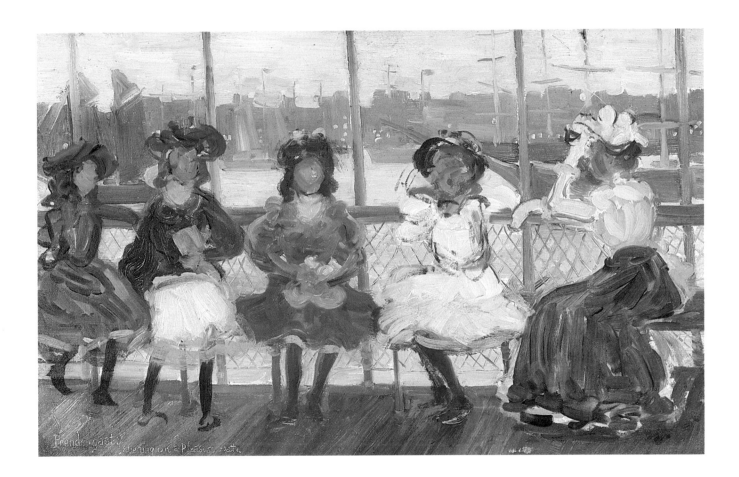

MAURICE BRAZIL PRENDERGAST (1858-1924)

Franklin Park, Boston, 1895-98
Watercolor and pencil on paper 17¼ x 12½ in. (sight)
Daniel J. Terra Collection
Terra Museum of American Art, Chicago (31.1985)

MAURICE BRAZIL PRENDERGAST (1858-1924)

PLATE T-111

Viewing the Ships, 1896
Watercolor on paper 9¾ x 13⅝ in. (sight)
Daniel J. Terra Collection
Terra Museum of American Art, Chicago (48.1984)

The Grand Canal, Venice, 1898-99
Watercolor on paper 17⅝ x 14 in. (sight)
Daniel J. Terra Collection
Terra Museum of American Art, Chicago (29.1980)

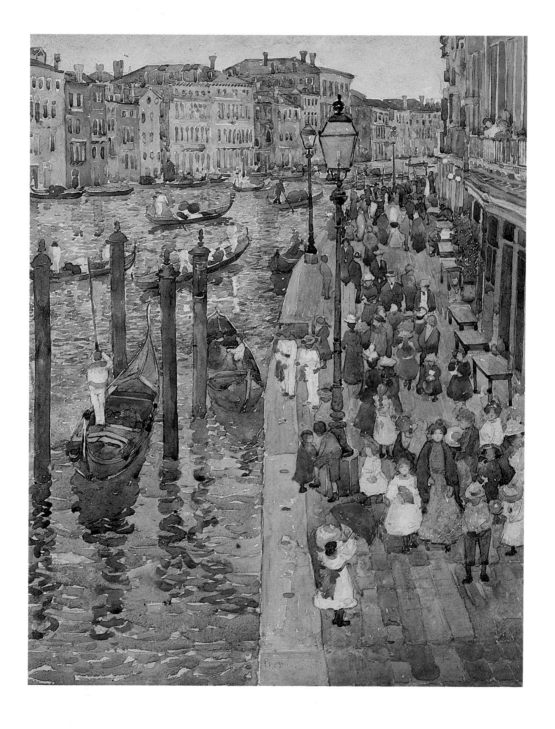

MAURICE BRAZIL PRENDERGAST (1858-1924)

Monte Pincio, Rome, 1898-99
Watercolor on paper 15¼ x 19⅜ in.
Daniel J. Terra Collection
Terra Museum of American Art, Chicago (43.1982)

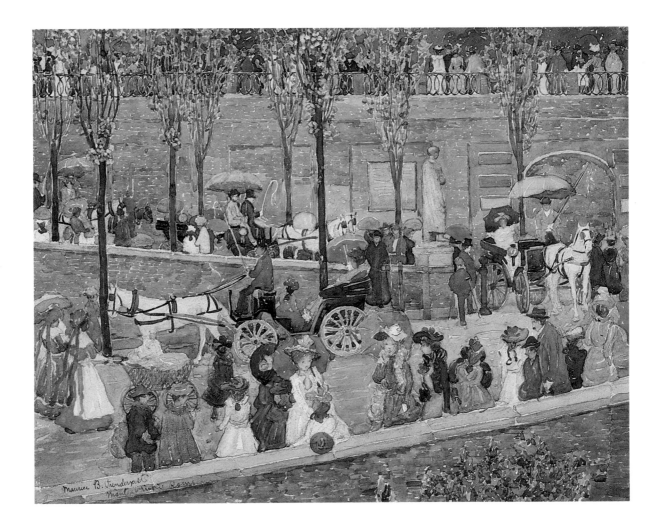

MAURICE BRAZIL PRENDERGAST (1858-1924)

PLATE T-114

Monte Pincio (The Pincian Hill), c. 1898-99
Monotype 7½ x 9¼ in. (image)
Daniel J. Terra Collection
Terra Museum of American Art, Chicago (41.1983)

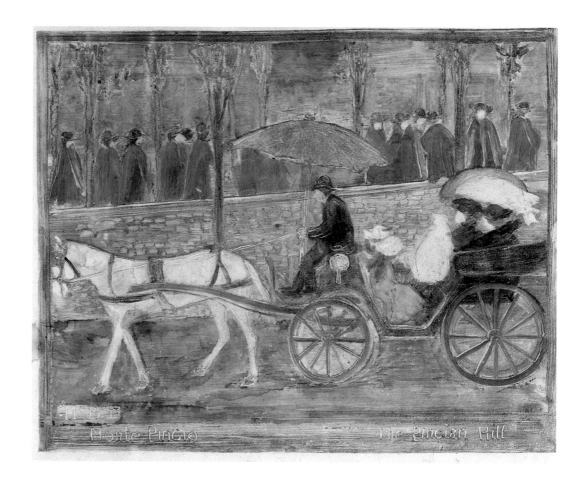

MAURICE BRAZIL PRENDERGAST (1858-1924)

Telegraph Hill, 1900
Oil on wood panel 14 x 14⅜ in.
Daniel J. Terra Collection
Terra Museum of American Art, Chicago (28.1983)

MAURICE BRAZIL PRENDERGAST (1858-1924)

Opal Sea, 1903-10
Oil on canvas 22 x 34 in.
Daniel J. Terra Collection
Terra Museum of American Art, Chicago (30.1980)

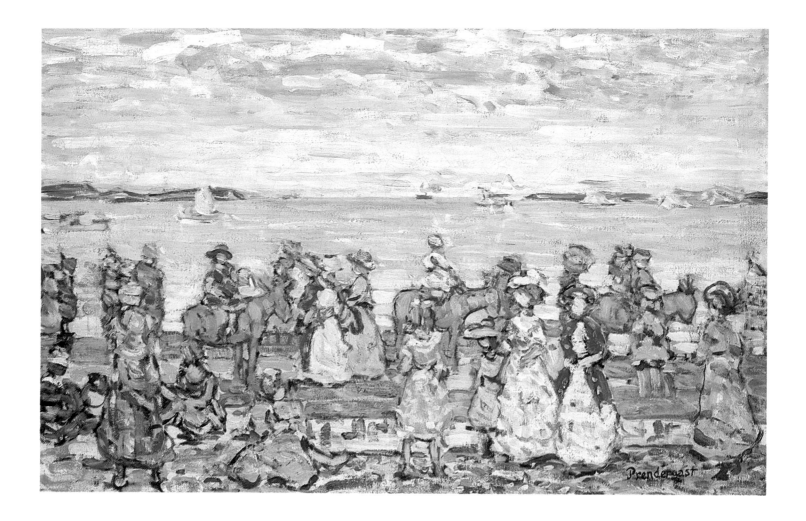

MAURICE BRAZIL PRENDERGAST (1858-1924)

Salem Willows, 1904
Oil on canvas 26¼ x 34¼ in.
Daniel J. Terra Collection
Terra Museum of American Art, Chicago (21.1984)

MAURICE BRAZIL PRENDERGAST (1858-1924)

Spring Flowers, 1904
Oil on panel 14 x 11 in.
Daniel J. Terra Collection
Terra Museum of American Art, Chicago (6.1983)

MAURICE BRAZIL PRENDERGAST (1858-1924)

Still Life with Apples, 1913-15
Oil on canvas 19¾ x 22⅝ in.
Daniel J. Terra Collection
Terra Museum of American Art, Chicago (45.1984)

PLATE T-120

Still Life with Apples and Vase, 1913-15
Oil on canvas 14 x 17¼ in.
Daniel J. Terra Collection
Terra Museum of American Art, Chicago (32.1980)

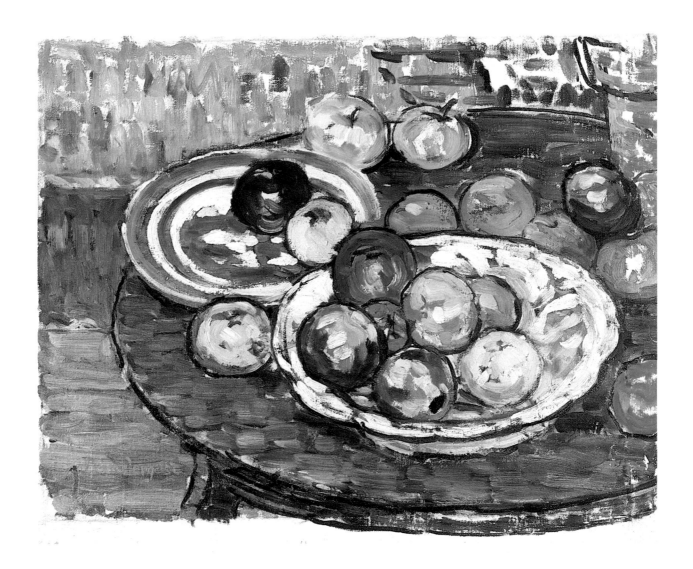

MAURICE BRAZIL PRENDERGAST (1858-1924)

The Grove, c. 1915
Oil on canvas 15¼ x 20³⁄₁₆ in.
Daniel J. Terra Collection
Terra Museum of American Art, Chicago (48.1980)

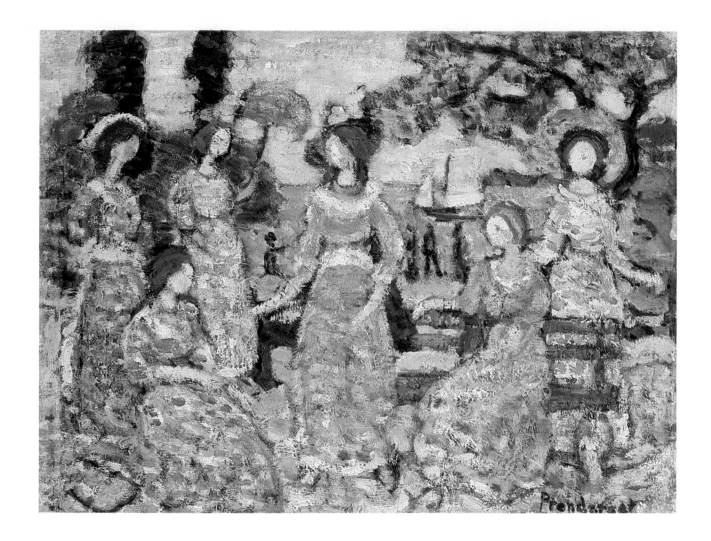

St. Malo, n.d.
Watercolor on paper 14⅝ x 21⅜ in. (sight)
Daniel J. Terra Collection
Terra Museum of American Art, Chicago (47.1984)

MAURICE BRAZIL PRENDERGAST (1858-1924)

Sunny Day at the Beach, n.d.
Pastel on paper 12 x 17¾ in.
Daniel J. Terra Collection
Terra Museum of American Art, Chicago (46.1984)

CHARLES FREDERICK ULRICH (1858-1908)

PLATE T-124

The Village Print Shop, 1885
Oil on wood panel 21¾ x 22½ in. (sight)
Daniel J. Terra Collection
Terra Museum of American Art, Chicago (40.1980)

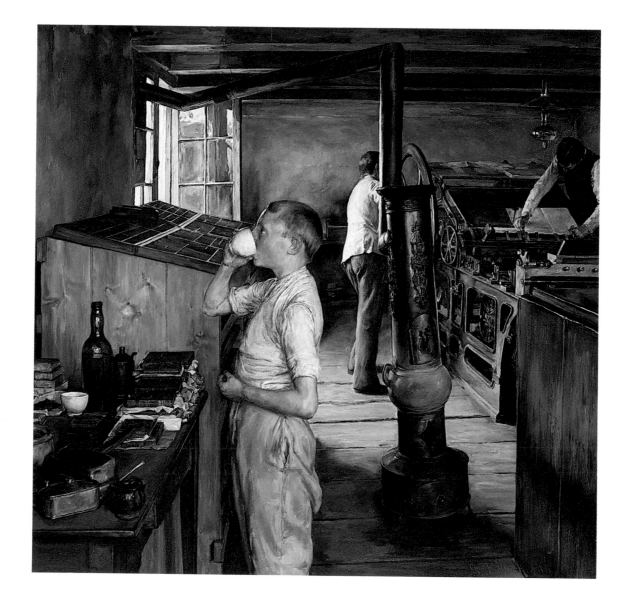

Charles Frederick Ulrich (1858-1909) was born in New York; his father was a painter and photographer. The younger Ulrich attended the National Academy of Design prior to studying in Munich with Ludwig Loefftz during the late 1870s. Ulrich's style developed from his strong academic training and his study of the Old Masters in Germany. He became particularly interested in genre, and his paintings are filled with descriptive detail. After his return to New York in 1883, he exhibited with several groups before returning to Europe in 1885. He spent the rest of his life traveling about Holland, Germany, Italy, France, and England. Ulrich exhibited both at home and abroad until his death in Berlin in 1908.

ROBERT W. VONNOH (1858-1933)

La Sieste, 1887
Oil on panel 8⁵⁄₁₆ x 10⁹⁄₁₆ in.
Daniel J. Terra Collection
Terra Museum of American Art, Chicago (27.1986)

Robert W. Vonnoh (1858-1933) was raised in Boston and received his first art training at the Massachusetts Normal Art School in 1875-77. In 1881 he departed for France to work with Gustave Boulanger and Jules Lefebvre at the Académie Julian. He would become a convert to the Impressionist style during a subsequent trip to France later in the decade. Vonnoh specialized in portraiture, especially of children, as well as landscape; he exhibited his paintings frequently in various American cities. A resident of Boston for most of his career, Vonnoh taught at several local art schools and, during the early 1890s, at the Pennsylvania Academy of the Fine Arts.

PLATE T-126

Mrs. Hassam and Her Sister, 1889
Oil on canvas 9¾ x 6⅛ in.
Daniel J. Terra Collection
Terra Museum of American Art, Chicago (17.1980)

Frederick Childe Hassam (1859-1935) was born in Boston. When a fire destroyed the family business, Hassam dropped out of school to work for a wood engraver; he quickly advanced to staff artist. Later, Hassam illustrated for various magazines while taking night classes from a local artist and at the Boston Art Club. In 1883 Hassam was able to go to Europe and make the Grand Tour. He eventually studied for three years in Paris at the Académie Julian under academicians Gustave Boulanger and Jules Lefebvre, but he was chiefly influenced by the Impressionists. Hassam brought the new style with him when he returned to the United States in 1889; he gained recognition for his landscapes. In 1898 Hassam joined "The Ten," which included Impressionist artists Edmund Tarbell, John H. Twachtman, and Julian Alden Weir. Until his death in 1935, Hassam exhibited regularly at the National Academy of Design, the Pennsylvania Academy of the Fine Arts, and the Corcoran Gallery of Art, in addition to the 1893 World's Columbian Exposition in Chicago and the 1913 Armory Show.

FREDERICK CHILDE HASSAM (1859-1935)

PLATE T-127

Commonwealth Avenue, Boston, 1891
Oil on canvas 22⅛ x 30⅛ in.
Daniel J. Terra Collection
Terra Museum of American Art, Chicago (16.1980)

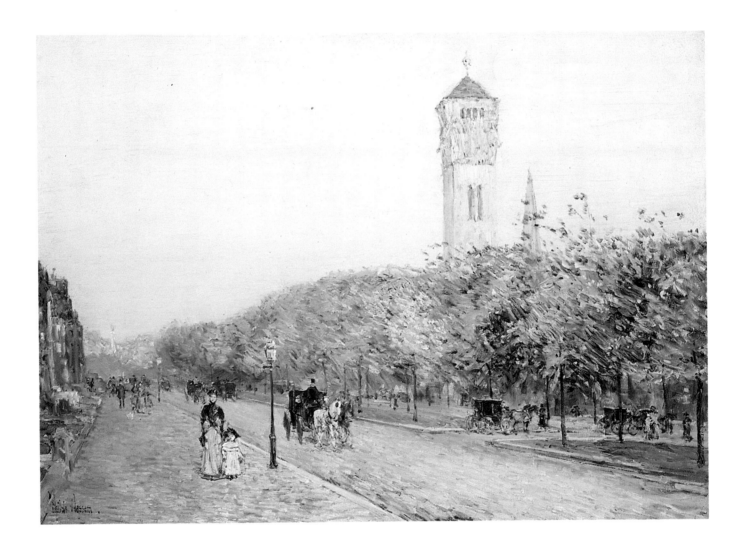

FREDERICK CHILDE HASSAM (1859-1935)

Columbian Exposition, Chicago, 1892
Gouache en grisaille on paper 10¼ x 13⅝ in. (sight)
Daniel J. Terra Collection
Terra Museum of American Art, Chicago (15.1980)

WILLIAM J. MC CLOSKEY (1859-1941)

Strawberries, 1889
Oil on canvas 12 x 16 in.
Daniel J. Terra Collection
Terra Museum of American Art, Chicago (1.1985)

William J. McCloskey (1859-1942) studied with Thomas Eakins at the Pennsylvania Academy of the Fine Arts, and developed a hard-edged *trompe l'oeil* still-life style similar to that of Eakins's other student William Harnett. McCloskey specialized in paintings of fruit arrangements and exhibited frequently in New York and Philadelphia. A peripatetic, and rather mysterious individual about whom very little is known, McCloskey in 1884 moved to Los Angeles, where he worked primarily as a portrait painter although he continued to exhibit still lifes in shows on the East Coast.

PLATE T-130

Les Invalides, Paris, 1896
Oil on canvas 13⅛ x 16⅛ in.
Daniel J. Terra Collection
Terra Museum of American Art, Chicago (27.1983)

Henry Ossawa Tanner (1859-1937) was born in Pittsburgh, the son of a bishop of the African Methodist Church. He studied with Thomas Eakins at the Pennsylvania Academy of the Fine Arts from 1880 to 1882. After several unsuccessful attempts to establish himself professionally in Philadelphia and New York, Tanner took a teaching job in Atlanta in 1888. By 1890 he was working in Cincinnati and from there was able to move to Paris later the same year, thanks to support from local patrons and his own savings. He settled permanently in France in 1893. A deeply religious man, Tanner was renowned for his biblical paintings, which he exhibited regularly in Europe and the United States.

Rock Garden at Giverny, c. 1887
Oil on canvas 18¼ x 22 in.
Daniel J. Terra Collection
Terra Museum of American Art, Chicago (49.1984)

John Leslie Breck (1860-1899) was raised in Massachusetts, but spent his adult life alternately in the United States and Europe. He received his training in Leipzig, Munich, and Antwerp before attending the Académie Julian in Paris in 1886. The following summers were the turning point of his career. Along with fellow artists Willard Leroy Metcalf and Theodore Robinson, Breck stayed at Giverny, near Claude Monet's residence, and assimilated French Impressionism. Some of his works he sent to Lilla Cabot Perry who exhibited them in her Boston studio; the lavish and vividly colored garden scenes were well received. In 1889, after success at the Paris Salon, Breck returned to Boston, where his paintings quickly gained recognition. He hosted a one-person show scarcely a year after his return, and continued exhibiting in Boston and New York until his early death in 1899.

JOHN LESLIE BRECK (1860-1899)

Garden at Giverny, c. 1890
Oil on canvas 18¼ x 22 in.
Daniel J. Terra Collection
Terra Museum of American Art, Chicago (1.1987)

THEODORE EARL BUTLER (1860-1937)

PLATE T-133

The Card Players, 1898
Oil on canvas 25½ x 32 in.
Daniel J. Terra Collection
Terra Museum of American Art, Chicago (25.1985)

Theodore Earl Butler (1860-1937) grew up in Columbus, Ohio, and studied at the Art Students' League in New York. In 1887 Butler went to Paris and attended the academies Julian, Colorossi, and Grand Chaumière. Two years later Butler accompanied Theodore Robinson to Giverny, where he established permanent residence and befriended the Impressionist master Claude Monet. Butler eventually married Monet's step-daughter, Susanne Hoschedé, in 1892; the wedding was the subject of Robinson's painting called *The Wedding March*. Butler thoroughly absorbed the style of Impressionism, and although considered a minor artist, he was influential during his time. He exhibited in the United States with the Society of Painters in Pastel and at the Armory Show of 1913 as well as in Paris at the Salon.

DENNIS MILLER BUNKER (1861-1890)

The Mirror, 1890
Oil on canvas 50⅜ x 40⅜ in.
Daniel J. Terra Collection
Terra Museum of American Art, Chicago (43.1980)

Dennis Miller Bunker (1861-1890), a native New Yorker, studied painting there with William Merritt Chase before traveling to Paris for the years 1881-84. He returned to settle in Boston, becoming the protégé of the eminent art collector Isabella Stewart Gardner. His sensitive portraits and landscapes of this time show the influence of the Barbizon School. In 1888 Bunker spent the summer with John Singer Sargent in England. Bunker greatly admired the successful Sargent and the two became close friends. The impact of Sargent on Bunker's work is obvious. Bunker spent the remaining two years of his life in Boston and New York, pursuing a promising painting career. Only months after marrying, the young artist died of influenza.

CHARLES COURTNEY CURRAN (1861-1942)

PLATE T-135

Lotus Lilies, 1888
Oil on canvas 18 x 32 in.
Daniel J. Terra Collection
Terra Museum of American Art, Chicago (10.1980)

Charles Courtney Curran (1861-1942) was born in Kentucky and studied at the Cincinnati School of Design before moving to New York to attend the Art Students' League and the National Academy of Design. He later studied in Paris at the Académie Julian. From 1888 onward he divided his time between New York and Paris, exhibiting regularly at the Salon as well as in many American exhibitions. Curran treated a broad spectrum of subjects, from landscapes to domestic genre, portraits, and ideal groups. In the latter part of his career, Curran became an instructor at the National Academy of Design and the Pratt Institute Art School in Brooklyn.

Summer Clouds, 1917
Oil on canvas 50 x 40 in.
Daniel J. Terra Collection
Terra Museum of American Art, Chicago (11.1980)

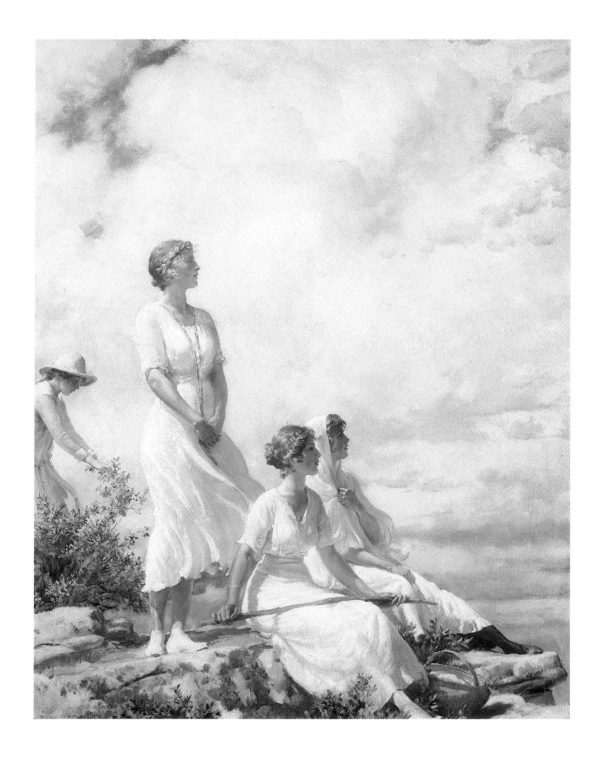

IRVING RAMSEY WILES (1861-1948)

On the Veranda, 1887
Oil on canvas 20¼ x 26¼ in.
Daniel J. Terra Collection
Terra Museum of American Art, Chicago (5.1985)

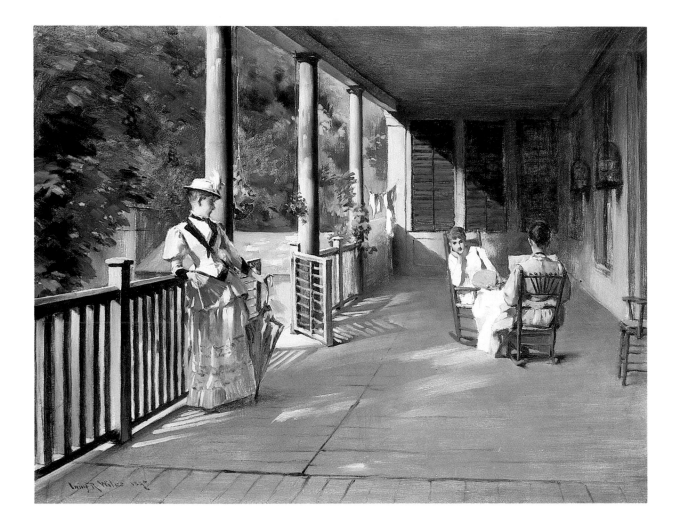

Irving Ramsey Wiles (1861-1948) was raised in Utica, New York, and received his first art training from his father, landscape painter Lemuel Maynard Wiles. From 1880 to 1882 Wiles studied with William Merritt Chase and James Carroll Beckwith at the Art Students' League in New York, and briefly with Carolus-Duran in Paris. Upon his return to New York, Wiles supported himself by doing free-lance illustration for *Harper's*, *Scribner's*, and *Century* magazines. By the end of the 1880s, he was exhibiting regularly at the National Academy of Design and at various expositions held in major cities both at home and abroad. Wiles spent much of his career instructing younger artists; he taught at the Art Students' League, the Chase School of Art, and his own Wiles School.

PLATE T-138

My Wife, Emeline, in a Garden, c. 1890
Oil on canvas 28⅛ x 24⅛ in.
Daniel J. Terra Collection
Terra Museum of American Art, Chicago (7.1985)

Edmund Charles Tarbell (1862-1938) began his career by working for a lithography firm in Boston before attending the School of the Museum of Fine Arts. After his graduation, Tarbell departed for Paris where he studied at the Académie Julian. In 1888 he returned to Boston and was appointed to the faculty of the Museum School, a post he held until 1913. Tarbell exhibited with "The Ten" in 1898 and hosted several one-person shows during his career. Although his subject matter remained conservative, Tarbell was known for his adept application of the Impressionist aesthetic; through his teaching he influenced more than a generation of Boston artists.

FREDERICK MAC MONNIES (1863-1937)

Baby Berthe in High Chair with Toys, 1897 (?)
Oil on canvas 15⅛ x 18⅛ in.
Daniel J. Terra Collection
Terra Museum of American Art, Chicago (1.1987)

Frederick William MacMonnies (1863-1937) was born in Brooklyn, New York. In 1881 he began work as a studio laborer for the noted American sculptor Augustus Saint-Gaudens. With Saint-Gaudens's encouragement, MacMonnies began taking formal art classes and, in 1884, joined the atelier of Jean-Alexandre Falguière in Paris. Although MacMonnies did not return to the United States until 1915, he received many important sculptural commissions in this country, most notably the monumental *The Barge of State* which dominated the exhibition grounds at the Chicago World's Fair in 1893. A long-time member of the American colony at Giverny, MacMonnies also did some landscape and figure painting.

PLATE T-140

Painting Atelier at Giverny, 1897 (?)
Oil on canvas 32 x 18 in.
Daniel J. Terra Collection
Terra Museum of American Art, Chicago (3.1987)

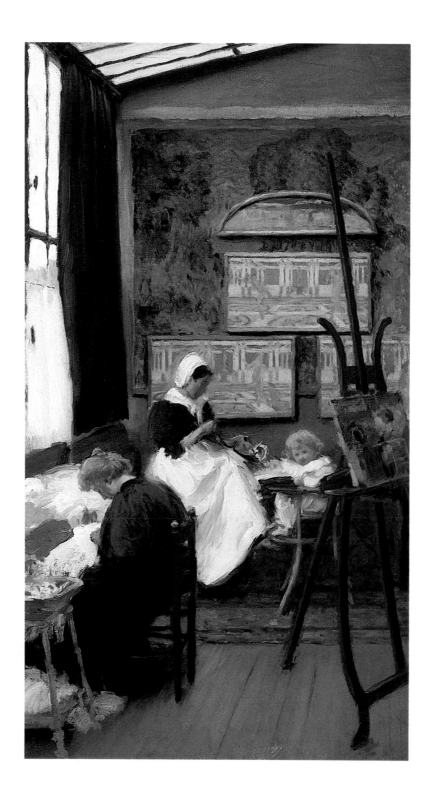

PLATE T-141

Mabel Conkling, c. 1902-5
Oil on canvas 86½ x 45 in.
Daniel J. Terra Collection
Terra Museum of American Art, Chicago (2.1987)

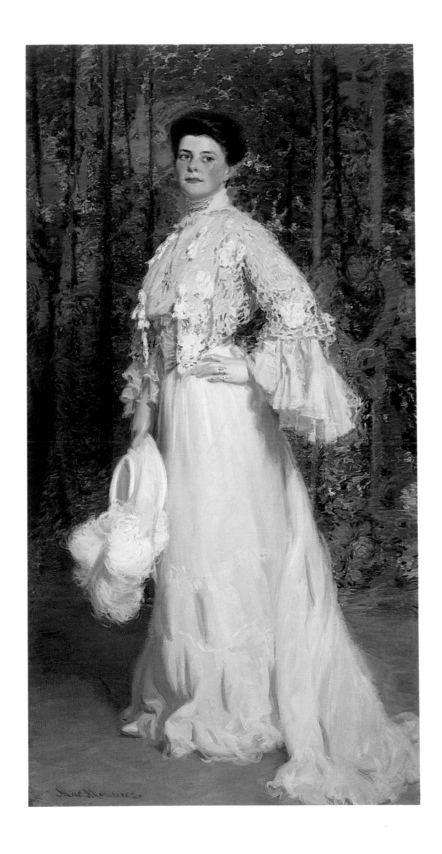

Chest, c. 1915
Carved wood with polychrome and gold leaf 23½ x 63 x 18¼ in.
Daniel J. Terra Collection
Terra Museum of American Art, Chicago (2.1986)

Charles Prendergast (1863-1948) was born and lived most of his life in Boston. Younger brother to Maurice Prendergast, Charles made a living as a frame-maker specializing in elegant gilt frames and incised gessoed panels. He was also an artist in his own right, producing mainly decorative panel paintings. He was an associate member of the National Academy of Design and other art organizations and exhibited at various museums and galleries.

CHARLES PRENDERGAST (1863-1948)

Four Figures and Donkey with Basket of Flowers, c. 1917
Polychrome and gold leaf on gessoed, incised panel 17⅞ x 23¾ in.
Daniel J. Terra Collection
Terra Museum of American Art, Chicago (11.1983)

CHARLES PRENDERGAST (1863-1948)

PLATE T-144

Three Sketches, 1938
Polychrome and gold leaf on gessoed, incised panel 32⅜ x 26¼ in.
Daniel J. Terra Collection
Terra Museum of American Art, Chicago (37.1985)

ROBERT REID (1863-1929)

A Breezy Day, c. 1898
Oil on canvas 37¼ x 33¾ in.
Daniel J. Terra Collection
Terra Museum of American Art, Chicago (10.1985)

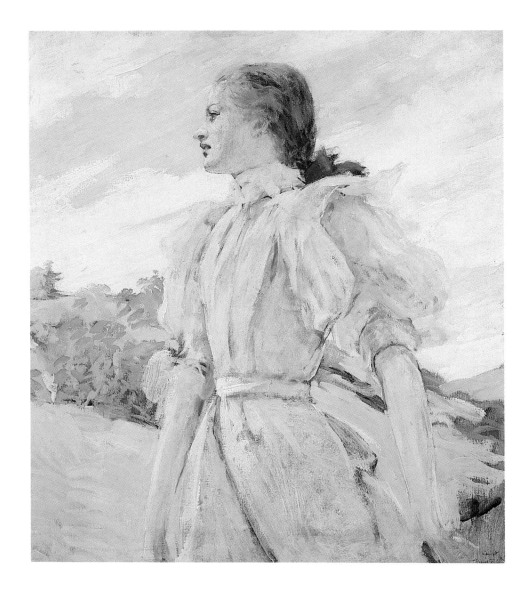

Robert Reid (1862-1929) was born in Stockbridge, Massachusetts, and attended the School of the Museum of Fine Arts in Boston and the Art Students' League in New York prior to traveling to Europe in 1885. There Reid studied at the Académie Julian in Paris with Jules Lefebvre and Gustave Boulanger and toured Italy, later settling in Normandy where he painted scenes of peasant life. After returning to New York in 1889, Reid began painting in the Impressionist style and was a founding member of "The Ten" in 1898. For most of his career, however, Reid worked primarily as a decorative painter, adapting Impressionism to the monumental scale of architectural murals.

PLATE T-146

Figure in Motion, 1913
Oil on canvas 77¼ x 37⅛ in.
Daniel J. Terra Collection
Terra Museum of American Art, Chicago (2.1984)

Robert Henri (1865-1929) was born in Cincinnati. He received his training at the Pennsylvania Academy of the Fine Arts with Thomas Anshutz from 1886 to 1888 before moving to Paris to work at the Académie Julian until 1891. He returned to the continent in 1895 and again in 1898. While his early work shows the influence of Impressionism, by the late 1890s Henri was painting portraits and genre studies in a darker, more dramatic realist style. After teaching at the Pennsylvania Academy for several years, Henri moved in 1900 to New York, where he became an influential, and inspirational, member of that city's community. Henri was an exceptional teacher, at the New York School of Art and later at the Art Students' League, as well as at his own Henri School. He was also a leading critic of the conservative art establishment. In 1908 he organized the exhibition of "The Eight" in protest against the National Academy; he was later involved in the organization of the Armory Show and the founding of the Society of Independent Artists. After the Armory Show, Henri lessened his involvement in art politics, choosing to devote the final years of his life to travel, painting, and art theory.

PLATE T-147

July Afternoon, n.d.
Oil on canvas 23⅝ x 28¾ in.
Daniel J. Terra Collection
Terra Museum of American Art, Chicago (22.1986)

Guy Rose (1867-1925) was born in San Gabriel, California, and studied with Emil Carlsen at the San Francisco Art School before going in 1888 to Paris, where he studied at the Académie Julian for three years. He returned to the United States in 1891 and was an instructor at the Pratt Institute Art School before his return to Paris in 1899. From 1904 to 1912 Rose lived at Giverny as one of a group of second-generation American Impressionists including Frederick Frieseke, Edmund Greacen, Richard Emil Miller, and Lawton Parker. These artists would exhibit together in Europe and New York from 1909 to 1910 as "The Giverny Group." Rose returned to the United States in 1912; he settled in California in 1914 and became director of the Stickney Memorial School of Art in California.

River Landscape, n.d.
Oil on canvas 56 x 50¼ in.
Daniel J. Terra Collection
Terra Museum of American Art, Chicago (49.1980)

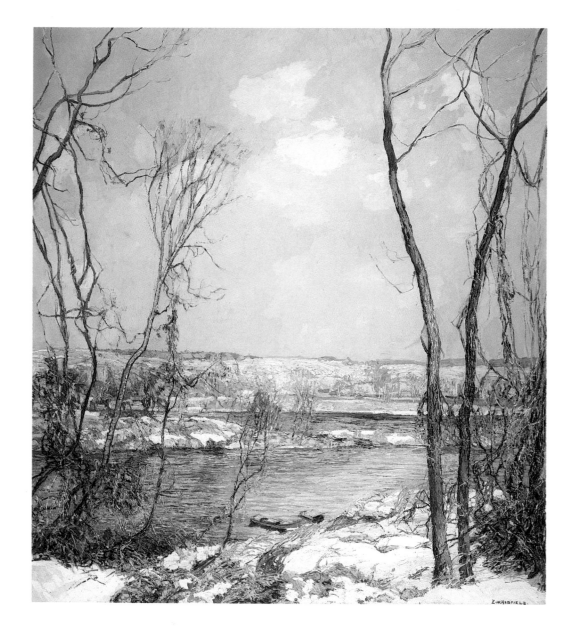

Edward Willis Redfield (1869-1965) was raised in rural Pennsylvania. A precocious talent, when only seven years old Redfield exhibited his *Study of a Cow* at the 1876 Centennial Exposition in Philadelphia. Redfield later attended the Pennsylvania Academy of the Fine Arts and in 1889 worked in the ateliers of William-Adolphe Bouguereau and Tony Robert-Fleury in Paris. However, like his close friend Robert Henri, Redfield found his greatest inspiration and training while working "en plein air" in the French countryside during his holidays away from the academic studios. After his return to the United States, Redfield became an important member of the second generation of American Impressionists. In 1898 he moved his home and studio to a farm north of Philadelphia and there founded the "New Hope" artists' colony which later attracted such painters as Walter Schofield and Daniel Garber.

JOHN MARIN (1870-1953)

PLATE T-149

Brooklyn Bridge, on the Bridge, 1930
Watercolor on paper 21⅜ x 25¼ in. (sight)
Daniel J. Terra Collection
Terra Museum of American Art, Chicago (11.1981)

John Marin (1870-1953) was born in Rutherford, New Jersey. After beginning a career in architecture, he enrolled at the Pennsylvania Academy of the Fine Arts in 1899, moving on to the Art Students' League in 1904. Marin spent the next several years abroad, sketching during the summers and working through the winters. In Paris, Marin met the photographer Edward Steichen, who brought Marin's watercolors to the attention of Alfred Stieglitz. Stieglitz gave Marin a one-person show at his gallery "291" in 1910; thereafter Marin became an important member of the powerful Stieglitz circle. Best known for his rhythmic abstract watercolors of New York City, and later for brooding views of the Maine seacoast, Marin continued to exhibit and experiment in his work until his death at age 83.

LYONEL FEININGER (1871-1958)

PLATE T-150

Denstedt, 1917
Oil on canvas 34⅜ x 46½ in.
Daniel J. Terra Collection
Terra Museum of American Art, Chicago (19.1986)

Lyonel Feininger (1871-1956) was born in New York, but lived in Germany from 1887 until 1937. Early in his career Feininger was a successful cartoonist for French and American as well as German magazines. While living in Paris from 1906 to 1908, where he befriended such young artists as Robert Delaunay and Jules Pascin, Feininger began painting full-time. He was an active member of the Berlin avant-garde, exhibited with Der Blaue Reiter group and, in 1919, was one of the first artists invited by Walter Gropius to join the Bauhaus. The rise to power in Germany of the Nazi Party during the 1930s caused Feininger finally to return to his native country and, after teaching for a short time in California, he settled in New York. American artists and critics readily acknowledged Feininger's importance, and in 1944 his art was showcased in a major retrospective at The Museum of Modern Art in New York.

ERNEST LAWSON (1873-1939)

Spring Thaw, c. 1910
Oil on canvas 25⅛ x 30 in.
Daniel J. Terra Collection
Terra Museum of American Art, Chicago (21.1980)

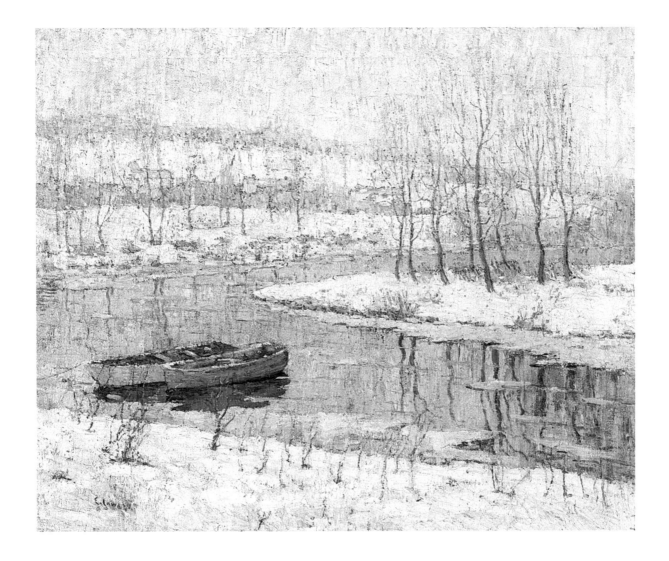

Ernest Lawson (1873-1939) was born in Nova Scotia. After working as a draftsman for an English engineering firm in Mexico, Lawson moved to New York in 1892. There he studied with John H. Twachtman and Julian Alden Weir at the Art Students' League and later at the summer school founded by Twachtman and Weir at Cos Cob, Connecticut. Thanks to his early association with Twachtman, Lawson was already well-versed in the Impressionist style when he left for study in France, first in 1893 and again the following year. He remained in Paris only two years, however, and by 1898 had settled in New York, where

PLATE T-152

Brooklyn Bridge, n.d.
Oil on canvas 20⅜ x 24 in.
Daniel J. Terra Collection
Terra Museum of American Art, Chicago (26.1984)

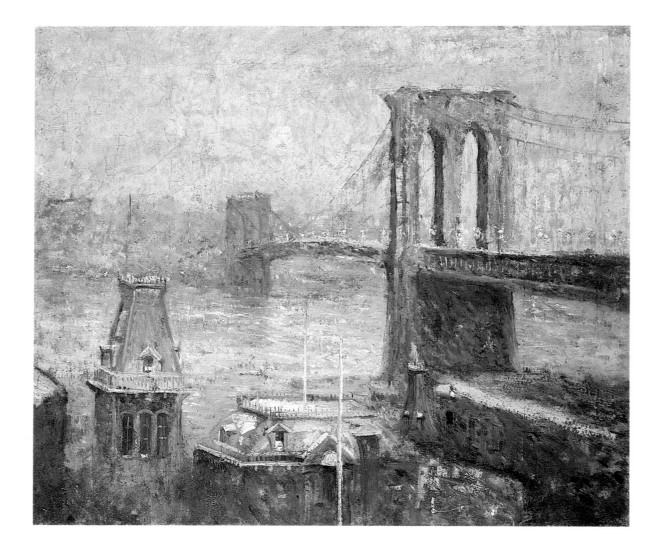

he began his celebrated series of views along the nearby Harlem River. Known for his thickly brushed canvases and surprisingly effective color combinations, Lawson often produced several versions of his landscape compositions, varying the color scheme or design only slightly in emulation of Claude Monet's series paintings. A regular exhibitor with such established organizations as the National Academy of Design and the Pennsylvania Academy of the Fine Arts throughout his career, Lawson was also associated with independent artists' groups, notably "The Eight," and sent work to the Armory Show in 1913.

ERNEST LAWSON (1873-1939)

Melting Snow, n.d.
Oil on panel 26 x 36 in.
Daniel J. Terra Collection
Terra Museum of American Art, Chicago (20.1980)

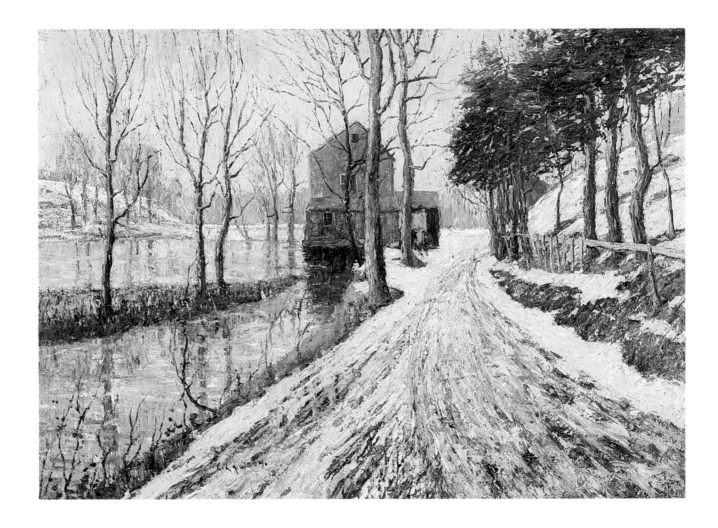

ERNEST LAWSON (1873-1939)

Springtime, Harlem River, n.d.
Oil on canvas 25 x 30 in.
Daniel J. Terra Collection
Terra Museum of American Art, Chicago (27.1985)

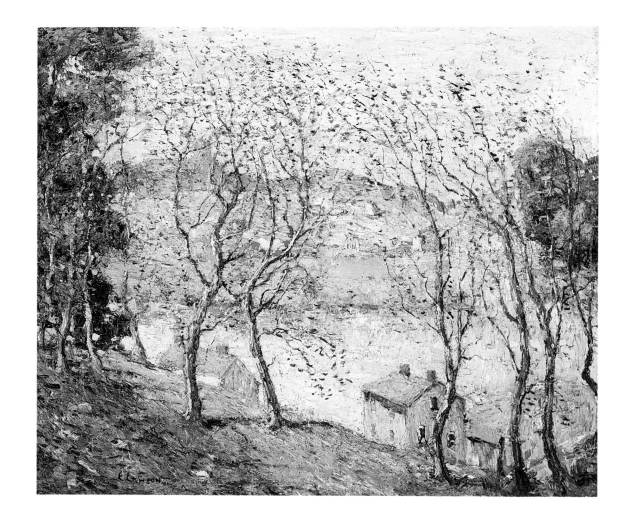

The Green Sash, 1904
Oil on canvas 45¾ x 32 in.
Daniel J. Terra Collection
Terra Museum of American Art, Chicago (24.1983)

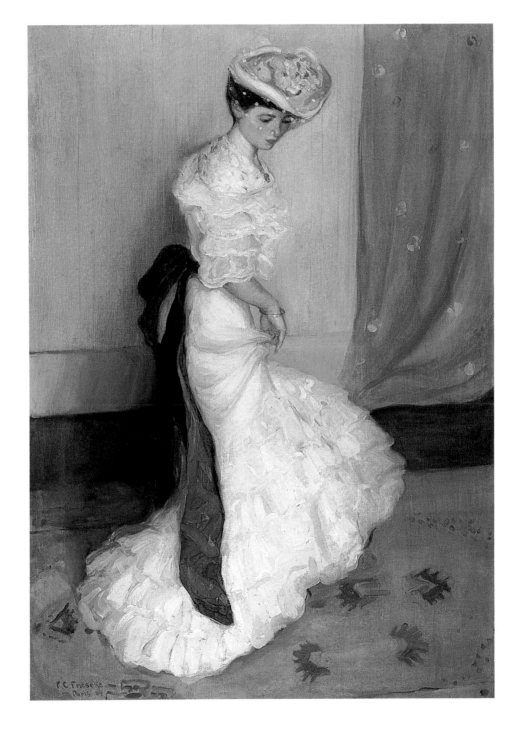

Frederick Carl Frieseke (1875-1939) was born in Owosso, Michigan. He began his art studies at The School of the Art Institute of Chicago before attending the Art Students' League in New York and the Académie Julian in Paris. His teachers in Paris were academicians Benjamin Constant and Jean-Paul Laurens, but Frieseke's most influential instructor was the expatriate James Abbott McNeill Whistler. Frieseke began summering in Giverny around 1900, but his work still retained the Whistler aesthetic. In 1906 Frieseke

Lady in a Garden, c. 1912
Oil on canvas 31⅞ x 25¾ in.
Daniel J. Terra Collection
Terra Museum of American Art, Chicago (1.1982)

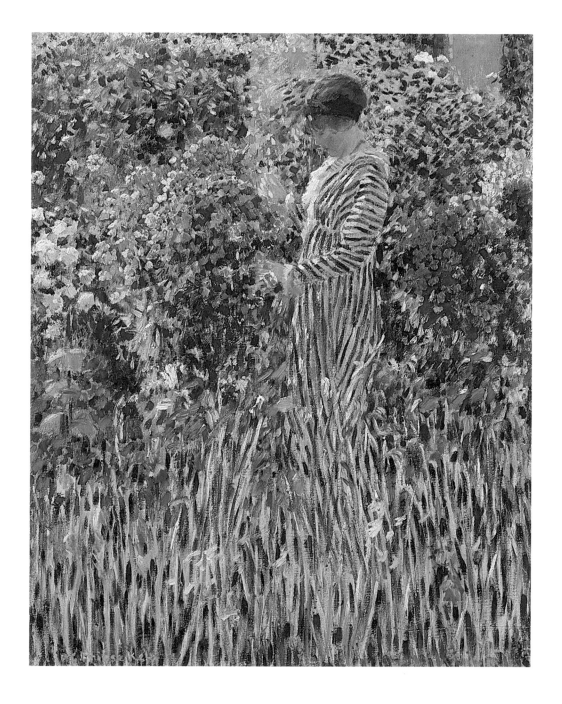

purchased the former residence of Theodore Robinson which bordered Claude Monet's property in Giverny. From this time onward Frieseke's paintings became increasingly Impressionistic, filled with color and light. Frieseke was an artist of some renown; during his lifetime he won many awards and exhibited in the United States and abroad.

Unraveling Silk, c. 1915
Oil on canvas 32¼ x 32¼ in.
Daniel J. Terra Collection
Terra Museum of American Art, Chicago (1.1981)

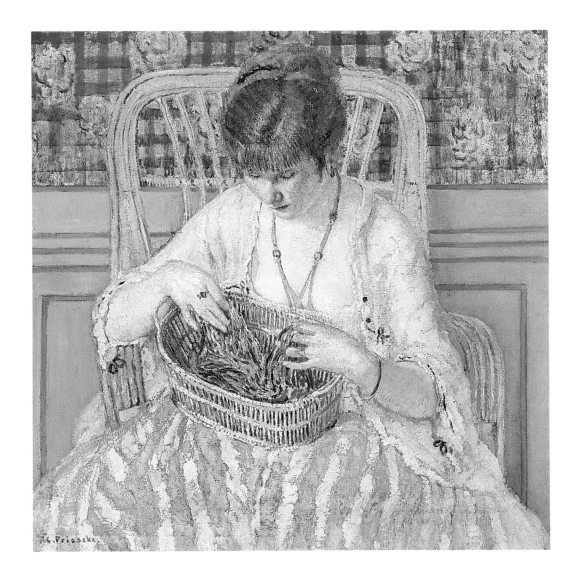

FREDERICK CARL FREISEKE (1874-1939)

Lilies, n.d.
Oil on canvas 25½ x 32 in.
Daniel J. Terra Collection
Terra Museum of American Art, Chicago (37.1986)

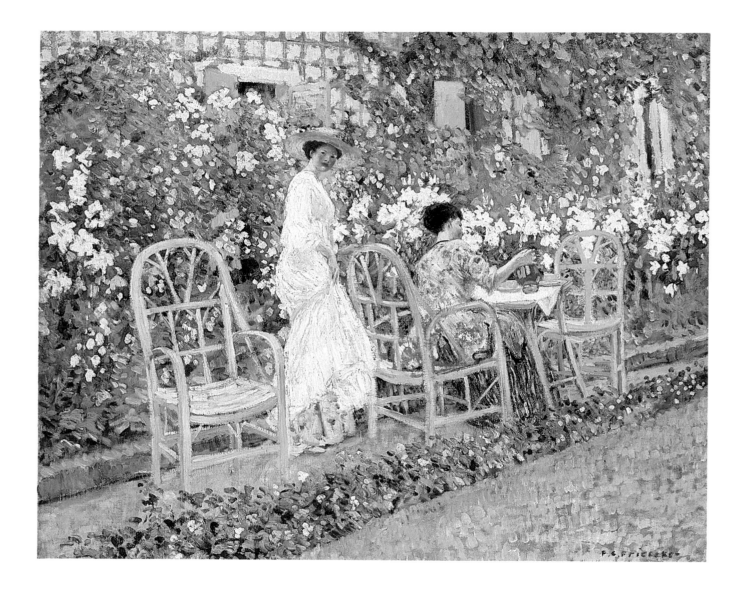

RICHARD EMIL MILLER (1875-1943)

PLATE T-159

Café de Nuit, 1906
Oil on canvas 48½ x 67¼ in.
Daniel J. Terra Collection
Terra Museum of American Art, Chicago (39.1985)

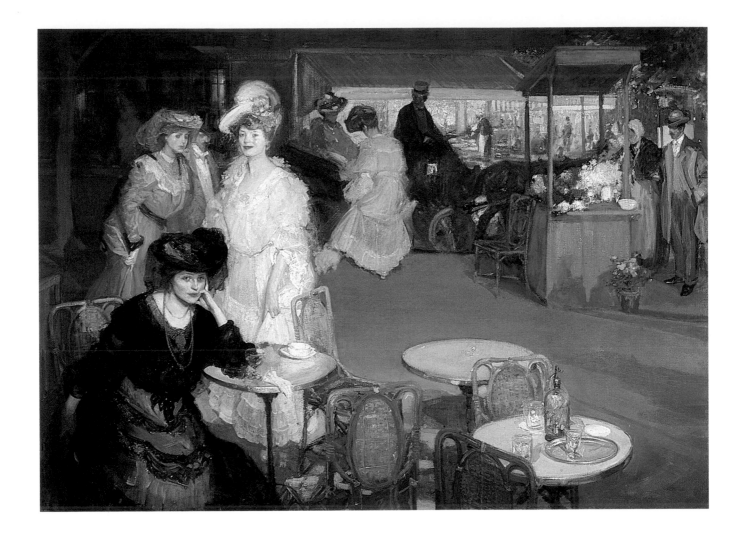

Richard Emil Miller (1875-1943) was raised in St. Louis, Missouri. In 1898 he went to study in Paris, where he remained for 20 years. In addition to painting, Miller taught at the Académie Colarossi and conducted summer classes at Giverny and St. Jean du Doight. He returned to the United States in 1918, eventually settling in Provincetown, Massachusetts, where he taught painting and founded an artists' colony.

MARTHA WALTER (1875-1976)

A la Cremerie, c. 1910
Oil on canvas mounted on board 12⅞ x 16 in.
Daniel J. Terra Collection
Terra Museum of American Art, Chicago (13.1981)

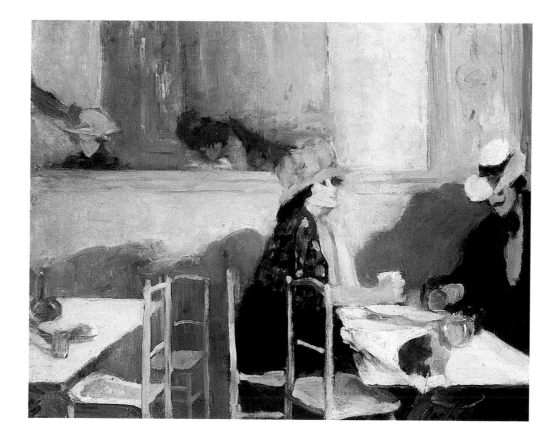

Martha Walter (1875-1976) was born in Philadelphia and studied with William Merritt Chase at the Pennsylvania Academy of the Fine Arts. She continued her studies in Paris at the Académie Julian in 1903 and at the Académie La Grande Chaumière. She traveled to Italy, Holland, Spain, and Germany on scholarship before establishing a studio in New York around 1909. From 1910 to 1920 Walter worked on a series of genre studies of newly arrived immigrants to the United States; this series, known as the Ellis Island paintings, represents her best work. Walter exhibited regularly at the Pennsylvania Academy and at other museums and continued working until her death at age 101.

Theater Scene, 1903
Oil on canvas 12⅞ x 15½ in.
Daniel J. Terra Collection
Terra Museum of American Art, Chicago (22.1985)

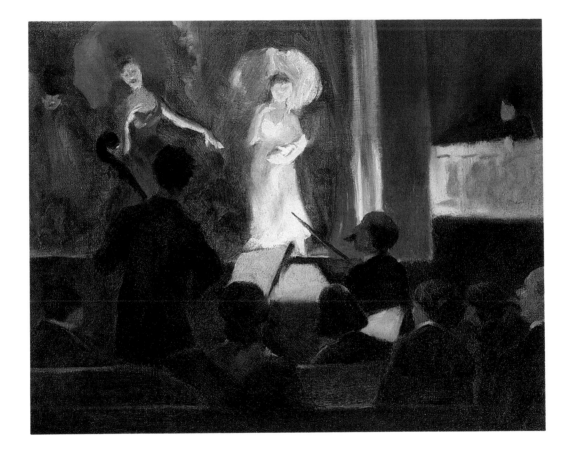

Everett Shinn (1876-1953) was born in Woodstock, New Jersey. As a boy Shinn demonstrated a remarkable ability for mechanical drawing and studied industrial design at the Spring Garden Institute in Philadelphia. Shinn later worked as an illustrator for the *Philadelphia Press* and, in 1893, enrolled at the Pennsylvania Academy of the Fine Arts where he studied with Robert Henri and formed associations with fellow students and coworkers from the *Press:* William Glackens, George Luks, and John Sloan. In 1897 Shinn moved to New York and became well known for his drawings of city life. His visit to Paris in 1900 inspired Shinn to concentrate on his painting; by 1905 he was exhibiting paintings and drawings regularly at galleries in both Paris and New York. In 1908 Shinn became one of "The Eight" artists to protest the National Academy of Design with an independent exhibition at the Macbeth Gallery in New York. A dapper, handsome man whose facility with the pencil or brush was renowned, Shinn was an inveterate theater-goer and is best known for his many paintings of music hall performers.

MARSDEN HARTLEY (1877-1943)

Painting No. 50, 1914-15
Oil on canvas 47 x 47 in.
Daniel J. Terra Collection
Terra Museum of American Art, Chicago (7.1986)

Marsden Hartley (1877-1943) was the last of nine children in a working-class family; the early death of his mother made Hartley's youth one of emotional insecurity and poverty. Hartley won scholarships to study at the Cleveland School of Art as well as at the Chase School and the National Academy of Design in New York. When he was twenty-eight, Hartley was given his first one-person exhibition at Alfred Stieglitz's gallery "291." With the backing of Arthur B. Davies and Stieglitz, Hartley went abroad for the next several years, painting in France and in Germany. In 1912-13 Hartley exhibited with the Expressionist group Der Blaue Reiter. He showed with them again in 1915-16, producing some of his most significant work. Hartley then returned for a short period to the United States, participating in the Armory Show of 1913 and making a visit to New Mexico; the American West became a theme of his symbolist landscape themes. While continuing to travel, Hartley exhibited at many major galleries and museums, but success and financial security remained elusive until the end of his career.

271

Peinture, 1917-18
Oil and pencil on canvas 25¾ x 32 in.
Daniel J. Terra Collection
Terra Museum of American Art, Chicago (10.1986)

Patrick Henry Bruce (1880-1936) was born in Virginia. He studied for a year under Robert Henri in New York, but was an expatriate for most of his life. Upon moving to Paris in 1903, Bruce initially painted in the Impressionist manner but later became a disciple of Henri Matisse. Bruce was influenced by the structuralism of Paul Cézanne and the Orphism of Robert Delaunay and developed therefrom a theme of colorfully flattened forms arranged in carefully composed still lifes. His highly abstract paintings were ahead of their time, and repeated public rejection caused Bruce to abandon painting in 1932. In a deep depression, he destroyed most of his work before returning in 1936 to New York, where he committed suicide.

Nature Symbolized #3: Steeple and Trees, 1911-12
Pastel on board mounted on panel 18 x 21½ in.
Daniel J. Terra Collection
Terra Museum of American Art, Chicago (14.1980)

Arthur G. Dove (1880-1946) studied art at Cornell University, from which he graduated in 1903. For several years he illustrated for the *Saturday Evening Post, McClure's, Collier's* and *Life,* until he was able to save sufficient money to go to France in 1908. In Paris, Dove befriended fellow Americans Arthur Carles and Alfred Maurer, and with them, studied the work of Paul Cézanne and the Fauves. Maurer also provided Dove with an introduction to Alfred Stieglitz, whom Dove contacted upon his return to New York. Dove joined the group of young modernists exhibiting at Stieglitz's gallery "291" in 1910 and, although he left New York City to live in the country soon after, Dove exhibited his work regularly. Critical recognition followed, but public acceptance of his colorful organic abstractions did not, and Dove relied for much of his career on the patronage of collector Duncan Phillips, who gave the artist a stipend in return for first choice among his paintings.

ARTHUR G. DOVE (1880-1946)

A Walk – Poplars, 1920
Pastel on silk 21⅛ x 17½ in. (sight)
Daniel J. Terra Collection
Terra Museum of American Art, Chicago (40.1982)

DANIEL GARBER (1880-1958)

Fisherman's Hut, c. 1940
Oil on canvas 50 x 60 in.
Daniel J. Terra Collection
Terra Museum of American Art, Chicago (23.1985)

Daniel Garber (1880-1958), a native of Indiana, studied first at the Cincinnati Academy in 1897, and later at the Pennsylvania Academy of the Fine Arts with Thomas Anshutz. A Cresson Traveling Scholarship enabled Garber to spend two years touring Europe from 1905 to 1907. Upon his return to the United States, Garber's colorful renderings of the Delaware Valley landscape north of Philadelphia quickly won him recognition as one of the country's best young Impressionist painters and, with Edward Willis Redfield, he became a leading member of the group of landscape painters known as the "New Hope School." Garber returned to the Pennsylvania Academy as a faculty member in 1909. He taught there for more than 40 years.

JOSEPH STELLA (1880-1946)

PLATE T-167

Telegraph Poles with Buildings, 1917-20
Oil on canvas 35⅞ x 30¼ in.
Daniel J. Terra Collection
Terra Museum of American Art, Chicago (9.1986)

Joseph Stella (1877-1946) was born in Italy and raised in New York. Stella attended the Art Students' League in 1897, and later studied with William Merritt Chase at the New York School of Art before touring Europe for three years. His encounters with Italian modernism made a great impact on Stella's own art; upon his return to the United States in 1913, he exhibited Futurist-inspired paintings at the Armory Show. In subsequent years Stella's work underwent several stylistic changes, progressing from an abstraction of urban subjects to more realistic and symbolic images. Stella was an early proponent of modern art in the United States and he also contributed numerous articles to leading international art magazines.

PLATE T-168

The Palisades, 1909
Oil on canvas 30 x 38 in.
Daniel J. Terra Collection
Terra Museum of American Art, Chicago (22.1983)

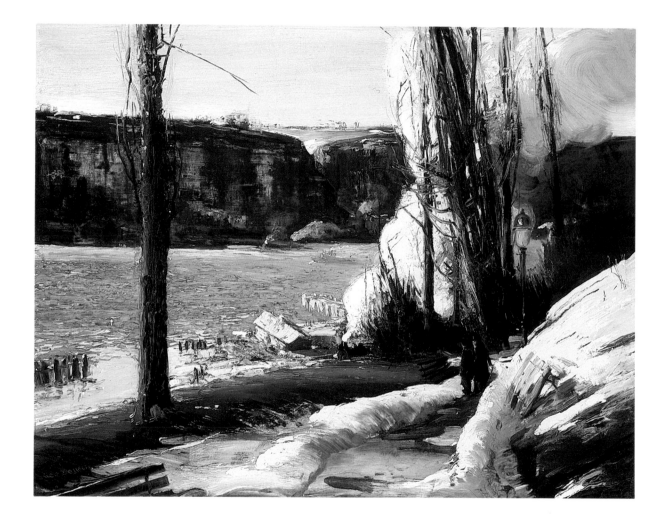

George Bellows (1882-1925) was a native of Columbus, Ohio. He attended Ohio State University, where he excelled in art and athletics. In 1904 he left college to study art under Robert Henri at the New York School of Art. Like other associates of Henri such as William Glackens, George Luks, Everett Shinn, and John Sloan, Bellows was interested in a realistic portrayal of American society and urban life. Characteristic of his style is a vigorous physicality conveyed not only by subject matter but also by color and brush stroke. Bellows had the distinction of being the youngest artist to be awarded associate membership in the National Academy of Design. He was very active on the New York art scene, founding the Society of Independent Artists and assisting in the staging of the Armory Show of 1913. In an age of expatriate artists, Bellows never went abroad, and the very Americanness of his paintings and lithographs contributed to his popularity among his native public and critics. He continued his successful career in New York until his premature death of appendicitis in 1925.

PLATE T-169

Dawn in Pennsylvania, 1942
Oil on canvas 24⅜ x 44 in.
Daniel J. Terra Collection
Terra Museum of American Art, Chicago (18.1986)

Edward Hopper (1882-1967) was born in Nyack, New York, and studied at the New York School of Art with Kenneth Hayes Miller and Robert Henri from 1900 to 1906. Hopper traveled to Paris, London, Berlin, and other major European centers during 1906-7 and 1909-10, painting scenes of city life. He settled permanently in New York in 1911 and in the following years began exhibiting etchings, watercolors, and oil paintings of urban and New England seaside subjects. After his first one person show in 1920, Hopper became recognized as an important contemporary American painter. He exhibited frequently and received numerous awards. His fame reached its height during the last 20 years of his life and he held several traveling exhibitions and major retrospectives.

Rue du Singe Qui Pêche, 1921
Tempera on board 21 x 16½ in.
Daniel J. Terra Collection
Terra Museum of American Art, Chicago (36.1985)

Charles Demuth (1883-1935) studied at the Drexel Institute in Philadelphia, and at the Pennsylvania Academy of the Fine Arts under Thomas Anshutz and William Merritt Chase from 1905 to 1911. He traveled to France in 1904 and to Berlin in 1907; he returned to Paris in 1912 to study at the Académie Moderne and the Académie Julian before making a final visit to Berlin in 1913. A year later Demuth hosted his first one-person show in New York which featured his delicate and linear watercolors of flowers and literary illustrations. During most of his career, Demuth divided his time between his studio in New York; Provincetown, Massachusetts, where he summered until 1920; and his hometown of Lancaster. He formed a wide circle of friends who were the leading artists or collectors of the time: Arthur G. Dove, Lyonel Feininger, John Marin, Georgia O'Keeffe, Gertrude Stein, and Alfred Stieglitz. Demuth experimented with different media and went through several stylistic changes during his career; he is known for his abstract paintings in oils and tempera as well as his watercolors.

PLATE T-171

Flower Forms, 1917
Oil on canvas 23⅛ x 19⅛ in.
Daniel J. Terra Collection
Terra Museum of American Art, Chicago (12.1986)

Charles Sheeler (1883-1965) was raised in Philadelphia. He studied first industrial design at the School of Industrial Art in Philadelphia and then art at the Pennsylvania Academy of the Fine Arts, where he was a student of William Merritt Chase. Sheeler accompanied Chase to Europe in 1904 and 1905, but after touring Italy in 1908-9, Sheeler's artistic interests began to change. His work became increasingly architectural and precise as a result of his studies of Italian Renaissance paintings, as well as Sheeler's encounters with Cubist painting in France and his own work in photography. His participation in the

Bucks County Barn, 1940
Oil on canvas 18¾ x 28¼ in.
Daniel J. Terra Collection
Terra Museum of American Art, Chicago (24.1985)

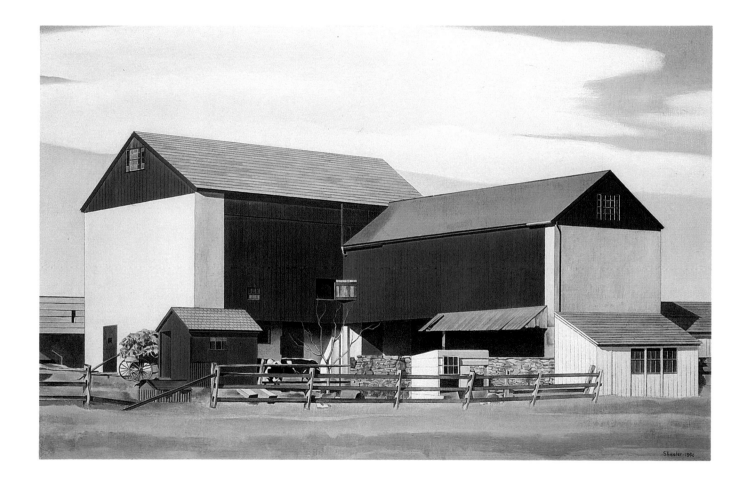

Armory Show of 1913 deepened Sheeler's commitment to the modernist idiom and finalized his break with Chase. Sheeler's paintings underwent several stylistic developments, evolving by the 1940s into colorful abstract compositions of machinery, buildings, and other elements of the industrial landscape. Sheeler's visions of the man-made environment are considered characteristic of the "Precisionist" style, which he developed with such American contemporaries as Charles Demuth, Ralston Crawford, and Louis Lozowick.

CHARLES SHEELER (1883-1965)

Counterpoint, 1949
Conté crayon on paper 20 x 28 in. (sight)
Daniel J. Terra Collection
Terra Museum of American Art, Chicago (38.1985)

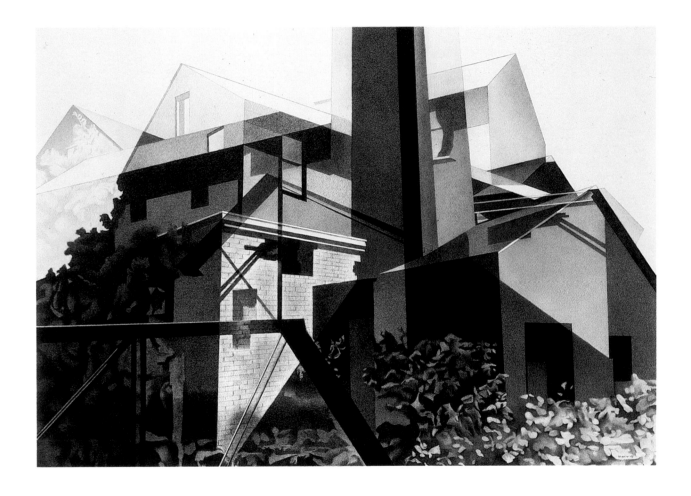

HELEN TORR (1886-1967)

Purple and Green Leaves, n.d.
Oil on copper mounted on board 20¼ x 15¼ in.
Daniel J. Terra Collection
Terra Museum of American Art, Chicago (39.1984)

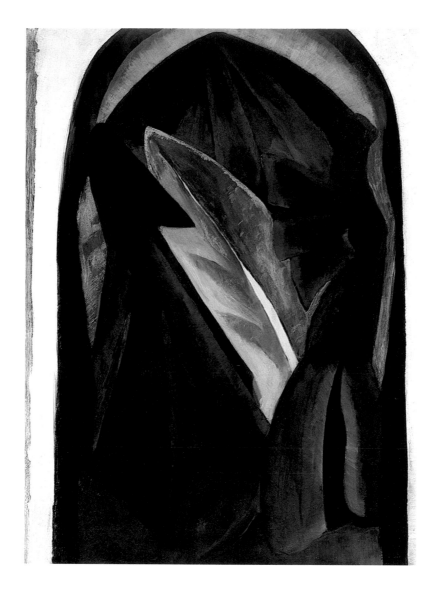

Helen Torr (1886-1967) attended the Pennsylvania Academy of the Fine Arts on scholarship in her native Philadelphia. Torr married the painter Arthur G. Dove in 1932. At that time Dove's artistic reputation was already established and he was an important member of the elite Stieglitz group. Torr showed her paintings only twice in her lifetime: with a group exhibition arranged by Georgia O'Keeffe (1933) and in a joint exhibition with Torr's husband, Dove, in 1933. Reviewers recognized the influences of O'Keeffe and Dove in Torr's work and criticized her for a lack of originality. Although supported unfailingly by Dove, Torr found it difficult to accept this criticism and ceased painting in 1938. Since her death in 1967, her work has received critical approval.

LOUIS RITMAN (1889-1963)

At the Brook, n.d.
Oil on canvas 36⅜ x 28⅝ in.
Daniel J. Terra Collection
Terra Museum of American Art, Chicago (28.1986)

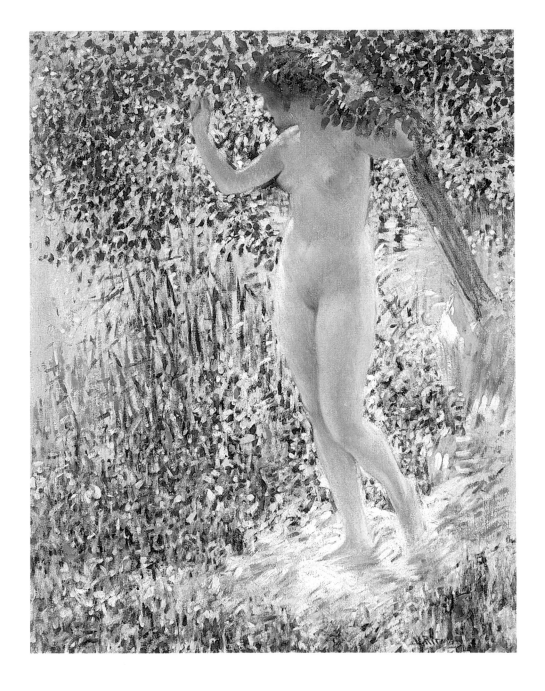

Louis Ritman (1889-1963) was born in Russia and raised in Chicago. He began his art training at The School of the Art Institute of Chicago under John Vanderpoel. In 1909 he traveled to Paris and attended the Ecole des Beaux-Arts. Ritman stayed in Paris until 1911 or 1912, whereupon he bought a house in Giverny where he lived for almost 20 years. His work shows the influence of French Impressionism and is similar to that of Frederick Frieseke, who was in Giverny during this time. When Ritman returned to the United States, he exhibited regularly in Chicago and also taught at The School of the Art Institute of Chicago.

PLATE T-176

Super Table, 1925
Oil on canvas 47⅞ x 33⅞ in.
Daniel J. Terra Collection
Terra Museum of American Art, Chicago (8.1986)

Stuart Davis (1892-1964) was immersed in the art world even as a child; his mother was a sculptress and his father was art director of the *Philadelphia Press*. A precocious artist, Davis studied with Robert Henri as a teenager and, at age 19, exhibited work in the Armory Show, where he was also able to study Cubism at first hand. After two one-person shows, Davis spent a year in Paris, returning to New York in 1930. His witty adaptations of the Cubist idiom to the American landscape and household objects, first demonstrated in his *Eggbeater* series of 1927-28, established Davis as an important American modernist. During the 1930s Davis worked for the WPA, executing murals for Radio City Music Hall and the Municipal Broadcasting Company in New York and for the University of Indiana at Bloomington. During his later career, Davis divided his time among painting, teaching, and writing.

Plastic Polygon, 1937
Oil on wood 45 x 30 in.
Daniel J. Terra Collection
Terra Museum of American Art, Chicago (6.1986)

Charles Green Shaw (1892-1974), a native New Yorker, studied at Yale University and majored in architecture at Columbia University prior to attending the Art Students' League and receiving private lessons from George Luks. During the 1920s Shaw wrote for such magazines as *Vanity Fair* and *The New Yorker*, but in 1929, after befriending the collector and artist Albert Gallatin, Shaw resumed his artistic activities. He began to produce works influenced by Jean Arp and by his own architectural background, most notably the series begun in 1933 entitled *Plastic Polygon*. Shaw's paintings are characterized by controlled compositions of superimposed planes. His later work reflects an increasing interest in three-dimensionality. Besides his position on the advisory board of The Museum of Modern Art in New York, Shaw was active with exhibiting at avant-garde galleries and authoring two books as well as illustrating several others.

MILTON AVERY (1893-1965)

The Checker Players, 1938
Oil on canvas 28 x 36 in.
Daniel J. Terra Collection
Terra Museum of American Art, Chicago (3.1982)

Milton Avery (1893-1965) was born in Altmar, New York. He received his brief training at the Connecticut League of Arts Students in Hartford; in 1925 he moved to New York where, apart from a trip to Europe in 1952, he remained until his death. Now best known for his seaside views and figure studies, throughout his career Avery's work received only sporadic attention from the American art press. His wife, Sally, supported him economically by working as an illustrator and emotionally by her commitment to his art. Avery's work provides an important link between that of such European masters as Henri Matisse and the American color field painters as well as Avery's younger artist acquaintances Mark Rothko, Adolph Gottlieb, and Helen Frankenthaler.

287

CHARLES BURCHFIELD (1893-1967)

PLATE T-179

Dream of a Fantasy Flower, 1960-66
Watercolor on paper 32¼ x 38½ in. (sight)
Daniel J. Terra Collection
Terra Museum of American Art, Chicago (41.1982)

Charles Burchfield (1893-1967) was raised in Salem, Ohio. He began painting as a teenager while employed at a metal-fabricating factory and won a scholarship to the Cleveland Institute of Art for the years 1912-16. From Cleveland, Burchfield went to New York to the National Academy of Design; however, he returned after only a year to Salem and the factory in order to support himself. He continued to paint his highly original scenes of nature and industry in his spare time. In 1921 Burchfield moved to Buffalo, New York, where he married and became the head designer at a wallpaper plant. Burchfield had his first important one-person show in 1920. The critical success of this and succeeding shows enabled Burchfield after 1929 to devote himself full-time to painting. At his death in 1967, Burchfield was widely respected and honored as a teacher as well as one of America's most original landscape painters.

CHARLES BURCHFIELD (1893-1967)

PLATE T-180

Autumn to Winter, c. 1966
Watercolor on paper 48⅞ x 74¼ in.
Daniel J. Terra Collection
Terra Museum of American Art, Chicago (5.1982)

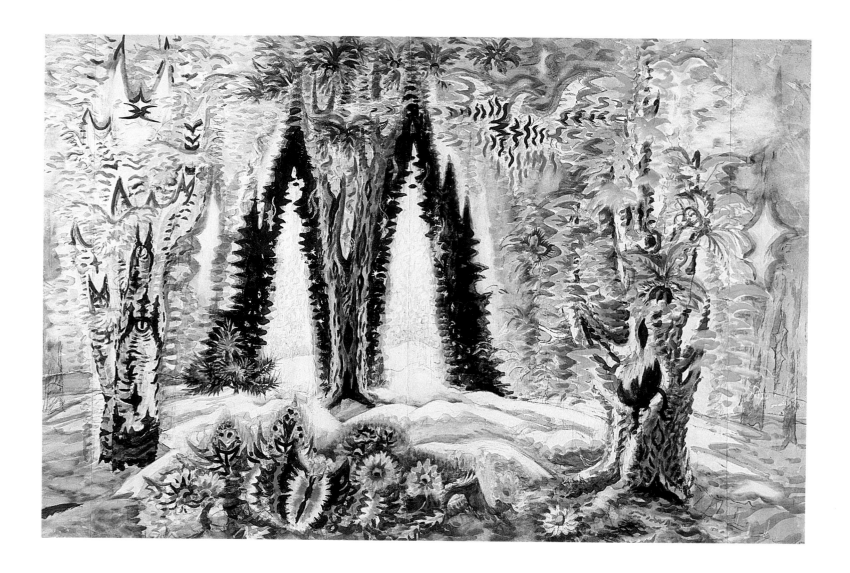

YASUO KUNIYOSHI (1893-1953)

Girl Thinking, 1935
Oil on canvas 49¼ x 39¼ in.
Daniel J. Terra Collection
Terra Museum of American Art, Chicago (9.1984)

Yasuo Kuniyoshi (1889-1953), a native of Japan, immigrated to the United States in 1906. He entered the Los Angeles School of Art and Design at age 15, and went on to study in New York at several art schools, the most influential being the Art Students' League where he met, among others, Alexander Brook, Reginald Marsh, and Kenneth Hayes Miller. During the 1920s and 1930s, Kuniyoshi's career gained momentum. His growing anxiety for the social and political issues of his time is reflected in the increasingly symbolic nature of his work. His final drawings and lithographs in particular manifest a disquieting, fantastical style and content. Kuniyoshi also taught at the Art Students' League and later at the New School for Social Research.

PLATE T-182

Pip and Flip, 1932
Tempera on paper mounted on canvas 48 x 48 in.
Daniel J. Terra Collection
Terra Museum of American Art, Chicago (23.1980)

Reginald Marsh (1898-1954) was born in Paris to American parents and grew up in New Jersey. By 1920, having graduated from Yale University, Marsh worked as an illustrator for *Vanity Fair* and the *New York Daily News* while studying periodically at the Art Students' League. Marsh was especially influenced by the work of Thomas Eakins and the Ash Can School painters who included George Luks and John Sloan. Marsh hosted his first one-person show in 1924, but did not really establish himself until after going abroad in 1925. His exposure to the European Old Masters is apparent in his illustrations and paintings after 1926. Marsh was a popular artist and well known for his pulsating portrayals of city life, crowded with people and activity. He also remained an illustrator all his life; his work was reproduced in *The New Yorker, Harper's Bazaar, Life, New York Evening Post, Fortune*, and others.

Passing Show, 1951
Oil on canvas mounted on board 65½ x 48 in.
Daniel J. Terra Collection
Terra Museum of American Art, Chicago (21.1983)

Philip Evergood (1901-1975) was a native New Yorker who was educated in England at Eton and Cambridge University. Undecided about a career, Evergood studied and taught English, French, Latin, and mathematics with thoughts of law and engineering before entering the Slade School, where he worked in drawing and sculpture until a desire to see the United States brought him back to New York in 1922. In New York, Evergood studied at the Art Students' League with George Luks; the following year he went to the Académie Julian in Paris. In 1927 he began regularly to exhibit his work on biblical themes in New York. The subject of his paintings changed to that of social and political commentary during the Depression. The pressing problems of the time made a lasting impression on Evergood, who participated in the WPA. In subsequent years Evergood remained active as a painter, exhibiting at major museums throughout the United States as well as teaching at different universities.

ANDREW WYETH (b. 1917)

Marsh Hawk, 1964
Tempera on masonite 32 x 45½ in.
Daniel J. Terra Collection
Terra Museum of American Art, Chicago (2.1982)

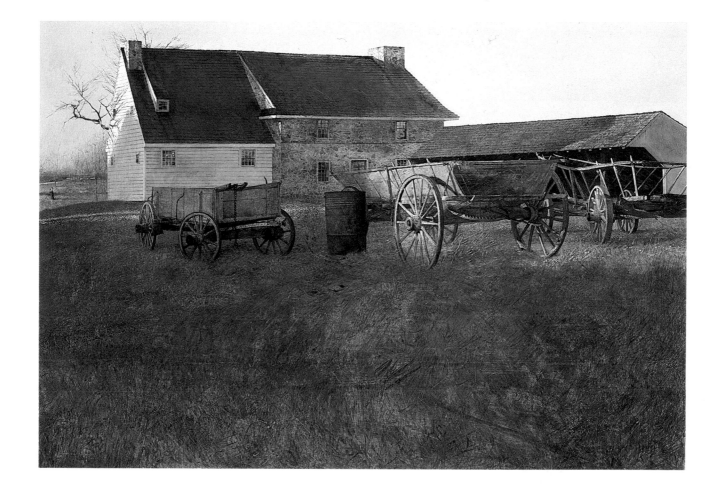

Andrew Wyeth (b. 1917) lives in Chadds Ford, Pennsylvania. Trained by his father, the well-known illustrator N.C. Wyeth, Andrew Wyeth planned initially to follow in his father's footsteps. After 1939 Wyeth abandoned the bright, freely drawn watercolor technique at which his father had excelled; he took up egg tempera, a medium requiring a slower, more methodical approach that reflected Wyeth's own desire to impart a deeper meaning and content to his precise realism. In 1948 he received international acclaim for his haunting painting *Christina's World.* Notwithstanding his fame, Wyeth has chosen to remain in Chadds Ford, selecting his subjects from the people and objects with which he is most familiar. At the same time, frequent media appearances have made him one of America's best-known artists.

PLATE T-185

Highway, 1953
Tempera on board 22⅞ x 17⅞ in.
Daniel J. Terra Collection
Terra Museum of American Art, Chicago (40.1984)

George Tooker (b. 1920) was born in Brooklyn, New York. He graduated from Phillips Andover Academy in 1938 and Harvard University in 1942 before studying at the Art Students' League with Kenneth Hayes Miller, Reginald Marsh, and Paul Cadmus. From Marsh, Tooker learned the medium of egg tempera, but his greatest influence was Cadmus's realism. Tooker had become very involved with social issues, and he consciously has used his highly original paintings for social commentary. Tooker has exhibited frequently in addition to teaching in New York at the Art Students' League.

JAMIE WYETH (b. 1946)

Kalounna in Frogtown, 1986
Oil on panel 35⅞ x 50⅛ in.
Daniel J. Terra Collection
Terra Museum of American Art, Chicago (11.1986)

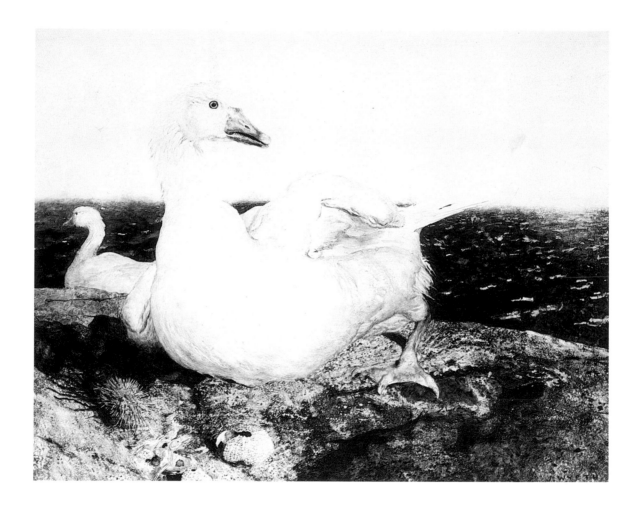

Jamie Wyeth (b.1946) was born in Chadds Ford, Pennsylvania, the son of Andrew Wyeth and the grandson of N. C. Wyeth. Like his father, Jamie Wyeth received his artistic education from family members, beginning with his aunt, Carolyn Wyeth, in 1956. Two years later he joined his father in his studio as his apprentice. In 1963 Wyeth moved to New York and established his workspace in a hospital morgue in order to gain a better understanding of anatomy. He hosted his first one-person show at the Knoedler Gallery in New York in 1965.

JAMIE WYETH (b. 1946)

PLATE T-187

Kleberg, 1984
Oil on canvas 30⅜ x 42⅜ in.
Daniel J. Terra Collection
Terra Museum of American Art, Chicago (20.1984)

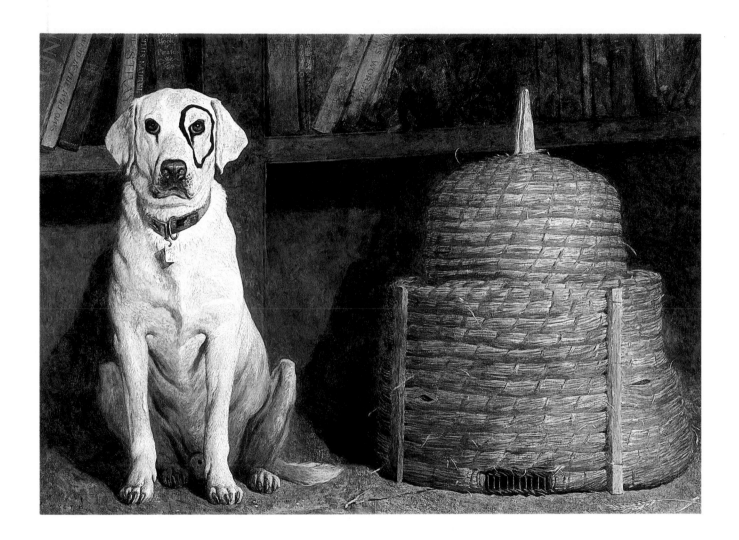

PLATE T-188

Sea Star, Burnt Island, 1985
Oil on canvas with shell frame 30⅞ x 45⅞ in.
Daniel J. Terra Collection
Terra Museum of American Art, Chicago (1.1986)

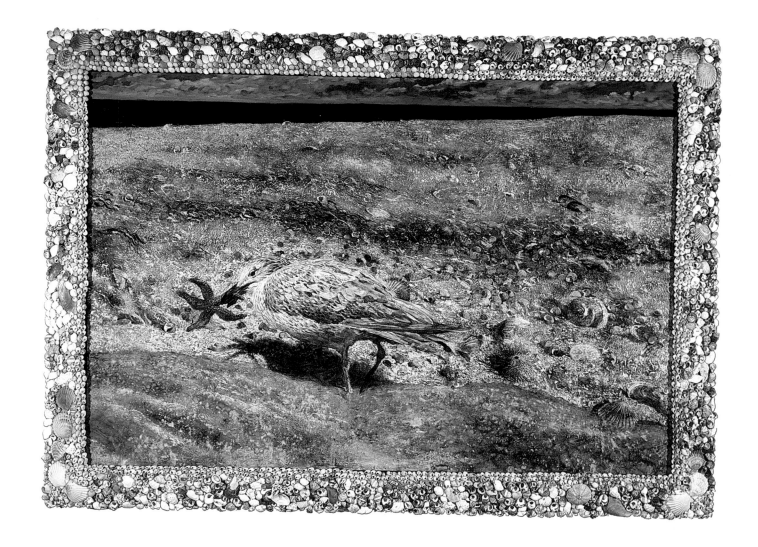

JAMIE WYETH (b. 1946)

Kalounna in Frogtown, 1986
Oil on canvas 35⅞ x 50⅛ in.
Daniel J. Terra Collection
Terra Museum of American Art, Chicago (11.1986)